The Drawings of Henry Moore

ALAN G. WILKINSON

# The Drawings of HENRY MOORE

THE TATE GALLERY
in collaboration with the
ART GALLERY OF ONTARIO

# 1035417

**Exhibition touring dates**

Art Gallery of Ontario, Toronto    5 November – 31 December 1977

Shimin Art Gallery Museum, Iwaki City, Fukushima    21 January – 12 February 1978

Prefectural Museum, Kanazawa City, Ishikawa    18 February – 26 March 1978

Kumamoto Municipal Museum, Kumamoto    1 April – 23 April 1978

Seibu Gallery, Tokyo    28 April – 31 May 1978

Tate Gallery, London    28 June – 28 August 1978

Exclusively distributed in France and Italy by Idea Books
46–8 rue de Montreuil, 75011 Paris and Via Cappuccio 21, 20123 Milan

ISBN 0 905005 85 6 paper  0 905005 90 2 cased
Published by order of the Trustees 1977
for the touring exhibition organised jointly by
the Tate Gallery and the Art Gallery of Ontario
Copyright © 1977 The Tate Gallery and Art Gallery of Ontario

Published by the Tate Gallery Publications Department,
Millbank, London SWIP 4RG
Designed by Pauline Key
Originated and printed at The Curwen Press Ltd, Plaistow, London E13

# Contents

Cover/Jacket
Henry Moore, *Standing Figures*, 1940 (detail)
Catalogue No. 132

# Foreword

It is a great pleasure for us to have co-operated in assembling this comprehensive exhibition of Henry Moore drawings.

Some of Moore's drawings, and in particular his Shelter Drawings, are,

ave often been included in

have been shown all over

rst retrospective exhibition

ibition by Dr Alan Wilkin-

entre in the Art Gallery of

t. Dr Wilkinson has also

Art Gallery of Ontario in

finally in the Tate Gallery

entres in Japan has been

usually long absence from

indebted to all lenders for

ore and Mary Moore who

of which have never been

oore himself both for his

t every stage.

Norman Reid
Director
Tate Gallery

The Drawings of Henry Moore

Errata

Page 14:    For reasons of space Fig.10 was omitted.

Page 22:    Penultimate paragraph.'Ideas for Sculpture :
            Internal and External Forms' is No.217 and not
            No.27.

Page 25:    Fig.33 is printed upside down.

Page 26:    Antepenultimate paragraph. 'The Arch' is L.H.
            503b.

Page 41:    Second paragraph. 'Sculpture in a Landscape' is
            No.191 and not No.19.

Page 45:    First paragraph, line 9 should read:-
            ... watershed that had been reached in the
            mid-1950s ...

Page 46:    First paragraph should read:-
            ... and three of the four sheep drawings shown
            here (Nos.242, 243 and 244 ...

Page 60:    Illustration No.42 should be No.44 and vice
            versa.

Pages       Illustration No.43 should be No.45 and vice
60-61:      versa.

Page 78:    Fig.84 should be reversed.

Page 105:   Catalogue No.143. The title and details should
            read as follows:-
            Shelter Scene : Two Seated Figures
            Watercolour, ink and chalk, 14¾ x 16⅜ (38 x
            42.8)
            Leeds City Art Galleries, Gift by H.M.
            Government through the War Artists' Advisory
            Committee, 1947.

Page 120:   Illustration No.187 is reproduced on its side.
            See colour reproduction opposite p.37.

Page 156    List of Lenders.
            M. F. Fehely should read M. F. Feheley.

# Life Drawing

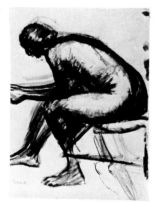

Fig.1 Henry Moore,
*Seated Figure*, 1924

'In my opinion, long and intense study of the human figure is the necessary foundation for a sculptor.'[1]

It may come as a surprise to those unfamiliar with Henry Moore's early life drawings to discover that his academic training at the Leeds School of Art and at the Royal College of Art was as traditional as the instruction Manet, Degas and Seurat received in Paris in the nineteenth century. In fact two student drawings (Fig.1 and No.2) bear comparison with the work of two of these artists whom Moore considers among the greatest draughtsmen in Western Art: Degas and Seurat. Since the Renaissance, drawing from the nude model had been the basis of a sound academic training. Moore was aware from the beginning of his career 'of the importance of drawing to a sculptor's development – the fact that all the sculptors I admire from Michelangelo to Rodin were great draughtsmen, and the ability to draw was as essential to a sculptor as to a painter'. What Rilke wrote of Rodin can with equal validity be said of Moore's aims as a student: 'Rodin knew that, first of all, sculpture depended upon an infallible knowledge of the human body'.[2]

In September 1919, having been awarded an ex-serviceman's grant, Moore began his first year at the Leeds School of Art. He considered the course as a means to an end: 'This was understood from the outset to be a first step. London was the goal. But the only way to get to London was to take the Board of Education examinations and win a scholarship'.[3] Though none of the drawings from his two years at Leeds has survived, the artist's recollections tell us something of his activities and of the academic atmosphere of an English provincial art school. Having spent two years (1917–19) in the army with the 15th London Regiment, Civil Service Rifles, Moore at twenty-one was somewhat older than most of the students:

> Art schools, then, and especially in the provinces, had a terribly closed, academic outlook. When I got to Leeds School of Art in 1919 there were students who'd gone there at fourteen or fifteen, as you could in those days, and any excitement or freshness they might have had, had been deadened and killed off by humdrum copying from the antique, just making very careful stump-shaded drawings with no understanding whatever of form.[4]

Students, he recalled, often spent as long as six months working on a single drawing, as they were expected to try to copy exactly the tone values, using forty-five degree parallel hatchings. So rigid was the academic attitude of the teachers, that if the lines were at forty-seven degrees a drawing was considered unacceptable.

Moore's first year at Leeds was devoted entirely to drawing, in preparation for the examination of the Board of Education. The drawing classes comprised a number of subjects: anatomy, architecture, perspective, animals in action, drawing from the antique, and life drawing.

During the first term, Moore has said, there was the monotony and repetition of having to draw from the same male model, an Italian who had been engaged from London. He 'adopted all the set school-of-art poses, going through physical exercises with arms up, arms down and so on'.[5] No doubt the first two drawings in this exhibition (Nos.1 and 2) which date from 1921, during Moore's first term at the Royal College of Art, have certain affinities with the exercises in tonal values done at Leeds.

Drawing from the antique proved particularly frustrating. Students were told that the plaster casts set before them were supreme examples of Greek sculpture (e.g. the 'Venus di Milo' and the 'Discobolus'); but Moore found them strangely disappointing and showed little interest in them. After his first few weeks at Leeds he thought: 'Well, is it me that doesn't know what sculpture is? Is there something wrong with me that I don't like these pieces?'[6] His dislike of these works was fully justified. Some of the casts were in fact of late Roman copies of original Greek sculptures and, moreover, they had been whitewashed year after year, so that whatever sharpness of form and surface sensitivity they might once have had were lost beneath a quarter-inch of lime.

At the end of his first year, Moore passed the drawing examination and told the Principal, Hayward Ryder, that he wanted to specialize in sculpture. At the time sculpture was not taught at Leeds, and a department had to be set up. R. T. Cotterill, who had just come down from the Royal College of Art, was put in charge and for a year was able to concentrate on Moore, his only full-time student. They managed to compress the two-year examination course into one, at the end of which Moore won a Royal Exhibition Scholarship, worth some £90 per annum. He had achieved his ultimate goal – entrance to the Royal College of Art in London.

Moore had just turned twenty-three when in September 1921 he began the three-year diploma course at the Royal College of Art in London. At the outset he was convinced of the value of academic training based on drawing and modelling from life:

My first few months at College had rid me of the romantic idea that art schools were of no value and I'd begun to draw from life as hard as I could. A sculptor needs to be able to see and understand three-dimensional form strongly, and you can only do that with a great deal of effort and experience and struggle. And the human figure is both the most exacting subject one can set oneself, and the subject one should know best. The construction of the human figure, its tremendous variety of balance, of size, of rhythm, all those things make the human form much more difficult to get right in a drawing than anything else.[7]

He soon found, however, that his academic work at the Royal College of Art was in opposition to the direction he was trying to follow privately in his sculpture:

My aims as a 'student' were directly at odds with my taste in sculpture. Already, even here a conflict had set in. And for a considerable while after my discovery of the archaic sculpture in the British Museum there was a bitter struggle within me, on the one hand, between the need to follow my course at college in order to get a teacher's diploma and, on the other, the desire to work freely at what appealed most to me in sculpture. At one point I was seriously considering giving up college and working only in the direction that attracted me. But, thank goodness, I somehow came to the realisation that academic discipline is valuable.[8]

In 1946, looking back on his student years, Moore explained how he managed to accommodate the conflict and tension between his academic work and his interest in archaic and primitive art, between the European

and non-European traditions: 'But finally I hit on a sort of compromise arrangement: academic work during the term, and during the holidays a free rein to the interests I had developed in the British Museum'.[9]

In Sir William Rothenstein, who was appointed Principal of the Royal College of Art in 1920, Moore found a sympathetic and enthusiastic supporter. Rothenstein's portraits of many famous men of his day are well-known. He also drew members of his staff: F. Derwent Wood, Professor of Sculpture, Ernest Cole, who succeeded Wood in 1924, the sculptor/painter Leon Underwood, and Henry Moore,[10] whom Rothenstein describes in his memoirs as 'the ablest student in the sculpture school'.[11] When one of Moore's drawings, entitled 'Night', was violently criticized by the Professor of Architecture, A. Beresford Pite, who declared 'This man has been feeding on garbage', Rothenstein reassured a very discouraged Moore and was no doubt instrumental in persuading him to stay on at college. Moore has said that although Rothenstein may not have whole-heartedly approved of his work outside college, he realized that his life drawing and modelling were promising. And, in fact, in 1931, as Sir John Rothenstein recalls, his father bought a Moore life drawing, 'a massive seated woman which hung in the hall of our house'.[12]

Another member of staff whom Moore admired was Leon Underwood, who taught in the Painting School at the Royal College of Art. He had Moore said, 'a passionate attitude towards drawing from life. He set out to teach the science of drawing, of expressing solid form on a flat surface and not the photographic copying of tone values, nor the art-school imitations of style in drawing'.[13] Underwood also opened a private studio in Brook Green, Hammersmith, where he taught life drawing one or two evenings a week. Moore with two friends from the Royal College of Art, Raymond Coxon and Vivian Pitchforth, often attended these private classes. Several of his student drawings clearly reflect the influence of Underwood's life drawings. Moore's 'Two Standing Nudes' of 1923 (Fig.2), is closely related stylistically to Underwood's 1923 'Nude No.2' (Fig.3).[14] Both Moore and his fellow-student, Barbara Hepworth, experienced Underwood's infectious enthusiasm for life drawing and have expressed their indebtedness to him as a teacher.[15]

The records of the Royal College of Art tell little of Moore's development, but a number of laconic reports on his term work in several departments are of interest, particularly those which include comments on his drawing. In July 1922, at the end of Moore's first year, F. Derwent Wood could write of his progress in the School of Modelling: 'His life work shows improvement. Design not to my liking. Is much interested in carvings'. In the School of Sculpture, his work was given the following assessment at the end of the first term, September–December 1922, of his second year: 'Is a good student who shows great improvement in all sections, his carving is excellent, drawing very promising'. In December 1923 his progress in the Modelling School was reported as follows: 'This student shows great improvement in his life work. His drawings are excellent, but his design might show improvement. He appears to be somewhat limited in his interest of tradition in Sculpture'. Did the instructor mean by 'tradition' only the sculpture of Greece and the Renaissance? Was he unaware of Moore's weekly visits to the British Museum to study the sculptural achievements of other civilizations and cultures: Palaeolithic, Sumerian, Egyptian, Mexican and primitive art? Moore contradicts the judgement of his instructor in a note in his No.6 Notebook of 1926 (No.69), which sums up his aim in the 1920s: 'Keep ever prominent the world tradition – the big view of sculpture'.

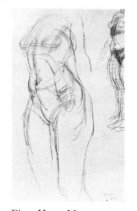

Fig.2 Henry Moore, *Two Standing Nudes*, 1923

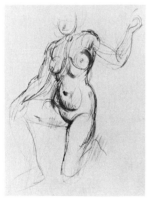

Fig.3 Leon Underwood, *Nude No.2*, 1923

Life drawing had for Moore two fundamental purposes. It enabled him to study the human figure on which he believes sculpture is ultimately based, and to learn what he often refers to as the science of drawing. The artist himself has elaborated on the second point.

Once I really became interested in drawing I tried to find out what drawing was, both as a science and as an art. Drawing is the expression and the explanation of the shape of a solid object on a flat surface, by the use of light and shade, and the understanding of the laws of perspective. I looked at the drawings of the Old Masters from the point of view of learning what drawing was. As a student in London I began to realize that good drawing was not copying the model, the tone values, the light and shade as in a photograph, not just the training of a copyist photographic eye. Nor was it even making the correct proportions or guessing the angles of outlines and such props to copying. It was an attempt to understand the full three-dimensionality of the human figure, to learn about the object one was drawing, and to represent it on the flat surface of the paper.

Sculpture students at the Royal College of Art were encouraged to participate in the life drawing classes in the School of Painting, every afternoon except Wednesday from 4 to 6 p.m. Drawing was not taught as part of the curriculum in the Sculpture School, though Moore occasionally drew in the modelling classes. Whereas he rarely missed a drawing class in the Painting School, most students in the School of Sculpture, Moore recalled, 'avoided drawing like poison. It showed them up, showed how bad they were. They would spend months modelling, afraid to do drawing'. Drawing from life, he has always maintained, is a far better way of testing what one knows and understands about the human figure than modelling. Once an armature has been constructed, Moore explained, a student can keep adding and subtracting clay almost indefinitely, and cannot help but create three-dimensional form and eventually arrive at a form roughly resembling the model. To represent a solid object on a flat surface is far more difficult. Life drawing is quite obviously a quicker way of studying and learning about the human figure: 'In the modelling classes we had the same model and pose for the whole term. Drawing was more exciting because there were many more models and the pose was changed every day or so'. Most of Moore's student drawings were completed within the two hours of the afternoon sessions. Drawing, in contrast to modelling, Moore said 'enables one to carry through a complex expression in a quicker period. It's living and working at a higher rate'. During his student years, drawing was more important to Moore than modelling. Based on his own experience he has suggested: 'If you are going to train a sculptor to know about the human figure, make him do more drawing to begin with than modelling'.

Moore has described how some of the students consciously set out to imitate an artist's drawing style, for example the late style of Ingres, without stopping to consider that an artist's mature work is the outcome of much previous experience and knowledge. In copying Ingres' late style, which many students preferred to his earlier work, they were attempting to reach the same conclusions without having gone through the necessary stage of learning the rudiments of good drawing. 'It's copying a style and not the form', Moore said, 'without understanding the form between the outlines. You can't do shorthand without learning longhand'. Moore has said of those who imitate the drawing style of others: 'Clever people can copy the handwriting of an artist–it's like forging a person's signature. One mustn't let technique be the consciously important thing. It should be at the service of expressing the form'.

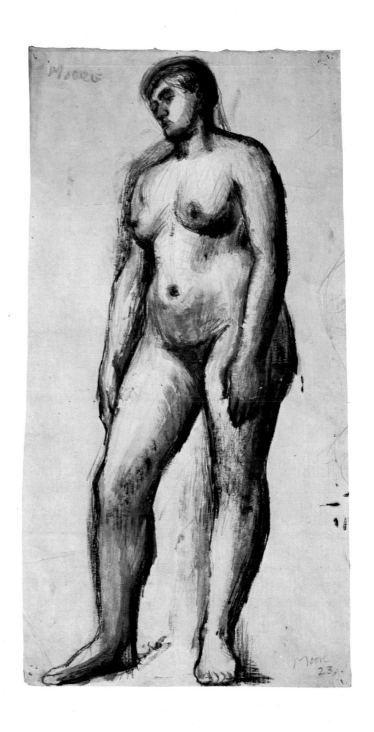

8  Standing Figure  1923  (entry on p.50)

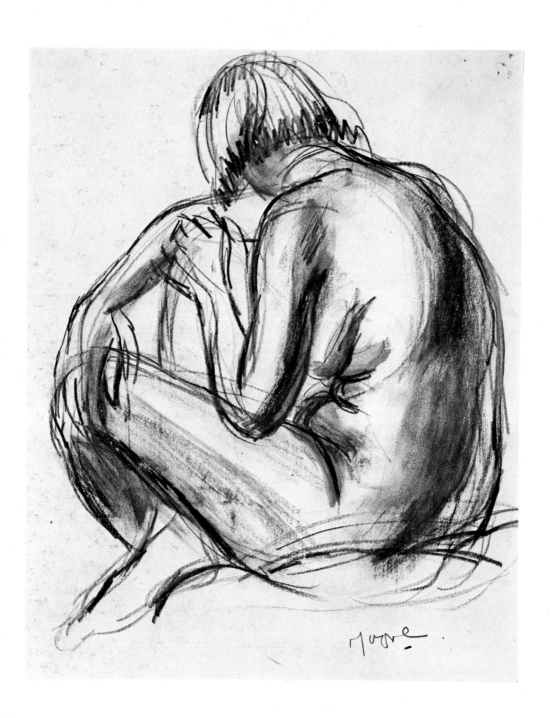

18  **Nude Study of a Seated Girl**  *c.*1924  (entry on p.53)

27  The Artist's Mother  1927  (entry on p.56)

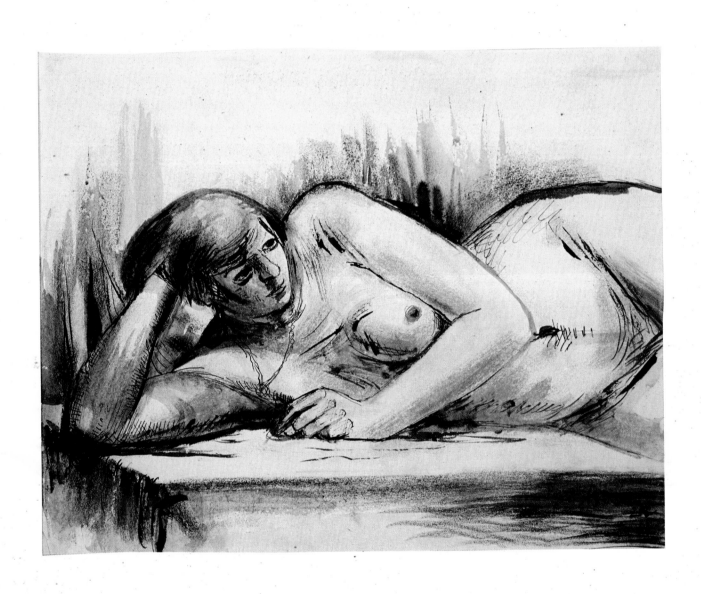

37 **Life Drawing: Reclining Nude** 1928 (entry on p.58)

Moore repeatedly has urged that one should begin by doing highly finished, three-dimensional drawings and later simplify. He has cited the examples of Matisse and Picasso:

> Pure outline drawing is a shorthand method of drawing, to be arrived at later in an artist's career. Matisse and Picasso often used this method, but they began their careers with this kind of highly finished three-dimensional drawing using light and shade, and then later simplified their styles. This is the real way to understand form and drawing.[16]

Among the most obvious features of Moore's life drawings (with the exception of the Paris drawings which will be discussed later) are their sculptural quality, the primacy of modelling and the use of as many as four media in a single drawing. To represent the outline of the human figure was rarely his aim, and even among Moore's recent work there are few linear drawings. His handling is often vigorous, even aggressive, as if he were almost attacking the flatness of the paper surface to create three-dimensional form. Indeed, the artist said, he sometimes pressed so hard that he nearly rubbed through the paper. In 'Standing Girl' of 1924 (No.13) the area between the right eye, and the right breast have been scraped.

In using three or four media in a single drawing, Moore's working method was as follows. Outlines and contours were drawn in pencil or chalk. If the initial outlines were established in pencil, these were often gone over with chalk. The strong, rough modelling within the figure was then drawn with chalk and brush. Finally, pen and ink were frequently used to give sharper definition to facial features, added density to the modelled areas of chalk and wash, and greater clarity to the outlines of the figure. Of course not all these media were used in every life drawing, but there are very few in which at least two of the four most commonly employed materials, pencil, pen and ink, wash and chalk, do not appear.

Another important feature common to both the life drawings and sculpture is the representation of the human figure in repose. Moore has never been attracted to what he calls 'the gesture school of poses'. Unlike Degas and Rodin, he was not interested in portraying the human body in movement or violent action, in making hurried sketches while the model roamed freely round the studio. Nor did he draw the figure in the erotic poses and foreshortened perspectives which characterize many drawings by Rodin, Klimt and Schiele. Of the three fundamental poses of the human body – standing, sitting and reclining – almost all of Moore's life drawings are of standing and seated figures. There are few drawings of reclining figures, one of the most important subjects of his sculpture. Tenaciously, Moore repeatedly drew the female models (there are few life drawings of the male figure) in uncomplicated, relaxed standing and seated positions: 'I wasn't drawing from life to learn a repertoire of poses'.

As a student at the Royal College of Art from 1921–4, Moore was, of course, obliged to draw the models in the poses set by the instructors. The most habitual pose, Moore recalled, was standing, an observation which is borne out in the surviving life drawings of the period. In late 1924, when Moore began teaching at the Royal College of Art, he had the responsibility of both hiring and posing the models for the modelling classes, where he sometimes drew with his students. During the next decade the most habitual pose was seated, although he continued to draw the standing figure. There are comparatively few drawings of the reclining figure from these years.

Up to about 1925, most of Moore's signatures were printed in capitals, and are useful in dating drawings from his student years.[17] Written signatures began about 1926 and have been used to the present day.

In the remainder of this chapter five important subjects are discussed, focusing on the drawings themselves: influences of the work of other artists in a number of life drawings, portraiture, the Paris drawings, the evolution of the two-way sectional line, and the connection between the life drawings and sculpture.

*Influences*

Several early life drawings reflect in a general way the style of two nineteenth-century draughtsmen whom Moore greatly admires. He has described 'Nude Study of a Seated Girl' of *c*.1924 (No.18) as Renoiresque. The similarities with Renoir's nudes, which Moore said had a considerable impact early in his career, are obvious in the gentle, rounded forms of the figure and indeed in the use of red chalk. Fig.4 shows a Renoir drawing in the artist's collection. In 'Seated Figure' of 1924 (Fig.1) the heavy chalk and wash outlines are distinctly reminiscent of Degas' charcoal drawings of the 1880s and 1890s of women at their toilet and nude dancers. One of two drawings by Degas in the artist's collection, 'Etude de Deux Danseuses' of *c*.1895 (Fig.5) serves as a useful comparison.[18]

Three drawings of 1928 are of particular interest. Strangely in 'Reclining Female Nude' (Fig.6) the handling of pen and ink and wash recalls the drawing style of Giambattista Tiepolo.[19] 'Three Quarter Figure' (Fig.7) is stylistically related to Braque's monumental figure compositions executed between 1922 and 1927[20] (Fig.8). The artist has described another drawing 'Seated Figure' of 1928 (Fig.9) as 'Braque-like', that is similar to the Braque figure type, but probably not indebted to a particular work. But one can, however, relate 'Three Quarter Figure' to a specific drawing. Comparing it to Braque's pastel 'Nu' of 1927, which was reproduced in *Cahiers d'Art*, 1928, p.11, there is little reason to doubt that the Moore drawing was based on it. It would therefore appear that 'Three Quarter Figure' was not in fact drawn from the model, but freely copied from the figure study by Braque.

*Portraiture*

Portraiture has played a very minor role in Moore's drawings and sculpture. Unlike Rodin and Epstein, he has rarely been concerned with the characterization of the human face on a psychological level:

> My aim has not been to capture the range of expressions that can play over the features but to render the exact degree of relationship between, for example, the head and the shoulders; for the pose of the total figure, the three-dimensional character of the body, can render the spirit of the subject treated.[21]

Moore did, however, execute a number of portrait drawings at the Royal College of Art and later of his family and friends. 'Head of an Old Man' of 1921 (No.1) is one of five portraits of this model. In addition, there is the clay 'Portrait Bust', also of 1921 (L.H.1, Fig.10) of the old man. Another student drawing is inscribed 'Anthony Betts student at the R.C.A.'.

Certainly the most important portraits were of members of the artist's family. Three of the five known drawings of the artist's sister Mary are included in this exhibition (Nos.4, 28 and 29). The 1927 'Portrait of the Artist's Mother', (No.26) one of six known studies, is undoubtedly Moore's most successful portrait and one of his finest drawings of the 1920s. A photograph of his mother taken, *c*.1908, is shown here (Fig.11). In a number of life drawings of the artist's wife (Nos.44 and 47) a certain

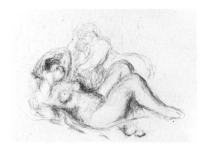

Fig.4 Auguste Renoir,
*Two Reclining Nudes*,
(Henry Moore)

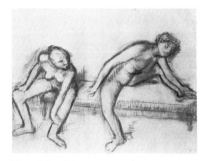

Fig.5 Edgar Degas,
*Etude de Deux Danseuses*, [?]*c*.1896
(Henry Moore)

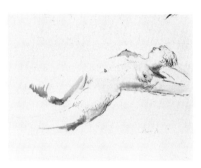

Fig.6 Henry Moore,
*Reclining Female Nude*, 1928

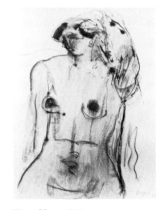

Fig.7 Henry Moore,
*Three Quarter Figure*, 1928

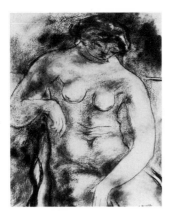

Fig.8 Georges Braque,
*Seated Woman*, 1927
© A.D.A.G.P.

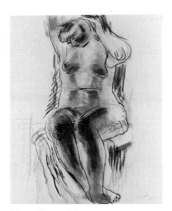

Fig.9 Henry Moore,
*Seated Figure*, 1928

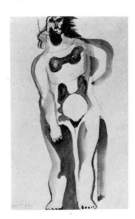

Fig.12 Henry Moore,
*Standing Nude*, 1927

likeness was achieved. There are two portrait drawings of the artist's daughter Mary, dated 1954.

An undated drawing of *c*.1926 is of the wife of the artist's great friend Raymond Coxon, and is inscribed 'Girl Reading (Edna Ginesi)'. No.56, one of four known drawings of the poet Stephen Spender, is dated 1934. Many years later, in 1973, he made a lithograph of Spender's contemporary W. H. Auden, 'Sketches of Auden Made from Memory' (C.G.M.265).

But when all is said and done, facial features are of little importance in Moore's work. His concern has been with the formal proportions of the human figure, the way in which the pose of the head and the general disposition of the body can reveal character. 'You can recognize a friend two hundred yards away solely by his proportions and by the way he moves and holds himself'.[22] And yet for Moore the head is the vital unit in figurative sculpture: 'It gives scale to the rest of the sculpture and, apart from its features, its poise on the neck has tremendous importance'.[23] In the splendid series of drawings of the artist's wife (Nos.52 and 55) it is the poise of the head which gives the figure its proud bearing and sense of alertness.

Between 1921 and 1926 no striking or abrupt stylistic changes occurred in the life drawings. The Paris drawings of 1927–8 and the development in 1928 of the two-way sectional line method of drawing, a stylistic innovation which was to have far-reaching implications in his later drawings, mark the first major changes in direction in Moore's approach to figure drawing.

*Paris*

Of his frequent visits to Paris in the 1920s and early 1930s, Moore said: 'From 1922 on I went once or twice a year to Paris – until 1932 or 1933 I didn't miss a year'. As a form of relaxation after visiting museums and galleries, and as a means of keeping his hand in, he enjoyed drawing from life at the free (no instruction) classes at the Colarossi and Grande Chaumière Academies.[24] During his student years he often went to Paris with friends from the Royal College of Art: Vivian Pitchforth, Raymond Coxon, Barbara Hepworth and Edna Ginesi. In the autumn of 1929, he made the trip with his wife Irina and the Coxons. An inexpensive book of tickets could be bought by students or the general public for the academy classes in the afternoons from 2 to 6 p.m., or for the classes in the evenings from 6 to 9 p.m. In the afternoon classes, Moore said, a pose usually lasted for several hours, enabling him to complete a fully worked drawing similar to those he had done at the Royal College of Art. In the evening classes, however, the rhythm changed. The first pose might last a full hour, with subsequent poses becoming progressively shorter: twenty minutes, five minutes and finally several of one minute each. Moore remembers the excitement of actually completing a drawing within the allotted time of one minute. These short poses demanded a spontaneous response to the essential pose and gesture of the human figure, which resulted in drawings totally different in handling and feeling from the strongly modelled sculptural studies.

In several Paris drawings, the extreme haste of execution produced such a free interpretation of the figure that it is difficult to determine whether they are indeed life drawings or studies for sculpture. Such a work is 'Standing Nude' of 1927 (Fig.12) which incorporates both suggestions of a model and of the more abstract language of Moore's sculptural ideas. Pose and outline, the artist said, were drawn from life, and then within the outlines he rendered the breasts and belly in a more schematic

manner. Another study which appears to hover between the life drawings and drawings done from memory is 'Reclining Nude' of 1928 (Fig.13) in chalk and wash, two media often used in the Paris drawings. Although based on a model, the straight lines of the torso, the line which connects the left breast and right nipple, give this study a simplified angularity not often to be found in the life drawings.

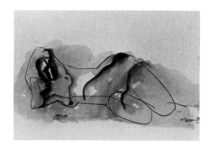

Most of the surviving Paris drawings date from 1928. Not all are nude studies. 'Seated Woman' of 1928 (No.33) is one of two drawings of the same clothed model, while the charming pen and ink 'Drawing of Clowns in Paris' of 1930 was, the artist said, done at the Colarossi Academy (Fig.14).

Fig.13 Henry Moore, *Reclining Nude*, 1928

In the Paris drawings, Moore remarked, he was no longer mastering the rudiments of good drawing, but rather learning to observe quickly, to test what he already knew and understood about the human figure. He would often concentrate on a particular problem he wanted to improve on, rather like, in his own words 'a tennis player practising his backhand'.

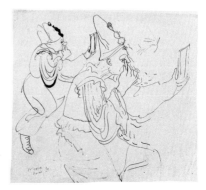

The Paris drawings are by no means the most typical or monumental of Moore's life studies, but they provide an interesting contrast with the more fully modelled drawings. In their spontaneity such drawings as Nos. 34 and 35 bear comparison with Rodin's rapid pencil and wash studies of the female nude.

Fig.14 Henry Moore, *Drawing of Clowns in Paris*, 1930

### The Two-way Section Line Method of Drawing

The most important stylistic innovation in the life drawings of 1928 was the genesis of what the artist calls the two-way sectional line method of drawing, a highly original means of representing three-dimensional form. Moore has defined it as drawing by the use of line 'both down the form as well as around it, without the use of light and shade modelling'. By drawing in two directions, that is both horizontally across the form, and vertically down the form, the volumes of the areas within the outlines of the figure are defined. As early as 1923, in 'Figure Lying Down' (Fig.15) there are four one-way sectional lines: two around the leg above and below the knee, one across the stomach, and one around the arm. 'Standing Nude' of 1928 (No.39) shows the tentative beginnings of the two-way section lines, which supplement the light and shade modelling in chalk and wash. Sectional lines define the shape of the model's left arm and hand. A continuous line can be traced from the left shoulder, running down the arm almost parallel to the pen and ink outline, reaching the bend at the elbow, turning at a little more than ninety degrees, and continuing down the arm and curving into the palm of the cupped hand. Just below the elbow three curved lines, drawn around the tubular shape of the arm, intersect the single line just described. Thus, in a rudimentary way, Moore's definition of the two-way sectional is exemplified: he has drawn the section in two directions, both down and across the form of the arm. Note also the line running down the left side of the chest, describing the slight concavity just below the shoulder, and then curving over and under the breast.

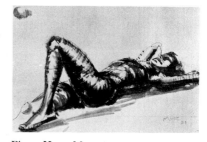

Fig.15 Henry Moore, *Figure Lying Down*, 1923

In another drawing of 1928 'Standing Female Nude' (Fig.16), the sectional line on the model's left leg is far closer to the handling developed in later drawings. A continuous line moves from right to left up and across the left leg, turns downwards where it meets the pen and ink hatchings, turns at ninety degrees, moves half way across the leg, turns down again and curves across and down, terminating just below the pen and ink hatchings.

The two-way section line method was used at times in the life drawings, in some of the studies for sculpture of the 1930s and early 1940s, and in the war drawings of 1940–2, but the technique was never fully developed

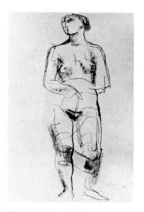

Fig.16 Henry Moore, *Standing Female Nude*, 1928

Fig.17 Henry Moore,
*Drawing for Family Group*, 1944
(Art Gallery of Ontario)

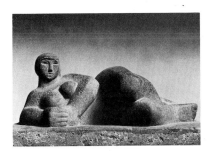

Fig.18 Henry Moore,
*Reclining Woman*, 1927

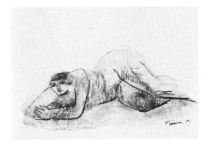

Fig.19 Henry Moore,
*Reclining Figure*, 1928

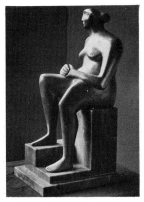

Fig.20 Henry Moore,
*Seated Figure*, 1930

until the mid-1940s (Fig.17). The method reached its culmination in the large family group drawings and scenes of domestic life of 1948 (Nos.209 and 210). He has continued to use the two-way sectional line in many drawings and prints of the last thirty years.[25]

In 1928 Moore had his first one-man exhibition at the Warren Gallery, London. The exhibition made £90, and apart from the two sculptures sold, the rest of the sales were of life drawings, priced at £1 each. Moore was encouraged to find that such established artists as Jacob Epstein, Augustus John, and Henry Lamb were among the purchasers of some thirty drawings sold. In the late 1920s and 30s the sale of drawings provided one of his principal sources of income: '. . . in my first four or five shows it was the drawings that kept me going, not the sculptures, and the other artists who bought'.[26] In fact up to the Second World War, the sale of drawings out-numbered the sale of sculpture by twenty to one. In the 1920s most of the drawings for sculpture were done in the small sketchbooks, and were not considered for exhibition or sale. The large drawings for sculpture produced in the 1930s were included and offered for sale in the exhibitions at the Leicester Galleries.

*Relationship between Drawings and Sculpture*
How are the life drawings of the late 1920s and 30s related to Moore's sculpture of the period? The artist has stated that his preference in sculpture for full, static, monumental forms is reflected in the treatment of the model in some of the figure studies. For example, he often consciously widened the figure as he drew, making it in his own words, 'more sturdy and weighty, which has to do with one's attitude towards stone'.

The style of several sculptures parallels that of the life drawings. The cast concrete 'Reclining Woman' of 1927 (L.H.43 Fig.18) belongs to the naturalism of the life drawings and is, in fact, very similar to a drawing of the following year 'Reclining Figure' (Fig.19). The lead 'Seated Figure' of 1930 (L.H.81 Fig.20) which was first modelled in clay, could almost be a realization in three dimensions of one of the drawings of the artist's wife seated in an armchair (Nos.52 and 54).

In a number of life drawings of 1929-30 are features which were undoubtedly influenced by the sculpture of the period. One of the most obvious is the schematic rendering of the hair at the side or back of the head, what David Sylvester has called 'a sort of cubic bun'.[27] The 'Reclining Figure' of 1929 (L.H.59, Fig.21) is one of the first sculptures in which the stylized treatment of the hair appears, no doubt suggested by the rectangular protuberances on each side of the head in the 'Chacmool' (Fig.28). But the sculptures which had the most direct impact on the life drawings were the series of masks of 1929-30.[28] The form of the hair in the 1930 oil 'Woman in Armchair' (No.49) corresponds to the two protuberances in the green stone 'Mask' of 1930 (L.H.77). However, the facial features in this drawing and in the 1929 oil in the Auckland City Art Gallery 'Seated Woman with Clasped Hands' (No.45) resemble those found in the cast concrete 'Mask' of 1929 in the collection of Sir Philip Hendy (L.H.62, Fig.22). In the Auckland drawing, the straight line of the nose, somewhat flattened against the right cheek, and the way in which the line from the nose to chin seems to cut into the mouth, creating the effect of two separate planes, strongly echo identical features in the Hendy 'Mask'.

In July 1929 Moore married Irina Radetsky, a painting student whom he had met at the Royal College of Art (Fig.23). The series of life drawings of the artist's wife, executed between 1929 and 1935, represents the culmination of many years of effort and struggle to master the science of

drawing. By the mid-1930s the sculpture and drawings for sculpture occupied more and more of his time. The last nude studies of the 1930s are two drawings of the artist's wife dated 1935, one of which is shown here (No.54). Sixteen years later, Moore did the charming pen and ink studies of his wife and daughter Mary (Nos.57 and 58) and in 1954 a series of nude studies made during a brief visit to London (No.61).

Of the human figure and life drawing Moore has said:

It's not just a matter of academic training. You can't understand it without being emotionally involved. It really is a deep, strong, fundamental struggle to understand oneself, as much as to understand what one is drawing.

He regards what he calls 'the human personality' of the model as of the utmost importance: 'If I didn't like the look of them, I tried to change them into human beings one liked better'. In fact he destroyed a number of life studies, because 'I did not like the human personality in the drawing'.

And so good drawing thus involves far more than the mastery of a science. Art, Moore said, is the expression of an individual personal vision: 'If the artist's vision is a commonplace one, he will not produce great drawings even if he has spent all his time learning drawing. Second rate draughtsmen repeat a stereotype vision. Facility alone does not produce good drawing'.

Echoes of the life drawings are to be found in many sculptures executed long after Moore had given up drawing from life. In 1953–4, while working on the 'Warrior with Shield' (L.H.360, Fig.24) he found that '. . . all the knowledge gained from the life drawing and modelling I had done years before came back to me with great pleasure'.[29] Reaffirming the importance of life drawing, Moore said recently that the greatest influence on his sculpture has been the study of the human figure. 'In the human figure one can express more completely one's feelings about the world than in any other way.'

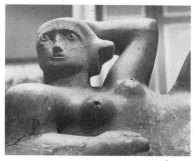

Fig.21 Henry Moore,
*Reclining Figure*, 1929 (detail)
(Leeds City Art Galleries)

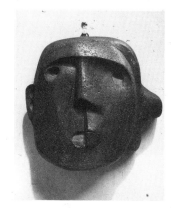

Fig.22 Henry Moore,
*Mask*, 1929

Fig.23 Wedding photograph, July 1929

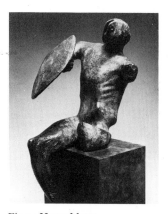

Fig.24 Henry Moore,
*Warrior with Shield*, 1953–4

# Copies of Works of Art

One of the most fascinating and hitherto unpublished aspects of Moore's notebooks and drawings are his copies of works of art from Palaeolithic times to Cézanne. The many sketches and the few more finished drawings of sculptures, paintings, drawings and artifacts comprise an invaluable record of specific works which particularly interested Moore, and provide concrete evidence of his far-ranging interests in the art of the past. In 1930 the artist commented:

> The world has been producing sculpture for at least some thirty thousand years. Through modern development of communication much of this we now know and the few sculptors of a hundred years or so of Greece no longer blot our eyes to the sculptural achievements of the rest of mankind. Palaeolithic and Neolithic sculpture, Sumerian, Babylonian and Egyptian, Early Greek, Chinese, Etruscan, Indian, Mayan, Mexican and Peruvian, Romanesque, Byzantine and Gothic, Negro, South Sea Island and North American Indian sculpture; actual examples or photographs of all are available, giving us a world view of sculpture never previously possible.[1]

Copies of works from all periods mentioned here (with the exception of Babylonian, Chinese, Indian, Romanesque and Byzantine) have been identified and are discussed in detail in the appendix at the end of this catalogue (see pp.143–150). In addition there are copies after drawings and paintings by European artists: Giotto, Giovanni Bellini, Jacopo Bellini, Dürer, Rubens, Cézanne and Gauguin (see Nos.62, 68, 71, and 72; and Figs.72, 77, 80, 81).

Most of Moore's copies were made between 1921 and 1926 and appear in the five surviving Notebooks Nos.2–6, from these years (see Nos.63–65 and 69). Three sheets of studies of Italian art, dating from Moore's trip to Italy in 1925 are included in this exhibition (Nos.66–68), as well as important drawings from the 1950s and 70s (Fig.58 and Nos.70–72). In the appendix, rather than examining Moore's copies chronologically, they have been divided into two sections: drawings of European, Egyptian and Sumerian art from Palaeolithic times to Cézanne, and copies of Primitive art: Negro, Oceanic, North and South American, and Mexican sculpture. None of the copies after the antique, which Moore did as a compulsory part of his academic training during his two years at the Leeds School of Art, has survived. The earliest known copy appears in the No.2 Notebook of 1921–2 (Fig.110).

During his first year in London, Moore was, he has written 'in a dream of excitement'.[2] Roger Fry's *Vision and Design* (1920), which he had read while still at Leeds, '. . . opened the way to other books and to the realization of the British Museum . . .',[3] to '. . . the richness and comprehensiveness of its collection of past art, particularly of primitive sculpture. . . .'[4] In addition there were the London libraries. Moore has described evenings spent in his little room in Sydney Street, '. . . when I could spread out the books I'd got out of the library and know that I had the chance of learning about all

the sculptures that had ever been made in the world'.[5] The Ethnographic collection of the British Museum and book illustrations were the two principal sources for the copies made in the five early notebooks of the 1920s. Moore has often worked from photographs and reproductions. In all probability the three sheets of drawings done in Italy in 1925 (Nos. 66–68) were copies from Alinari photographs. And the recent 1974 head and landscape (No.71) based on Dürer's 'Portrait of Conrad Verkell' in the British Museum (Fig.80) was drawn from a reproduction in the artist's possession.

The eleven copies of works of art included in this exhibition are discussed in the catalogue notes, Nos.62–72. In the appendix on pp.143–150, there is a comprehensive survey of Moore's drawings of works of art and artifacts, from the earliest known copy on p.28 of No.2 Notebook of 1921–2 (Fig.110) to recent drawings, of the work of Dürer and Giovanni Bellini Nos.71 and 72.

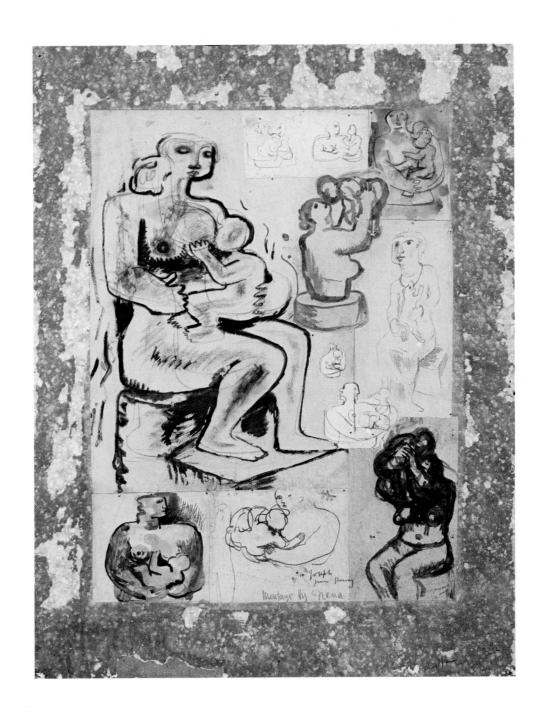

84  Mother and Child Studies  *c.*1929  (entry on p.81)

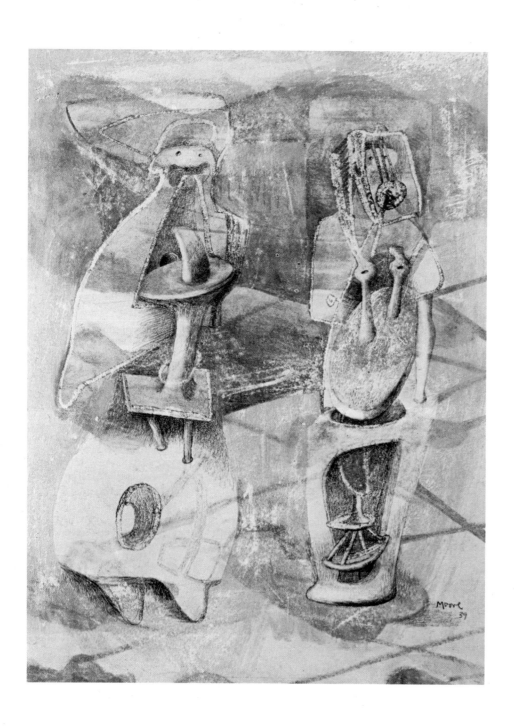

127  Two Women: Drawing for Sculpture
     Combining Wood and Metal  1939  (entry on p.99)

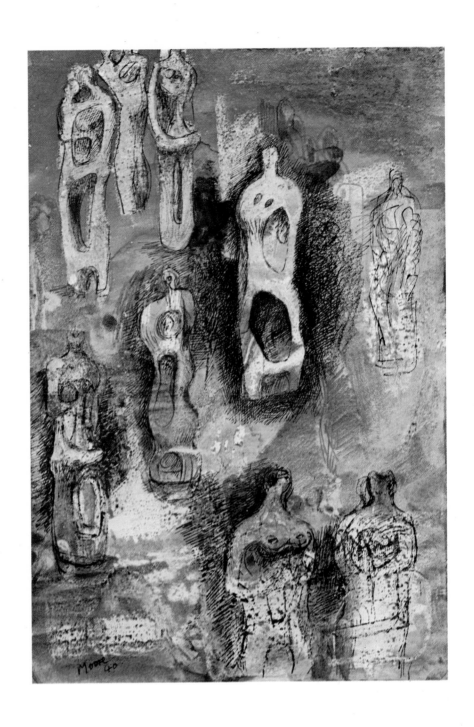

132 **Standing Figures** 1940 (entry on p.101)

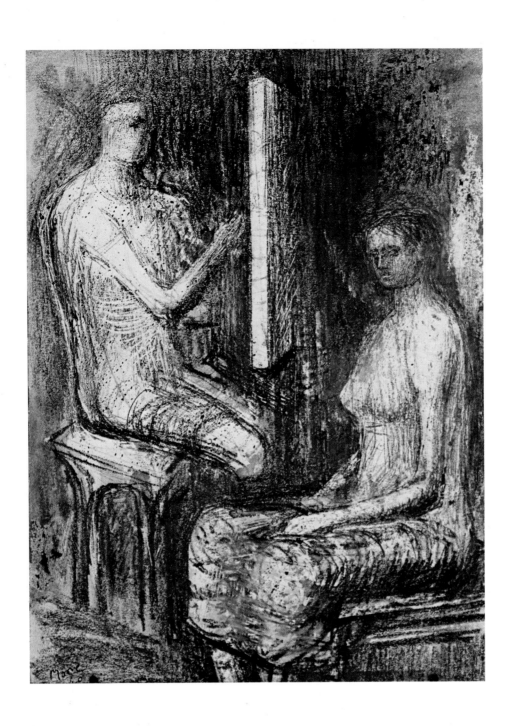

136 **Artist and Model** 1940 (entry on p.102)

# Drawings 1921–40

**Studies for Sculpture 1921-40**

'My drawings are done mainly as a help towards making sculpture – as a means of generating ideas for sculpture, tapping oneself for the initial idea; and as a way of sorting out ideas and developing them.'[1]

The importance of Henry Moore's drawings for sculpture cannot be over-estimated. Few great sculptors have left through their drawings such a complete and extensive record of the genesis of their sculptural ideas. Between 1921 and the mid-1950s almost all Moore's most important carvings and bronzes, as well as many minor works, had their origin in the notebook pages. Of the six surviving notebooks of the 1920s, five are included in this exhibition (Nos.63–5, 69 and 73).[2] Like the recently published study of the notebooks of Degas,[3] a careful examination of Moore's sketchbooks of the 1920s tell us a great deal about his development and the evolution of his art during his formative years.[4] Their varied contents include the preliminary studies for many of the carvings of the 1920s (No.73), copies of works of art and artifacts (see 'Copies of Works of Art' pps.143–150), lists of possible subjects for sculpture, laconic notes about the nature of sculpture and the human figure, and the qualities he was striving to achieve in his own work.

The drawings for sculpture were a means to an end – 'a help towards making sculpture'. During the 1920s and 30s Moore worked predominantly in stone and wood, and it would have been impossible to explore in these materials the profusion of ideas which found release in the drawings. As the artist has pointed out, 'Sculpture compared with drawing is a slow means of expression, and I find drawing a useful outlet for ideas which there is not time enough to realize as sculpture'.[5] The function of the drawings for sculpture was quite different from that of the life drawings. In the latter, Moore was working from nature, learning about the human figure and the science of drawing. The studies for sculpture were, on the other hand, destined to be realized in three dimensions. Particularly as a young sculptor, Moore found that ' . . . there are lots of possibilities that one hasn't tried out'[6] which could be explored in the drawings ' . . . to prevent them from blocking each other up'.[7]

During the first thirty-five years of his career, Moore's working method was the antithesis of Rodin's approach. As Albert Elsen has pointed out, 'Rarely did Rodin make a sculpture from his own drawings'.[8] Moore on the other hand has said:

> In my case my drawings for sculpture *were* drawings for sculpture and not drawings of sculpture. There are a few examples where a maquette which was made from a hasty drawing was used to help in the realization of a more finished drawing.[9]

Most of the drawings for sculpture were, of course, executed from the imagination. Moore has explained the two approaches he used in generating ideas for sculpture. With one method, a form of automatism, he began drawing:

with no preconceived problem to solve, with only the desire to use pencil on paper, and make lines, tones and shapes with no conscious aim; but as my mind takes in what is so produced, a point arrives where some idea becomes conscious and crystallizes, and then a control and ordering begin to take place.[10]

He often drew in this way in the evening. The second approach he has described as follows:

Early in the morning I used to find one would start off with a definite idea, that, for instance, it was a seated figure I wanted to do. That in itself would lead to a lot of variations of the seated figure; you would give yourself a theme and then let the variations come, and choose from those which one seemed the best.[11]

By filling a single sheet with numerous studies, often variations on the same theme, he could compare them at a glance:

Often I would make pages of drawings of ideas. On one sheet of paper there could be as many as thirty projects, such as Stringed Figures, all produced in a few hours. [See No.123]. One of them would hold my attention and I would think it was the best one. And then I would have to settle down to the longer job of making it into a sculpture.[12]

Having completed a drawing, Moore often set it aside for several weeks, a month, even several years, and came back to it with a more detached view, and then made his selection.

In his working drawings a sculptor is confronted with certain problems which do not concern a painter. The ideas executed in two dimensions are ultimately destined to be recreated in three dimensions, and it is therefore necessary, Moore has pointed out, for the sculptor to make 'the object he draws capable of having a far side to it, that is, make it an object in space, not an object in relief (only half an object stuck on the paper, and stopping at the edges). It is necessary to give it the possibility of an existence beyond the surface of the paper'.[13] Naturally the particular view drawn becomes the important one, and gives the clues to the other views. From 1921 to the mid-1950s, because Moore's work was more frontal than it has been in recent years, one drawing provided enough information to begin a sculpture: 'I would often start a sculpture from an idea I'd produced in a single drawing and work out what was to happen at the sides and at the back as I went along'.[14] For example, in the countless drawings of reclining figures, the sculptural ideas are shown frontally, so that we follow the entire length of the figure horizontally across the page. With few exceptions, the ideas for sculpture are presented in this way, but occasionally, for less frontal works, such as the marble 'Snake' of 1924 (Fig.25), there are a number of studies of several different views (No. 73).

It should be emphasized that Moore often modified the form as it first appeared in the preparatory drawing while transmitting it from the flat surface of a notebook page into a three-dimensional sculpture. He has remarked on the difference between drawing and sculpture:

'A sculptural idea which may be satisfactory as a drawing always needs some alteration when translated into sculpture'.[15] As an example, Moore has cited 'Ideas for Sculpture: Internal and External Forms' of 1948 (No.27) which includes the study for 'Maquette for Internal and External Forms' of 1951 (L.H.294, Fig.26). The artist has commented:

'It is the drawing for the sculpture and an example of how a work changes from the drawing to the sculpture. The interior form at the top is given much more room in the sculpture, where it is less crowded'.

During the 1920s almost all the drawings for sculpture were done in the small notebooks. The carvings of the period, whether small scale works

[22]     Page 22:   Penultimate paragraph.'Ideas for Sculpture :
                    Internal and External Forms' is No.217 and not
                    No.27.

like the small marble 'Snake' of 1924 (Fig.25), or larger sculptures such as the brown Hornton stone 'Reclining Figure' of 1929 (L.H.59, Fig.21), were based on the small sketches in the notebooks. The drawings for both these works are shown here, Nos.73 and 80. Some of the most important of the relatively few larger drawings for sculpture of the 1920s are included in this exhibition. One of the earliest, 'Mother and Child' of 1924 (No.75), based on a sketch on p.23 of No.4 Notebook, is one of six known sheets of studies for the Hornton stone 'Mother and Child' of 1924–5, City Art Gallery, Manchester, (L.H.26, Fig.27). Several large drawings of 1928–30 include the first collages, composed of the two major themes in Moore's work: the reclining figure (Nos.81 and 86) and the mother and child (No.84). Two of these 'Mother and Child Studies' of c.1929, (No.84, Art Gallery of Ontario) and 'Studies for Sculpture' of c.1930 (No.86, National Gallery of Victoria) were designed by Irina Moore, who cut out the small studies from sketchbook pages.

In many ways the decade of the 1930s was the most decisive period of Moore's career. His work of the previous ten years had been enriched by his study of the collections of sculpture in the British Museum, and by the books he had read on the history of world sculpture, (see Copies of Works of Art, pp.143–150). The Leeds 'Reclining Figure' of 1929 (L.H.59, Fig.21) and 'Reclining Woman' of 1930 (L.H.84) in the National Gallery of Canada,[16] which reflect the powerful influence of the 'Chacmool' carving (Fig.28), may be said to mark the culmination of Moore's formative years. Early in 1931 he carved the blue Hornton stone 'Composition' (L.H.99, Fig.29), in which the human form has been subjected to disturbing and violent distortions unlike anything to be found in Moore's previous work. This radical and abrupt change in direction was almost certainly provoked by Picasso's sculpture of 1928, entitled 'Metamorphosis' (Fig.30) and by his paintings and the drawings of the late 1920s, particularly by the scenes of bathers made during the summer of 1927.[17] The series of preparatory drawings for Moore's 'Composition' (No.88 and Fig.31) illustrate the fascinating way in which a clearly recognizable subject, the suckling child, evolved and was transformed into the enigmatic composition found in the definitive sketch (No.88). They also emphasize that if Picasso's 'Metamorphosis' was in the back of Moore's mind, he had made something of it very much his own.

During the next four or five years, Moore's art continued to reflect contemporary developments in Paris. The decisive influence of Picasso, Arp and Giacometti, and his association with the Surrealist Movement are discussed in the notes on the drawings of the 1930s. Their work liberated Moore's imagination in the direction of a more elusive, more evocative organic abstraction. Of Picasso, Moore has said: 'His value to people like me was the freedom he gave – he was bold enough to do things, and let other people know that they could do it too'.

Herbert Read in his introduction to the exhibition catalogue *Art in Britain 1930–40 Centred around Axis, Circle, Unit One* (Marlborough Fine Art Ltd, London, March–April 1965)[18] and in his essay of *A Nest of Gentle Artists*, has described the years when 'Henry Moore, Ben Nicholson, Barbara Hepworth and several other artists were living and working together in Hampstead, as closely and intimately as the artists of Florence and Siena had lived and worked in the Quattrocento'.[19] During this unique period, Read has written 'there emerged, out of the slumbering provincialism that had characterized British art for nearly a century, no less than four artists [Hepworth, Moore, Nicholson and Sutherland] of international status . . .'.[20] In 1935 they were joined by Naum Gabo, and in

Fig.29 Henry Moore,
*Composition*, 1931

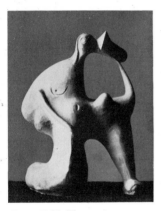

Fig.30 Pablo Picasso,
*Metamorphosis*, 1928
© S.P.A.D.E.M. Paris, 1977

1938 by Piet Mondrian, both of whom moved to Hampstead (see map on p.9 of the Marlborough catalogue). Parallels between Moore's drawings and sculpture of the 1930s and the work of his contemporaries in Hampstead are discussed in the catalogue notes.

Among Moore's studies for sculpture of the early 1930s are the transformation drawings which are of vital importance in understanding his working method and the evolution of a number of carvings of the period. In 1934 in an article for *Unit One* Moore wrote of the observation of natural objects:

> The human figure is what interests me most deeply, but I have found principles of form and rhythm from the study of natural objects such as pebbles, rocks, bones, trees, plants, etc. Pebbles and rocks show nature's way of working stone. Smooth, sea-worn pebbles show the wearing away, rubbed treatment of stone and the principle of asymmetry. Rocks show the hacked, hewn treatment of stone, and have a jagged nervous block rhythm.
>
> Bones have a marvellous structural strength and hard tenseness of form, subtle transition of one shape into the next and great variety in section. Trees (tree trunks) show principles of growth and strength of joints, with easy passing of one section into the next. They give the idea for wood sculpture, upward twisting movement.
>
> Shells show nature's hard but hollow form (metal sculpture) and have a wonderful completeness of single shape.[21]

The earliest indication that Moore was beginning to think about natural forms is the inscription 'remember pebbles on beach', on the inside front cover of No.6 Notebook of 1926. On his frequent visits to the Natural History Museum he often brought a notebook and made drawings of bones and shells. The drawings of natural forms comprised two types. There were straightforward sketches, such as 'Studies of a Lobster Claw' of 1932 (No.92), made without any intention of altering the forms of the objects drawn. Far more important were those studies in which the original shape of the bone, pebble or shell has been altered. In these drawings, Moore began by sketching the natural forms (as in the straightforward studies mentioned above) and then proceeded to transform the organic shapes into human forms. This is well illustrated in 'Transformation Drawing: Ideas for Sculpture' of 1930 (No.89), one of the earliest of the transformation studies. One can see in the tall figure at left the original shape of the bone form, to which has been added the head and arms. Most of the transformation drawings date from 1932, and include studies of bones, shells and pebbles. During the past twenty years natural forms have again provided the source for a number of drawings and sculpture. However, instead of altering their shape in the drawings, Moore now works directly with the flint stones, bones and shells, often making plaster casts of them, or adding clay or plasticine to transform them into human forms. Natural forms in themselves, the artist pointed out, are dead forms, and merely to copy them will not produce sculptural form: 'It is what I see in them that gives them their significance'.

Throughout the 1930s Moore continued making notebook drawings on which the sculptures of the period were based. By 1932–3 larger and more fully realized drawings appear more frequently. In several, a large study in the centre of the sheet is surrounded by small drawings of the same theme, as in 'Mother and Child: Ten Studies' of 1933 (No.96), and a drawing of the following year 'Study for Recumbent Figure' (No.103). In the fascinating studies related to 'Four Piece Composition: Reclining Figure' of 1934 (L.H.154, Fig.32), we can follow Moore developing the component

[24]

Fig.33 Henry Moore,
*Abstract Drawing*, 1935

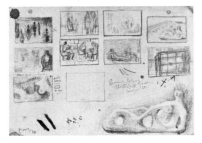

Fig.36 Henry Moore,
*Study for Detroit Reclining Figure*, 1938

parts for a single figure made up of three dismembered sections: head, body and legs (No.102). Also from the mid-1930s come Moore's most abstract drawings and sculpture, which may be compared with the work of Hepworth and Nicholson (see Notes for No.107). But however seemingly abstract these drawings may appear (Fig.33) there is usually a tenuous link or reference to the human anatomy.

Drawings are known for many of the carvings and bronzes of 1935–40: for 'Mother and Child' of 1936 (L.H.171) in the collection of Sir Roland Penrose; for the enigmatic 'Head' of 1937 (L.H.177); for the Tate's 'Recumbent Figure' of 1938 (L.H.191, Fig.34, see No.120); for most of the stringed figure carvings and bronzes of 1937–9 (see No.123); for 'The Helmet' of 1939–40 (L.H.212, Fig.35, see No.128 and L.H. Vol.1, p.212, top), and for the large elmwood 'Reclining Figure' of 1939 (L.H.210, Fig.36), now in the Detroit Institute of Arts.

## Pictorial Ideas and Settings for Sculpture 1930–40

This title is taken from the inscription on a drawing of *c*.1938 (No.121). It shows thirteen small compositions both of 'pictorial ideas', illusionistic scenes such as woman bathing child and interior scene, and of 'settings for sculpture'. Moore has defined his pictorial compositions as 'an imaginative drawing in which the whole drawing came together as an idea and which could not be translated into sculpture'. Studies in which sculptural ideas appear in settings are, on the other hand, an extension of the drawings for sculpture in which, the artist said 'I have thought of a piece of sculpture in a particular setting – a landscape, a stage, in rooms or caves – that is of placing the sculpture in some defined or suggested space'. The two categories overlap in that a drawing of sculptural ideas in a setting is, to some extent at least, pictorial.

> In 1953 Moore wrote:
> There is a general idea that sculptors' drawings should be diagrammatic studies, without any sense of background behind the object or of any atmosphere around it. That is, the object is stuck on the flat surface of the paper with no attempt to set it in space – and often not even to connect it with the ground, with gravity. And yet the sculptor is as much concerned with space as the painter.[22]

It was in the 1929–30 life studies of the artist's wife that clearly defined settings appeared for the first time in the drawings (Nos.46 and 48). One of the earliest sculpture drawings in which a setting was at least suggested is 'Figure on Steps' of 1930 (No.87). The four levels of steps which support the figure and 'connect it with the ground', are clearly defined. Above the right leg, the geometrical design is similar to that found in the life drawing 'Seated Female Nude', also of 1930 (No.48), and provides both a background and a sense of space behind the figure. In a drawing of 1933, 'Figure Studies' (No.97), the figures are not so much placed in a defined setting as surrounded by a sort of thin veil of chalk and wash background. A series of diagonal lines slice across the sheet. In 'Monoliths' of 1934 (Fig.37) an architectural setting appears for the first time, as a background for the three forms at upper left, and thus anticipates the superb drawing of 1943, 'Figures with Architecture' (No.197).

In the drawing of 1936, pictorial ideas and settings for sculpture proliferated. Two of the most important drawings of that year are included in this exhibition. In 'Stones in a Landscape' (No.113) the sculpture forms, closely related to several carvings of 1936 (L.H.170 and 171), are situated in a timeless classical landscape which Moore has compared to the region

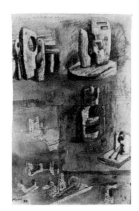

Fig.37 Henry Moore,
*Monoliths*, 1934

Page 25:    Fig.33 is printed upside down.

of Mycenae. Scale and perspective are somewhat ambiguous; how close or far are the columns behind the stones at upper left? And how large are the sculptures themselves which dominate the landscape, towering ominously above the Greek temples whose columns appear like fragile matchsticks? 'Figures in a Cave' of 1936 (No.112), one of Moore's most haunting pre-war drawings, anticipates the tunnel settings of the shelter and coal-mine drawings of 1940–2. The small composition at upper left in 'Page from Sketchbook' (Fig.38) of 1937 (possibly dating from the previous year) is either a study for 'Figures in a Cave', or, though less likely, a later version of the same subject. The inscription at centre 'see page 517 Frobenius' leads to the source of the cave setting, and of some of the other studies on this sketchbook sheet. The setting of 'Figures in a Cave' was without question based on the photograph, plate 164c, in Leo Frobenius' *Kulturgeschichte Afrikas* (1933),[23] showing a tomb or grave in the cave of a small hill in Southern Rhodesia (Fig.39. See notes for No.112).

Fig.38 Henry Moore,
*Page from Sketchbook*, 1937

'Sculpture', Moore has written, 'is an art of the open air. Daylight, sunlight, is necessary to it, and for me its best setting and complement is nature. I would rather have a piece of my sculpture put in a landscape, almost any landscape, than in, or on, the most beautiful building I know.[24]

Moore has always enjoyed working out of doors. He carved the marble 'Snake' in 1924 (Fig.25) in the open air during his summer holidays in Norfolk. In the 1930s much of his carving was done in the country. In 1931 the Moores bought their first cottage at Barfreston, Kent. Three years later they sold it and they bought Burcroft, at Kingston near Canterbury. The property overlooked a valley and hills in the distance and included five acres of shelving ground. Of this peaceful Kentish landscape, Moore has written:

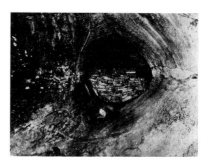

Fig.39 Cave in Southern Rhodesia

Here for the first time I worked with a three or four mile view of the countryside to which I could relate my sculptures. The space, the distance and the landscape became very important to me as a background and as an environment for my sculpture.[25]

At Burcroft he began photographing in landscape the rough-hewn stones he intended carving (Fig.40), as well as completed sculptures. 'Any bit of stone stuck down in that field looked marvellous, like a bit of Stonehenge'.[26] Moore has identified the landscape in one of his best known pre-war drawings, 'Sculptural Object in Landscape' of 1939 (No.124) as the valley and distant hills behind his cottage at Kingston (see Fig.40). In 1939 he could imagine and dream of creating sculpture on the scale of the enormous bone-like object in the Sainsbury drawing. Only in recent years, in such works as 'The Arch' of 1963–9 (L.H.5036) and the 'Sheep Piece' of 1971–2 (L.H.627, Fig.41), shown in Battersea Park during the summer of 1977, have such dreams become a reality.

Fig.40 Stone in garden at Burcroft

The 1939 'Pictorial Ideas and Settings for Sculpture' (No.126) is a kind of dictionary of pictorial ideas and settings for sculpture. In the left half of the sheet are six studies of sculptures in cell-like rooms, the subject of some half-dozen large drawings of 1936–8, one of which is shown here (No.116), and of a number of drawings of the 1940s (Nos.194 and 208).

1940 was a particularly prolific year of drawing. There are the dense and richly inventive sheets of studies for sculpture, such as the Ashmolean drawing (No.133), filled with projects never to be realized in three dimensions. In a number of drawings, such as 'Standing Figures', also of 1940 (No.131), wax crayon was used for the first time, with pen and ink, chalk, and watercolour (see Shelter Drawings, pp.28–36). The sculpture

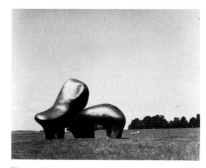

Fig.41 Henry Moore,
*Sheep Piece*, 1971–2

Page 26:   Antepenultimate paragraph. 'The Arch' is L.H.
              503b.

studies of 1934–40, including such works as 'Two Women: Drawing for Sculpture Combining Wood and Metal' (No.127) are among Moore's finest drawings for sculpture. Not directly related to sculptural projects is the series of draped, naturalistic figure studies of 1940, of which the Tate's 'Two Seated Figures' (No.135) is a fine example. Stylistically related to it is the 1940 drawing in the Whitworth Art Gallery, Manchester, entitled 'Artist and Model' (No.136), the only known study of this theme in Moore's entire oeuvre.

In the autumn of 1940, Moore began work on his shelter drawings which are the subject of the following chapter.

# Wartime Drawings 1940–42

## Shelter Drawings 1940–41

When war was declared on 3 September 1939 Henry Moore was living and working at his country cottage at Kingston near Dover (see No. 137). For him the summers were always exceptionally productive periods when, free from his teaching responsibilities at the Chelsea School of Art, he could concentrate without interruption for several months on his sculpture and drawing.

Instead of returning to London at the end of the summer as they usually did, the Moores stayed on at their cottage for nearly a year, during the period known as the Phoney War. Life went on as before. Moore continued teaching two days a week at Chelsea, driving up to London and stopping overnight at his studio in Hampstead. At the cottage they made themselves as self-sufficient as possible. Irina Moore started a small chicken farm. Moore himself was working very hard on a number of sculptures for an exhibition to be held at the Leicester Galleries in February 1940. In December 1939 he completed the large elmwood 'Reclining Figure' (L.H.210), now in the Detroit Institute of Arts, as well as about a dozen small lead sculptures, including some stringed figures. As yet the war had not interfered with his work.

In June 1940, with the fall of France and an invasion of England seemingly imminent, the Phoney War came to an abrupt end. The south coast around Dover became a restricted area and the Moores knew that they would soon be forced to return to London. About this time Moore read an advertisement in a London newspaper for a Government course in precision toolmaking at the Chelsea Polytechnic, which was affiliated with the Chelsea School of Art. Both he and Graham Sutherland volunteered for the course and were told they might begin at any moment. The Moores returned to their studio at 11a Parkhill Road, Hampstead. Throughout that summer Moore waited to hear from the Polytechnic. As there was no point in starting work on a large sculpture that might have to be abandoned, he concentrated on drawing and produced some of his finest studies for sculpture. He heard nothing further about the toolmaking course; there had apparently been many more applications than places. In late August or early September, Moore took over the tenancy of a neighbouring and less expensive studio at 7 Mall Studios, Tasker Road, from Barbara Hepworth and Ben Nicholson, who had moved to Cornwall with their three children.

The Moores moved into the new studio before the first full-scale day and night air offensive on Saturday 7 September 1940. Several days after the Blitz began, the Moores went to the West End of London by bus rather than taking their car as they usually did. After dining with friends they returned home on the London Underground. As the train stopped at each station, Moore, for the first time, caught fleeting glimpses of men, women and children gathered on the station platforms, making themselves as comfortable as they could for the long night ahead. Londoners had begun using the station platforms beside the tracks as air raid

shelters, in spite of the efforts of the authorities to persuade them to use surface shelters.

When the Moores got off the Northern Line train at Belsize Park, they were told by the air raid warden to remain below for their own safety. This may well have been the night of 11 September when General Pile had ordered the commanders of all the 199 anti-aircraft units in the London area to fire every possible round at the enemy bombers. During the first four nights of the Blitz, Anti-Aircraft Command had been relatively ineffectual because the gunners, before firing, had to identify enemy planes, in order not to hit the British fighters. On the night of the 11th, the R.A.F. night fighters were grounded so that the gunners would not be hampered. Constantine FitzGibbon has described the effect of the anti-aircraft fire: 'That night the barrage opened up, and its roar was music in the ears of the Londoners. The results astonished Pile, the London public and apparently the German pilots too, who flew higher as the night went on'.[1] During this barrage Moore spent about an hour on the station platform at Belsize Park among the shelterers. This afforded him, he said recently, the opportunity 'to observe and remain in the atmosphere of the station longer than I would have done'. His response to this experience was spontaneous and direct. Within a day or two he executed what he thinks may have been the first shelter drawings, 'Women and Children in the Tube' of 1940 (No.139) now appropriately in the collection of the Imperial War Museum, London.

In view of Moore's previous obsessions with the mother and child, and the reclining figure themes, it is understandable why scenes of shelter life made such an immediate and overwhelming impact. The positions of the shelterers and the setting, Moore said, 'fitted in with me perfectly'. They combined two of his favourite motifs: 'I saw hundreds of Henry Moore Reclining Figures stretched along the platforms',[2] and '. . . even the train tunnels seemed to be like the holes in my sculpture'.[3] The circumstances of war had put in his way a subject which related to his previous work, and with which he could identify emotionally. Sharing the dangers of living in London during the Blitz, Moore said 'I was very conscious in the shelter drawings that I was related to the people in the Underground'.

Following this first contact with shelter life, Moore began visiting various stations to study and absorb the chaotic scenes on the crowded platforms. During the first two months of the Blitz, each night an average of 100,000 people sheltered in the London Underground. On his return home, he began filling the 'First Shelter Sketchbook' with drawings done from memory, based on the subterranean world, which he has compared to 'a huge city in the bowels of the earth'.[4]

In November 1939 the Ministry of Information appointed Sir Kenneth Clark Chairman of the War Artists' Advisory Committee, whose purpose it was to select suitable artists to record not only the military aspects of war, but also life at home and in the factories, the activities of the Home Guard and other voluntary groups. Early on in the war, when Clark had tried to persuade Moore to become a War Artist, he had declined because he felt at the time that the war had not changed life noticeably, it had 'made no difference, no emotional impact on me'. But with the bombing of London and his encounter with shelter life, he had found inadvertently a subject which both fascinated and deeply moved him. When Clark was shown the drawings in the 'First Shelter Sketchbook', he asked Moore to reconsider, and this time he did not refuse.

Some time in October 1940 the Moores spent a week-end near Much Hadham, Hertfordshire, with their friend Leonard Matters, a Labour

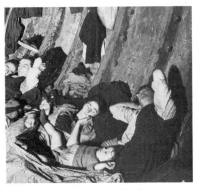

East London Underground Station,
November 1940
(Photograph by Bill Brandt)

Member of Parliament. There was a particularly heavy raid on London that week-end, which Moore remembers seeing from Much Hadham, some twenty-five miles north of the city. On the Monday morning the Moores returned to Hampstead to find their studio badly damaged by the blast from a bomb that had completely destroyed a neighbouring studio. That night they returned to Much Hadham and stayed with Matters until they could find a house to buy or rent. At Perry Green, a small hamlet just outside Much Hadham, they were able to rent part of an old farmhouse called Hoglands. A few months after they had moved in, the entire house was offered for sale, and this just at the time when Moore had sold the large elmwood 'Reclining Figure' of 1939 (L.H.210) for £300, the exact amount required for the deposit on the property. They bought the house and there they have lived to this day.

The style of the shelter drawings is pre-figured in several works of 1940. In the Tate Gallery's 'Two Seated Figures' (No.135), the clothed figures and the naturalistic treatment of the subject are features which characterize the shelter drawings as a whole. In 'Standing, Seated and Reclining Figures against a Background of Bombed Buildings', also of 1940, imaginary figures are set against a jagged and fractured background of ruined buildings (Fig.42). Though the reclining figures recall the studies for sculpture of the previous few years, the draped standing figure at the left anticipates the style of the shelter drawings. Groups of figures in the bombed streets of London were to be the subject of a number of sketchbook pages and of one large drawing (No.145). Most prophetic is 'Air Raid Shelter Drawing: Gash in Road' of 1940 (Fig.43) which, the artist said, was based on bomb damage he had seen, although he invented the figures sheltering underground. The 'Eighteen War Sketches' of 1940 (No.138) comprise small studies of some of the more usual iconography of war: search-lights, gun shells bursting like stars, barbed wire, bombs bursting at sea.

Moore has described 'Women and Children in the Tube' (No.139) as his first shelter drawing. Though there is little that suggests the setting of the London Underground, except for the curved wall behind the bench, and the edge of the platform at bottom right, the drawing is, nevertheless, a kind of preliminary statement, incorporating motifs which are found in many of the shelter drawings. To begin with, there is the tightly knit group of seated figures, three women each holding a child. In nearly all Moore's previous multi-figure compositions, the ideas for sculpture appear either in quite regular rows (Nos.114 and 123) or they are crowded together in no particular order (No.133). Each study is isolated in space from neighbouring figures. In the shelter drawings, depicting the crowded conditions on the station platforms, Moore was faced with the problem of organizing multi-figure compositions of a far greater formal complexity than anything he had attempted in his earlier drawings. Another feature in No.139 which occurs in many subsequent drawings is the way in which the figures in the foreground are clearly and crisply defined, while those in the background become less distinct and fade away into the distance, diagonally across the page.

We have seen how certain pre-shelter drawings look forward to the more naturalistic style of the studies of shelter life. But it is also true that some of the earliest shelter drawings, especially those at the beginning of the 'First Shelter Sketchbook', which the artist gave to Lady Clark,[5] are a continuation of the more abstract, anti-naturalistic style of the drawings and sculptures of the late 1930s. It must be remembered that Moore began the shelter drawings quite unexpectedly, at a time when he had

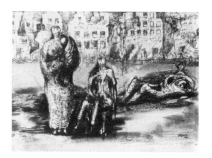

Fig.42 Henry Moore,
*Standing, Seated and Reclining Figures against a Background of Bombed Buildings*, 1940

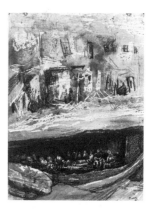

Fig.43 Henry Moore,
*Air Raid Shelter Drawing: Gash in Road*, 1940

Fig.44 Henry Moore,
*Page 2 from First Shelter Sketchbook,*
1940
(British Museum)

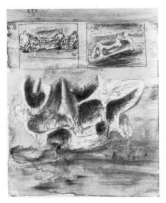

Fig.45 Henry Moore,
*Page 10 from First Shelter Sketchbook,*
1940
(British Museum)

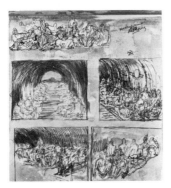

Fig.46 Henry Moore,
*Page 21 from First Shelter Sketchbook,*
1940–41
(British Museum)

been concentrating on his drawings for sculpture. As the artist said, 'I could not throw to one side all my sculptural interests and preoccupations',[5] and yet he realized that the subject demanded a new approach. Of the shelter and coal-mine drawings Moore has said: '. . . I think I could have found sculptural motifs only, if I'd tried to; but at the time I felt a need to accept and interpret a more "outward" attitude.'[6] The transition from the style of the sculptural subjects to a more naturalist approach was thus both conscious and deliberate.

In the first dozen or so pages of the 'First Shelter Sketchbook', both styles are very much in evidence. On p.2 (Fig.44) the mother and child study at upper left is clearly related to certain sculpture drawings of the previous four or five years. The idea was, the artist said, 'made up', and had no real connection with shelter life. The two standing figures and the half figure, on the other hand, were based on the memory of an actual scene in the London Underground, and illustrate the emergence of a more naturalistic approach to the subject.

In several early sheets in the 'First Shelter Sketchbook' the sculptural style predominates. On p.10 (Fig.45), the reclining figure at upper right, and the large sculptural object, are related stylistically to previous drawings for sculpture. The large form in the centre of the page is, Moore pointed out, an abstract idea for drapery from a purely sculptural point of view. Sculptural ideas appear less frequently towards the end of the 'First Shelter Sketchbook', and, with the exception of two or three drawings, do not occur in the 'Second Shelter Sketchbook', belonging to Irina Moore.

In the first half of the 'First Shelter Sketchbook', Moore explores most of the subjects and compositions which were to comprise the shelter drawings as a whole: groups of figures sitting and reclining on station platforms, the mother and child theme, studies of individual shelterers, views straight down the train tunnels with two rows of reclining figures, and people wandering about the streets amid debris on the morning after a raid. Page 21 (Fig.46) includes five group compositions, including what must be the first sketch of the Liverpool Street Extension, the setting for one of the most famous shelter drawings, 'Tube Shelter Perspective' in the Tate Gallery (No.160).

Moore's working method in the shelter drawings is of considerable interest. The drawings fall mid-way between the life studies based on direct observation and the drawings for sculpture done from the imagination. Moore explained the creative process involved when he said the shelter drawings were not drawn from nature but 'from the memory of actuality'. After all, the shelterers were leading private or family lives, though in a communal environment. To have sketched them directly would have been an intrusion on their privacy. If, however, a particular scene or group of figures held Moore's attention, he would walk past a number of times trying to fix the idea firmly in his mind. Occasionally he went into a corner or exit passage to make hurried notes on the back of an envelope or on a scrap of paper, either brief descriptions or small sketches. These served as vivid reminders when he came to recreate the scenes in the sketchbook. This was not the first time Moore had worked from memory. During his student years he occasionally made drawings at home, done from the memory of the life model he had drawn during the day at the Royal College of Art.

On his return to Hoglands, having spent one or two nights visiting various stations in the London Underground, Moore would spend several days drawing in the sketchbook, while the groupings and positions of the

shelterers were still fresh in his mind. He would fill six or seven pages and from these choose one or two to be made into much larger, more finished drawings. He then returned to London for more visual material. In this way he filled the first and second Shelter Sketchbooks. Two unfinished ones were broken up and some of the sheets sold. About sixty-five finished drawings were enlarged from studies in the sketchbooks. Of these, seventeen were purchased by the War Artists' Advisory Committee, who later distributed them among museums throughout England.[7]

Scattered throughout the sketchbooks were lists of possible subjects, a way of recording quickly the overflow of ideas and remembered scenes. (This practice has a precedent in the notebooks of the 1920s and 30s, in which Moore often made lists of subjects for drawings.) One such note describes a scene looking out from a shelter, a reminder of the destruction above: 'View from inside shelter at night time, with moonlight and flare light on bombed buildings'. Another inscription emphasizes the importance of memory in the shelter drawings: 'Remember figures seen last Wednesday night (Piccadilly Tube). Two sleeping figures (seen from above) sharing cream coloured thin blankets (drapery closely stuck to form). Hands and arms. Try positions oneself'. More than any other note in the sketchbooks, the last sentence reveals Moore's determination to base the drawings on life. It was as if he himself wanted to experience something of the tension and exhaustion expressed in the poses seen.

London Underground stations all look very much the same, and Moore made little attempt to differentiate between them. Once he had sketched the general setting, which in most of the drawings meant a station platform with a curved wall and sometimes a tunnel in the distance, he concentrated on the groups and positions of the shelterers. Several shelters, however, differed from the rest and these particularly attracted his attention. One was at Tilbury in the basement of a large warehouse. 'A Tilbury Shelter Scene' (No.149) in the Tate Gallery, shows the enormous size of this shelter, with bales of paper at upper right. For Moore the most visually exciting of all was the newly built and still unfinished tunnel of the Liverpool Street Extension, with, in his own words, 'no lines [the tracks had not been laid], just a hole, no platform, and the tremendous perspective'. When he first saw it, the tunnel floor was occupied by two regular rows of sleeping figures, with a narrow aisle between them. The first sketch of this shelter, which appears near the beginning of the 'First Shelter Sketchbook', on p.21 at centre left (Fig.46), almost certainly dates from late 1940. Seven other sketches and larger drawings are known, culminating in the definitive version of this subject, 'Tube Shelter Perspective' in the Tate Gallery (No.160). A dim grey-blue light pervades the scene. This bleak, cave-like setting shows little evidence that the tunnel is in fact part of the London Underground system. Two rows of sleepers lying on their backs recede deeply into the picture space. The seven or eight figures nearest us in each row are carefully worked; the rest gradually become mere shadows of the human form, and fade away into the distance. The spiralling tunnel suggests the eye of a tornado, a place of silence and yet of terrifying tension. It is as if we are looking into a sculpture, deep in a Moore cavern, inhabited by a race invented by him. The subterranean setting is timeless and anonymous; it is as if we have come unexpectedly upon the tomb of a mass burial. The bodies, swathed like Egyptian mummies, seem to belong more to the dead than the living. A passive yet terrifying scene, this drawing is one of the most memorable images of civilian life produced by an artist during the Second World War.

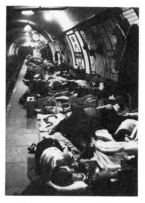

Elephant & Castle Tube Station, 11 November 1940

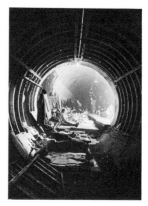

West End London Shelter

During his initial contact with the shelterers, Moore was attracted by the spontaneous and somewhat disorganized character of shelter life. One inscription in a sketchbook records: 'Muck and rubbish and chaotic untidiness around'. This atmosphere is apparent in a number of the earliest shelter drawings, those of late 1940. In one of the most beautiful, 'Shadowy Shelter' in the Graves Art Gallery, Sheffield (No.141) reclining figures, and several seated figures at the extreme right, sprawl diagonally across the page. Several bodies share a single blanket and are joined by the strokes of wax crayon and pen and ink lines which define the drapery. The figure in the central foreground could almost be a preparatory study for the *Time Life* 'Draped Reclining Figure' of 1952-3 (L.H.336, Fig.47). A discussion of the influence of the shelter drawings on Moore's subsequent sculptures appears at the end of this chapter.

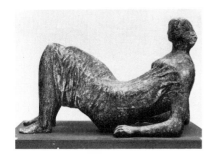

Fig.47 Henry Moore,
*Draped Reclining Figure*, 1952-3
(Art Gallery of Ontario)

Most of the drawings depict either crowded station platforms or two or three figures, but occasionally there is a single shelterer. In drawings such as the 'Shadowy Shelter' just discussed, anonymous human beings huddle together, and little attention is given to individual facial features. In other drawings, usually of one or two figures, Moore concentrates on what he has called 'the psychological, human element'.[8] The dominant mood he was trying to convey was the sense of drama and expectancy, 'the feeling of people being underground with the knowledge of something happening above'. In 'Air Raid Shelter: Two Women' in the Leeds City Art Galleries (No.143) the two draped seated figures have the monumental grandeur which Moore so admired in the work of Masaccio. They sit and wait; the train tunnel recedes into the distance behind them. The tragic nobility of their faces suggest a passive acceptance of a fate over which they have no control. Perhaps, like the anxious woman in 'The Dry Salvages', from T. S. Eliot's *Four Quartets*, they will remain awake through the long night:

Trying to unweave, unwind, unravel
And piece together the past and the future,
Between midnight and dawn, when the past is all deception,
The future futureless, before the morning watch
When time stops and time is never ending...[9]

Scenes from the bombed wreckages of London's streets and buildings were the only other war subject that attracted Moore. Although he found them 'terribly dramatic and exciting', street scenes were not as humanly touching a subject as shelter life. In 'Morning after the Blitz' of 1940 (No.145) people wander about amid the rubble, with the stark wires of the tram lines hanging precariously overhead. Such was the devastation which the shelterers often saw in the early morning when they emerged from the Underground station platforms. In 'Little Gidding', another of Eliot's *Four Quartets*, he describes a similar if less crowded scene, in which the poet walks the streets of London after an air raid:

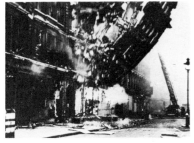

The collapse of No.23 Victoria Street,
11 May 1941

In the uncertain hour before the morning
Near the ending of interminable night
At the recurrent end of the unending
After the dark dove with the flickering tongue
Had passed below the horizon of his homing
While the dead leaves still rattled on like tin
Over the asphalt where no other sound was...[10]

'Group of Shelterers During an Air Raid' of 1941, in the Art Gallery of Ontario (No.151) was closely based, as it would appear were all the large drawings, on a sketchbook study. Page 17 from 'Second Shelter Sketchbook' squared for transfer, is reproduced here (Fig.48) to show how

Dome of St. Paul's Cathedral rises high above the smoke clouds while German raiders shower fire bombs over London, December 1940
(Photograph by Herbert A. Mason)

closely the original sketch was followed. The squared pencil lines are faintly visible in the Toronto drawing. Ideas related to earlier drawings and sculpture do surface in a few sheets in the 'Second Shelter Sketchbook', as in the two reclining figures at the top of p.17. Although Moore did not choose to enlarge any of the purely sculptural ideas that appear in the sketchbooks, some of the figures do combine both naturalistic and more abstract forms. An example of the latter is the thin axe-like head of the figure at the right in the Toronto drawing, which anticipates the head of the bronze 'Warrior with Shield' of 1953-4 (L.H.360, Fig.24).

Drapery was an extremely important new element in the shelter drawings and one which was to have far reaching implications for Moore's subsequent drawings and sculpture. Though draped figures do appear in a number of earlier sculptures and drawings (see Nos.122 and 135), it was not until he began the shelter drawings that Moore made a serious study of the subject. He has said, in fact, that drapery was the one formal element with which he was not entirely familiar.

The use of drapery in the shelter drawings was of course in response to the subject itself: fully clothed figures often wrapped or covered with blankets, shawls and bed-clothes that served as protection against the draughts in the London Underground. Reference has already been made to a study of drapery from an abstract, sculptural point of view on p.10 of the 'First Shelter Sketchbook' (Fig.45). In studies of fifteen or twenty shelterers the drapery, though very much in evidence, is not given special emphasis. But in some of the drawings of three or four figures, the drapery almost becomes the subject itself, existing as an independent form. On p.6 in the 'Second Shelter Sketchbook' is written 'bundles of old clothes that are people'.

The importance of drapery is well illustrated in 'Air Raid Shelter: Two Mothers Holding Children' of 1941 (Fig.49). The drapery creates an external shell protecting the internal forms within. In the study at left, the passage depicting the heads of the mother and child, and the marvellous rhythm of the edge of the blanket curving around the forms, is one of the most beautiful in all the shelter drawings. Thematically the internal and external forms created by the drapery around the figures look forward to several important post-war drawings and sculpture, most notably in 'Ideas for Sculpture: Internal and External Forms' of 1948 (No.217), and in two bronzes – 'Internal and External Forms' of 1953-4 (L.H.297, Fig.26) and 'Reclining Mother and Child' of 1960-1 (L.H.480).

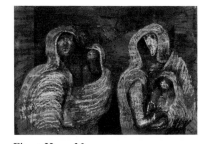

Fig.49 Henry Moore,
*Air Raid Shelter: Two Mothers Holding Children*, 1941

In the life studies of the early 1920s, Moore often combined as many as four different media in a single drawing: pencil, chalk, pen and ink and wash. Some time before the war, while doing some drawings to amuse his niece, he discovered quite by accident another medium, wax crayon, and this was used extensively in the shelter drawings and coal-mine drawings which followed.[11] The artist has explained the technique and the use he made of the medium:

> I used some of the cheap wax crayons (which she had brought from Woolworth's) in combination with a wash of water-colour, and found, of course, that the water-colour did not 'take' on the wax, but only on the background.
>
> I found also that if you use a light-coloured or even a white wax crayon, then a dark depth of background can easily be produced by painting with dark water-colour over the whole sheet of paper. Afterwards you can draw with India ink to give more definition to the forms. If the waxed surface is too greasy for the India ink to register it can be scraped down with a knife.[12]

The extraordinary surface richness and sense of depth in many of the shelter and coal-mine drawings are thus achieved with as many as five media: pencil, chalk, wax crayon, pen and ink and watercolour.

Because the vision behind Moore's drawings is that of a sculptor, interested primarily in showing the three-dimensional shape of things, colour is of secondary importance. Moore states in an unpublished note on drawing that he uses 'colour for its emotional effect, not its decorative or realistic effect'.[13] In the shelter drawings, working as he did from memory, the colours were freely invented, rather than precise descriptions of what he had seen. Occasionally the dominant colours are included in the title, as in 'Pink and Green Sleepers' in the Tate Gallery (No.165). Perhaps more important than details, such as brightly coloured blankets found in a number of shelter drawings, is the emotional effect and atmosphere achieved by the overall tonality. The blue-grey tonality in the Tate Gallery's 'Tube Shelter Perspective' (No.160) emphasizes the dim eerie light of the tunnel.

Among the most powerful and disturbing of the shelter drawings is the series of sleeping figures seen from a low viewpoint, as if we were kneeling at their feet (Nos.162–8)[14]. Only the arms and foreshortened heads are visible; the rest of their bodies are covered with blankets. Four studies related to the series are unique among Moore's drawings in their almost expressionistic violence and frenzied execution (see No.162). Two preparatory studies for one of Moore's most famous drawings, the Tate Gallery's 'Pink and Green Sleepers', are included in the exhibition (Nos. 163 and 164). Dr Walter Hussey's 'Two Sleepers' (No.167) is surely one of the most haunting and terrifying drawings Moore has ever produced. The focus on the two heads is even closer than in the Tate version of a similar subject. The mouths hang open; the eyes, hardly visible, do not belong to the living. The hand of the figure at right is like a claw without flesh. A blanket is drawn up under the chins of the two figures. Above, it is as if someone has gently pulled back the other blanket and uncovered the faces of the dead.

The shelter drawings mark a turning point in Moore's development. His dedication, experience and love of drawing in the 1920s and 30s had made the shelter drawings possible: 'If I had not been interested in drawing, and spent fifteen years doing life drawing, and put so much time and effort into my drawings for sculpture up to the war, I couldn't possibly have done the shelter drawings'. Before the war, drawing had been, Moore said, 'a second string in one's bow', although of vital importance to his development as a sculptor. But the war temporarily diverted his attention away from sculpture and for nearly two years he worked exclusively on drawing. Dealing with a subject from life which profoundly moved him, the humanist side of his nature, which for so long had been in conflict with his interest in primitive art, found an outlet in the shelter drawings. In 1946 he wrote to James Johnson Sweeney:

> And here, curiously enough, is where, in looking back, my Italian trip [1925] and the Mediterranean tradition came once more to the surface. There was no discarding of those other interests in archaic art and the art of primitive peoples, but rather a clearer tension between this approach and the humanist emphasis.[14]

He was to see shelter and coal-mine drawings as 'perhaps a temporary resolution of that conflict which caused me those miserable first six months after I had left Masaccio behind in Florence and had once again come within the attraction of the archaic and primitive sculptures of the British Museum'.[15]

In the same letter to Sweeney, Moore also said:

> You will perhaps remember my writing you in 1943 that I didn't think that either my shelter or coal-mine drawings would have a very direct or obvious influence on my sculpture when I would get back to it – except, for instance, I might do sculpture using drapery, or perhaps do groups of two or three figures instead of one. As a matter of fact the *Madonna and Child* for Northampton and the later *Family Groups* actually have embodied these features.[16]

Mention should also be made of 'Three Standing Figures' of 1948 (L.H. 268), now in Battersea Park, London, which is related to what Moore has called one of the pervading themes of the shelter drawings: 'the group sense of communion in apprehension'.[17]

Not only did the shelter drawings have a tremendous influence on Moore's subsequent work, but they also made a considerable difference to his relationship with the general public. The War Artists' Advisory Committee organized exhibitions at the National Gallery, which were among the few to be seen in London during the war. Here thousands of people saw Moore's shelter drawings for the first time. They acquainted a large public with his ability to render the human figure in a disarmingly straightforward and profoundly moving way. And the subject, the Londoners themselves, was one with which his audience could readily identify. From the sales of the shelter drawings to the War Artists' Advisory Committee, Moore found that he could support himself without recourse to part-time teaching.

The shelter drawings record what Moore has described as 'an extraordinary and fascinating and unique moment in history. There'd been air-raids in the other war, I know, but the only thing at all like those shelters that I could think of was the hold of a slave-ship on its way from Africa to America, full of hundreds and hundreds of people who were having things done to them that they were quite powerless to resist'.[18] The influence of his war-time experiences was not limited to his work alone: 'Without the war, which directed one's direction to life itself, I think I would have been a far less sensitive and responsible person – if I had ignored all that and went on working just as before. The war brought out and encouraged the humanist side in one's work'.

The shelter drawings may be described as visionary, not in the religious sense of the word, but in the interpretation of a deeply felt, highly imaginative experience. As such they go far beyond the kind of factual, documentary record of war produced by many war artists. In their almost visionary intensity, Moore's shelter drawings have, with Samuel Palmer's watercolours of his Shoreham Period, a rightful place among the supreme achievements of English graphic art.

## Coal-mine Drawings 1941-2

By the late summer of 1941, Moore had been working on the shelter drawings for almost a year and was beginning to lose interest in the subject. As the Government stepped in and began organizing and tidying up the shelters, building bunks (No.155) and installing canteens, the scenes of shelter life had lost much of their spontaneous and chaotic appearance which Moore had found so fascinating during the first few months of the Blitz. His great friend Herbert Read suggested that he might consider doing a series of drawings of coal-miners, 'Britain's Underground Army', whose work was of crucial importance in the war effort. The coal-mines, Read pointed out, would have something of the atmosphere of the train

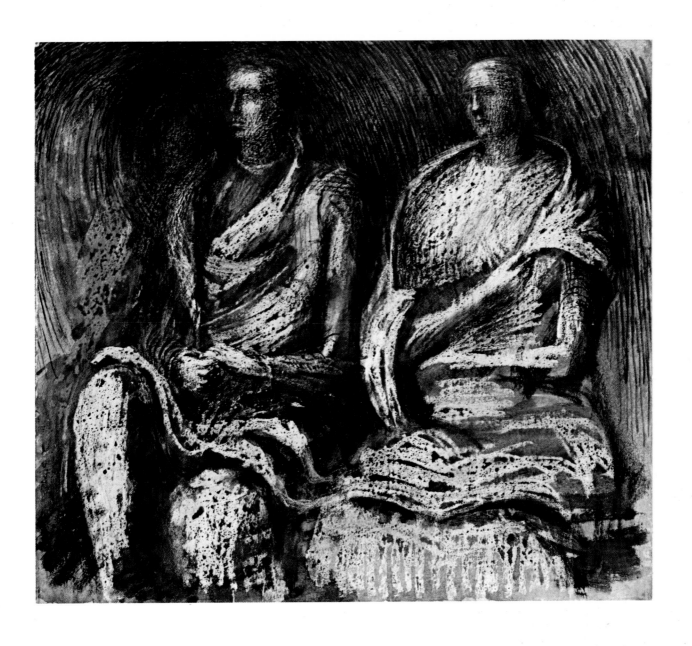

143 **Air Raid Shelter: Two Women** 1941 (entry on p.105)

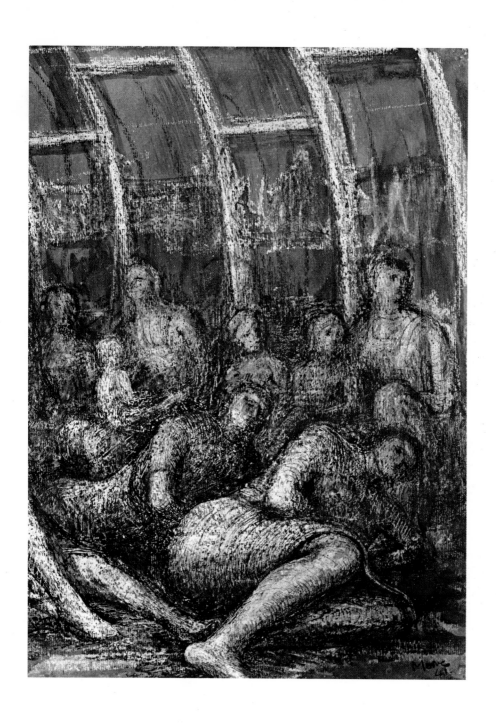

148  **Shelterers in the Tube**  1941  (entry on p.106)

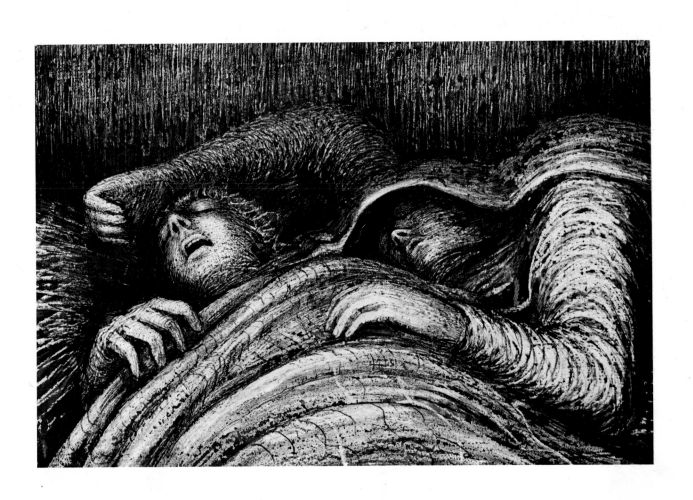

165  Pink and Green Sleepers 1941  (entry on p.112)

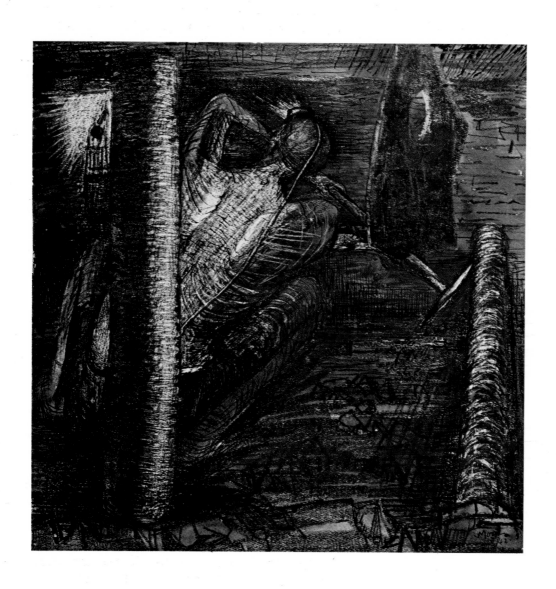

187 **Miner at Work** 1942 (entry on p.120)

tunnels in the London Underground. In addition coal-mining was connected with Moore's own family background.

On 29 August, 1941, Moore received a letter from E. M. O'R. Dickey, Secretary of the War Artists' Advisory Committee:

At yesterday's meeting of the Artists' Advisory Committee the Chairman told us that you would like to do some coal-mining subjects, and the Committee recommended that you be commissioned to do so for a fee of 25 guineas.

Dickey's letter continues:

Before I write to the Ministry of Mines I think I should ask you if there is any particular place you have in mind that you would like to visit. Please let me know what your ideas are, and I shall do my best to see that you get all the facilities you need from the Mines people.[1]

Moore replied in letter dated 9 September, 1941:

You ask if there is any special place I have in mind to visit – I had thought of going to my home town – Castleford in Yorkshire, which has several coal mines, but there's also one at Temple Newsam Nr. Leeds which I should like to look at.

I don't think I shall be ready to go until the beginning of October – for I think I should like to look at, and consider first, the other commission of the special First Aid Posts.[2]

In fact, Moore's visit to Yorkshire was postponed until December. He wrote again to Dickey on 24 November:

I intend going to Leeds next Monday Dec. 1st (i.e. all being well by then with this right hand of mine)[3] and should go on the first thing on Tuesday morning Dec. 2nd to the Wheldale Colliery at Castleford. My idea is to stay at Castleford for about a week, getting a general idea of what strikes me most, and then come back here [to Perry Green] for about a week or so to make drawing notes of the first impressions, and then go back to Yorkshire a second time and for a longer stay and with more definitive objectives in my mind.[4]

Moore was excited at the prospect of returning to Yorkshire. He had been back only once or twice in the twenty years since 1921, the year his parents had moved to Norfolk. He was looking forward to visiting Castleford and 'seeing what nostalgic and sentimental effects it might have on me'. Dickey had written to the Mines Department in London advising them of Moore's forthcoming trip to Castleford.[5]

Moore remembers a thick fog on the day of his arrival in Castleford, presumably on 2 December 1941, and the difficulty he had in finding his way to the small local inn where he had booked a room. The following morning he went to see the Manager of Wheldale Colliery where his father had worked. A Deputy was appointed to show him round. Moore had never been down a mine before, and the experience was overwhelming. Thirty years later he was able to describe in vivid terms his first impressions:

Crawling on sore hands and knees and reaching the actual coal-face was the biggest experience. If one were asked to describe what Hell might be like, this would do. A dense darkness you could touch, the whirring din of the coal-cutting machine, throwing into the air black dust so thick that the light beams from the miners' lamps could only shine into it a few inches – the impression of numberless short pit-props placed only a foot or two apart, to support above them a mile's weight of rock and earth ceiling – all this in the stifling heat. I have never had a tougher day in my life, of physical effort and exertion – but I wanted to show the Deputy that I could stand just as much as the miners.[6]

During his first few days down the pit, Moore made no attempt to draw; he wanted only to observe the conditions underground, the structure of the roads and tunnels, and the positions of miners at work. At the bottom of the shaft the main underground roads were relatively high and wide. 'Page from Coalmine Sketchbook: Types of Roads' (No.172) shows the shape and supports of the tunnels leading from the main shaft to the coal-face. Nearing the coal-face the tunnels became so narrow and low that the miners had to crawl on all fours to reach the seam of coal. In these dark and cramped spaces Moore began drawing in the small 'Coalmining Notebook' (also called 'The Pit Notebook')[7] of 1941 (No.169). A series of photographs of Moore sketching have survived (Figs.50a and b).[8]

The coal-mine drawings were in certain respects a continuation of the shelter drawings. Page 39 from 'Coalmining Subject Sketchbook' (Fig. 51), showing miners walking along a tunnel, is close in subject and technique to the sketchbook page 'Tube Shelter Perspective' (No.160). The combination of pen and ink, chalk, wax crayon and watercolour, which had been perfected in the shelter drawings, is also used in many of the coal-mine drawings. But they differ from the shelter drawings on several counts. To begin with, Moore drew *in situ* hurried sketches in the small 'Coalmining Notebook', in which he recorded the various settings and positions of the miners at work and at rest. Second, for the first time he approached the male figure in a positive way:

> I had never willingly drawn male figures before – only as a student in college. Everything I had willingly drawn was female. But here, through these coal-mine drawings, I discovered the male figure and the qualities of the figure in action. As a sculptor I had previously believed only in static forms, that is, forms in repose.[9]

But the actions of the miners at work, although at times violent, has a kind of compressed energy and restricted movement, in such activities as drilling in a drift (No.177), pushing a coal tub (No.182) and swinging their pickaxes at the coal-face (No.186). The movement was, the artist has said, mainly with the top parts of the bodies, 'and so the lower part is stuck as it were to the pedestal . . .'[10] This is well illustrated in one of the finest of the large drawings of individual figures, 'Studies of Miners at Work' (No.186). In the two squatting figures at the bottom of the sheet, the feet anchor the miners to the ground, with their bodies from the waist up free to turn and pivot with the swinging movement of the pickaxe. Moore emphasizes the broad shoulders and powerful backs of the miners, features of the male figure which were to reappear in several post-war sculptures, notably in the 'Family Group' of 1948–9 (L.H.269), and the 'King and Queen' of 1952–3 (L.H.350, Fig.52).

'The shelter drawings', Moore has written, 'came about after first being moved by the experience of them, whereas the coal-mine drawings were more in the nature of a commission coldly approached'.[11] And yet technically, the subject of the miners and the surrounding darkness down the pit posed challenging problems which were not encountered in the shelter drawings:

> There was first the difficulty of seeing forms emerging out of deep darkness, then the problem of conveying the claustrophobic effect of countless wooden pit-props, 2 or 3 feet apart, receding into blackness, and of expressing the gritty, grubby smears of black coal-dust on the miners' bodies and faces at the same time as the anatomy underneath.[12]

The source of light was often included in the drawings, either the lamps fixed to the miners' helmets (No.186) or the lanterns which sometimes hung on the pit-props (No.187) or were carried by the miners (No.184).

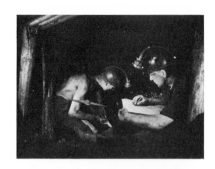

Figs.50 a and b, Henry Moore sketching, Wheldale Colliery, December 1941

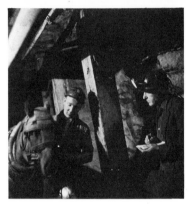

Fig.51 Henry Moore, *Page 39 from Coalmining Subject Sketchbook*, 1942

Fig.52 Henry Moore, *King and Queen*, 1952–3 (Sir William Keswick, Dumfries)

The page from 'Coalmine Sketchbook: Miners Faces' of 1942 (No. 180) is one of the finest of the notebook drawings. In the studies of miners' heads, Moore found 'a special problem was to show the black smudges of coal-dust on the miners' faces, and at the same time show the shape, the form beneath the black smudges, that is, one was using the same chalk or pencil to do two things, to show colour and form together, without confusion or contradiction'.[13] In full control of the various media, Moore has here brilliantly captured the stoical, grim faces of the miners, fully three-dimensional beneath the black coal-dust. He pointed out 'how clearly the whites of the miners' eyes showed up against the black grime on their faces, giving a highly dramatic sense, and reminding me of Masaccio, who in his frescoes always emphasized the whites of eyes'.[14]

Moore spent about a fortnight at Castleford and did not in fact return for a second visit as he had suggested he would in his letter to Dickey quoted earlier. The drawings done *in situ* at the Wheldale Colliery were those in the 'Coalmining Notebook' (No.169). The more finished pages from the other two notebooks, the 'Coalmining Subject Sketchbook' and 'Coalmine Sketchbook', and some twenty large drawings were done on his return to Hoglands. Following the same practice used in the shelter drawings, the large coal-mine drawings were based on studies in the sketchbooks. He usually followed the original sketches very closely as seen by comparing 'Miners Resting during Stoppage of Conveyor Belt' of 1942, in the Leeds City Art Galleries (No.176) with the study for it, in the Art Gallery of Ontario (No.175).

'Coalminer Carrying Lamp' of 1942 (No.179) is connected with a memory from Moore's childhood. While working on this drawing he was reminded of a reproduction of Holman Hunt's 'The Light of the World' (Fig.53) which hung in his parents' house in Castleford.

The coal-mine drawings were highly regarded by the War Artists' Advisory Committee. In a letter to Moore dated 28th May 1942, Dickey wrote: 'Your coal-mining subjects were received with acclamation at yesterday's meeting of the Artist's Advisory Committee'.[15] Eleven drawings were purchased by the Committee and like the shelter drawings distributed among London and provincial museums.[16] By the early summer of 1942 Moore had completed the series and his activities as a war artist came to an end. In 1974 he wrote of his coal-mine drawings:

> I now believe that the effort of making these drawings was of great value for my later 'black' drawings and graphics. In 1941 I was not particularly aware of Seurat's drawings. It was only later that I came to admire him, especially in the last ten years since I have owned two of his drawings myself [Fig.54]. I look at these almost every day, and I feel that my recent 'black' drawings also owe a lot to him.[17]

For many years the coal-mine drawings have been somewhat over-shadowed by the shelter drawings. Of the latter drawings Moore said: 'I would have done some of them whether the War Artists' Advisory Committee existed or not, whereas the coal-mine drawings were a subject suggested to me, a commission I undertook. Yet I'm glad I did them and was given a chance to know in reality something of the difficult and dramatic conditions of a miner's working life'.

If the coal-mine drawings are of a more factual and documentary nature than the visionary shelter drawings, they perhaps surpass them as a brilliant technical achievement. In Moore's renewed interest in drawing and print making in the 1970s, it was the experience of the coal-mine drawings, with their sense of mystery, of dark forms emerging out of depth and blackness, that he found particularly useful. In the exhibition

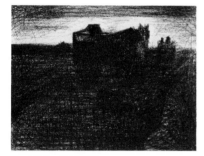

Fig.54 Georges Seurat,
*Les Deux Charrettes*, *c*.1883
(Henry Moore)

of Moore's War Drawings at the Imperial War Museum in 1976, and in the selection shown here, the coal-mine drawings have been given the exposure and, it is hoped, the acclaim they deserve.

# Drawings 1942–77

### Studies for Sculpture and Pictorial Drawings 1942–56

For a period of two years, from mid-1940 to the summer of 1942 Moore worked exclusively on his drawings: the studies for sculpture of 1940 (executed while waiting to hear if he had been accepted for the course in precision tool making) and the shelter and coal-mine drawings which had been commissioned by the War Artists' Advisory Committee. This was, in fact, to be the only prolonged period of his career when no sculpture was produced. Having completed the coal-mine drawings by the summer of 1942,[1] Moore was anxious to return to his sculpture, and he began filling a sketchbook with sculptural projects (No.188). The most important ideas to emerge were three sheets of studies of 1942 for the large elmwood 'Reclining Figure' of 1945–6 (L.H.263), which, like the three maquettes for the large carving (L.H.247, 248, 249), was made three years after the preparatory drawings. In a fourth drawing, 'Reclining Figure and Pink Rocks', also of 1942 (No.189), the reclining figure is set against a two-piece sculptural background, of which the form at left is closely related to the background in 'Reclining Figure' of 1938 (No.118). In a drawing which the artist considers to be one of the finest of the period, 'Reclining Figure and Red Rocks' of 1942 (No.190), the dramatic thrust of the rock at left anticipates the leg end of the 'Two-Piece Reclining Figure No.1' of 1959 (L.H.457, Fig.55).

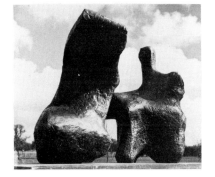

Fig.55 Henry Moore,
*Two Piece Reclining Figure No.1,* 1959

In a number of other drawings of 1942 are to be found sculptural forms and settings which appeared in the pre-shelter drawings. In 'Sculpture in a Landscape' (No.19), the upright form which includes an enormous spear head, was borrowed from 'Seated Figure and Pointed Forms' of 1939 (No.125), while the form at centre right, with three points nearly touching, was taken from the study at lower right in 'Pointed Forms' of 1939 (incorrectly inscribed 1940) (L.H. vol.1, p.221), in the Albertina, Graphische Sammlung.

The cell-like rooms, which first appeared in the drawings of 1936–7 (No.116), were again used as indoor settings, in 'Six Settings for Sculpture' dated 1942 (No.194). The last drawings of such interior scenes would appear to be 'Three Standing Figures in a Setting' of 1948 in the Victoria and Albert Museum (No.208), and 'Eight Variations of Figures in a Setting' of 1950 in a private collection (Fig.56).

'Crowd Looking at a Tied-Up Object' of 1942 (No.193), undoubtedly Moore's most famous pictorial drawing, is shown here for the first time with the preparatory sketch (No.192). With its Surrealistic overtones, it falls chronologically mid-way between Man Ray's 'The Enigma of Isadore Ducasse' (cloth and rope over a sewing machine) of 1920 and Christo's 'Lower Manhattan Packed Buildings' of 1964–6.[2] The exact source or prototype for this enigmatic pictorial scene has, until recently, remained a mystery. The artist told the author that the idea of a tied-up object may have been suggested by an occurrence commonplace in many sculptor's studios. As a student in a modelling class at the Royal College

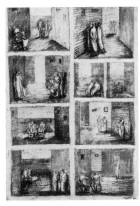

Fig.56 Henry Moore,
*Eight Variations of Figures in a Setting,* 1950

Page 41:   Second paragraph. 'Sculpture in a Landscape' is No.191 and not No.19.

of Art, Moore remembers having kept clay moist by covering it with a damp cloth and tying string around it. Kenneth Clark has recently remarked on the Goyaesque character of the drawing and has suggested the etching 'Disparete de Miedo' (Fearful Folly), from *Los Proverbios* as a possible source.[3] But the precise source for the drawing was surely a photograph in Frobenius' book *Kulturgeschichte Afrikas* (1933),[4] showing a group of Nupe tribesmen from northern Nigeria standing around two veiled (but not tied-up) Dako cult dance costumes (Fig.57). Although the drawing was almost certainly inspired by the illustration in Frobenius, Moore has recreated his own setting and the sense of drama and expectancy. Dwarfed by the enormous tied-up object, a crowd has gathered to wait for its unveiling. Fascinated and overwhelmed by its ominous presence, they stand close together, as if for protection. Less enigmatic are the works by Man Ray and Christo cited above, for we know what has been tied-up. In the Moore drawing the identity of the form beneath the rope and canvas will remain forever a mystery.

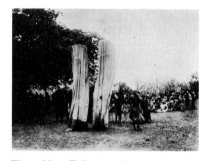

Fig.57 Nupe Tribesmen (Northern Nigeria) standing around two veiled Dako cult dance costumes

The influence of the shelter drawings on Moore's subsequent sculpture has been discussed in the chapter on the War Drawings. Needless to say, their influence is also reflected in the drawings of the 1940s, in the extensive use of drapery, in the more naturalistic approach to the human figure, and in group compositions. If, for example, one were shown a detail of the seated woman at right in 'Figures with Architecture' of 1943 (No.197), one might easily suggest a date of 1940, so closely related is the handling and heavy drapery to the figures in 'Two Women on a Bench in a Shelter' (No.144). In his letter to Sweeney quoted in the chapter on the War Drawings, Moore remarked on the two major influences which the shelter drawings might have on his sculpture: the use of drapery and groups of two or three instead of single figures. Few drawings could better illustrate this observation than 'Group of Draped Standing Figures' of 1942 in the Art Institute of Chicago (No.195). Ideas for sculpture were first explored in the drawings and it was often two or three years before they were realized in three dimensions. The group at centre in the Chicago drawing could almost be considered as a preparatory study for the 'Three Standing Figures' of 1945 (L.H.258), the sketch model for the large Darley Dale stone 'Three Standing Figures' of 1947–8 (L.H.268), now in Battersea Park, London.

Moore made numerous drawings for two important commissions of the 1940s: the Hornton stone 'Madonna and Child' of 1943–4 (L.H.226) for the Church of St. Matthew, Northampton, and the large bronze 'Family Group' of 1948–9 for Barclay School, Stevenage, Herts. (L.H.269). One of the finest sheets of studies for the Northampton carving, 'Page from Madonna and Child Sketchbook' of 1943 is shown here (No.199). In addition to the preparatory drawings there are twelve terracotta maquettes of 1943 for the carving (L.H.215–226), which include the definitive study, 'Madonna and Child' (L.H.224). One of these (L.H.222) served as the study for the Hornton stone 'Madonna and Child' of 1948–9 for St. Peter's Church, Claydon, Suffolk (L.H.270).

Likewise there are numerous family group drawings of 1944 (Nos.200–202), and fourteen terracotta maquettes of 1944–5 (L.H.227–240). One of these, the small terracotta 'Family Group' of 1945 (L.H.239), served as the sketch model for the large bronze 'Family Group' of 1948–9 for Barclay School. The artist has given a detailed account of both commissions in *Henry Moore on Sculpture* (edited by Philip James), 1966, pp.220–9.

The preparatory sketchbook studies and the series of maquettes which preceded the two commissions just discussed mark a major change in

direction in Moore's working method. The practice of first making a small maquette (based on a drawing) before embarking on the larger carving had, in fact, begun in the late 1930s. For example, there is a small maquette for the Tate Gallery 'Recumbent Figure' of 1938 (L.H.191) and for the large elmwood 'Reclining Figure' of 1939 (L.H.210) now in Detroit. For the Northampton 'Madonna and Child' and the Stevenage 'Family Group', however, Moore made not one maquette, but a whole series for each project. No longer was he content to select from the preparatory drawings what he considered to be the most suitable idea and make a single maquette from it. He now chose to realize many of the sketchbook studies in three dimensions.

The maquettes and several larger studies for the 'Madonna and Child' and 'Family Group' were cast in bronze. In fact, a number of small sculptures of 1938–40 had also been cast, in bronze, lead and cast iron. But it was not until 1943–5 that the major shift in emphasis occurs, from working almost exclusively in stone and wood, to also working in clay, and later in plaster, materials which are suitable to be cast in bronze. One senses, with the series of maquettes for the two commissions under discussion, that Moore was becoming less dependent on drawing, as he chose to develop many ideas in three dimensions. By the mid-1950s this method of work had made the drawings for sculpture redundant.

The year 1948 marks the culmination of the two-way sectional method of drawing, which was first developed in a somewhat tentative way in the life drawings of 1928 (Fig.16 and No.39). Instead of isolated passages, which are also to be found in some of the sculpture drawings of the late 30s and in some of the shelter studies, the two-way sectional lines are not only used in a systematic way, but the lines are stronger and more decisive, particularly in drawings like the massive 'Seated Figure' of 1948 in the collection of Dr. and Mrs. Henry Roland (No.215). The handling is more delicate and refined in the large 'Family Group' drawing of 1948 in the Art Gallery of Ontario (No.212), and in the two charming rocking chair drawings, also of 1948 (No.210, private collection and No.211 City Museum and Art Gallery, Birmingham).

The pictorial drawings of 1946–9 are for the most part scenes of domestic life, such as 'Girl Reading to Woman and Child', of 1946 (No. 207), 'Two Women Seated at a Table' of 1948 (No.209), and the large family group drawings also of 1948, one of which is shown here (No.212). Another large sectional line study of 1948 is entitled 'Women Bathing a Child', no doubt reflecting a familiar scene at Hoglands.

Among the drawings for sculpture of the late 1940s are two sheets of studies for important bronzes which were executed in the early 1950s. 'Standing Figures: Ideas for Metal Sculpture' of 1948 (L.H. vol.I, p.270) includes the sketch for the bronze 'Standing Figure' of 1950 (L.H.290). From the study just left of centre in 'Ideas for Sculpture: Internal and External Forms', also of 1948 (No.217) evolved the three bronze versions of the 'Internal and External Forms' of 1951 to 1953 (L.H.294–296), and the very large elmwood carving of this subject, in the Albright-Knox Art Gallery, Buffalo (L.H.297).

In 1950 Moore was commissioned by the Arts Council of Great Britain to make a large bronze reclining figure for the 1951 Festival of Britain. He produced two small maquettes in 1950 (L.H.292a and 292b) based on two studies from a notebook page 'Sketch for Reclining Figure' of 1950 (L.H. vol.II, pl.100). In 1951 he made the large version 'Reclining Figure' (L.H.293), from the 17-inch 'Maquette for Reclining Figure' (L.H.292), which in turn was based on 'Small Maquette for Reclining Figure' (L.H.292a).

'Three Standing Figures' of 1951, in the Art Institute of Chicago, (No.224) would appear to be the study for 'Maquette for Three Standing Figures' of 1952 (L.H.321), although the forms were somewhat modified in the sculpture.

'Drawing for Sculpture: Studies for Seated Figures' of 1951 (Fig.58, whereabouts unknown) includes at lower left the sketch for what is surely the most disturbing and aggressive representation of the mother and child theme in Moore's entire oeuvre, the 'Mother and Child' of 1953 (L.H.315, Fig.59). The serrated head of the mother might suggest a debt to Picasso's 'Seated Bather' of 1930 (Zervos VII, 306) in the Museum of Modern Art, New York. Or as Herbert Read has written:

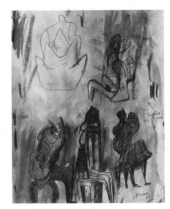

Fig.58 Henry Moore,
*Drawing for Sculpture: Studies for Seated Figures*, 1951

> This group is so close an illustration of the psycho-analytical theories of Melanie Klein that it might seem the sculptor has some first-hand acquaintance with them; but the artist assures me that this is not so. It may be that, in Neumann's words, 'it is a picture of the Terrible Mother, of the primal relationship fixed for ever in its negative aspect', but if so, it is a picture that comes from the artist's unconscious: it has no direct connection with any psycho-analytical theory.[5]

This negative expression of the mother and child motif is unlike anything else in Moore's work. The gaping beak-like mouth of the child strains to devour rather than feed at the breast, but is held away by the outstretched arm of the mother, whose hand seems to be strangling the extraordinarily long neck of the child.

The preparatory drawing and the sculpture came neither from the artist's unconscious, nor from current psycho-analytical theory. The idea was based on the low relief on a Peruvian pot (Fig.60) which is reproduced in Ernst Fuhrmann's *Peru II* (1922). The artist's copy of this book is inscribed on the fly-leaf 'Henry Moore'. The exact identity and significance of the forms in the Peruvian work are unclear. At left is a man with the head of a bird, and on the right a fish with an enormous mouth and a face like a crescent moon. The bird man holds with both hands a long neck with a bird-like head, which the fish form is about to devour. Moore has transformed this complex image into a single mother and child relationship; the snake form with the head of a bird becomes the child, the fish form the mother. Moore's obsession with the mother and child theme is nowhere better illustrated than in the extraordinary metamorphosis of the Peruvian work. It is worth quoting again the artist's remark 'So that I was conditioned, as it were, to see it in everything'.[6]

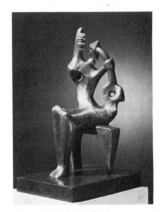

Fig.59 Henry Moore,
*Mother and Child*, 1953
(Tate Gallery)

Fig.60 Peruvian Pot

In 1953, the same year as the large version of the 'Mother and Child' discussed above, Moore produced the 'Maquette for Warrior with Shield' (L.H.357), followed in 1953-4 by the life-size version (L.H.360, Fig.24). The sculpture, the artist has written, 'evolved from a pebble I found on the seashore in the summer of 1952, and which reminded me of the stump of a leg, amputated at the hip'.[7] As early as 1930, an ironstone pebble had been used as the point of departure for 'Head' (L.H. 88). Found on a beach in Norfolk during the summer of 1930,[8] this pebble became the subject of some sketches by Moore in which he worked out the final form of the carving. 'Ideas for Sculpture: Heads', a drawing of 1930, includes the study for 'Head' of 1930 (L.H.88). The inscription on this drawing, 'profile pebble', indicates that it was the profile which suggested the head. There were no preliminary drawings, however, for 'Warrior with Shield'; the maquette evolved directly from the pebble which Moore had found by the sea.

The last sculpture for which there were related drawings, appears to have been the 'UNESCO Reclining Figure' of 1957-8. None of the half

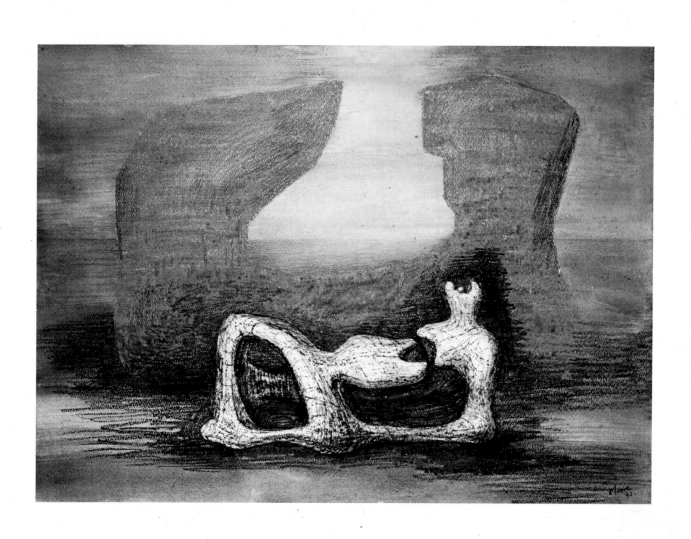

190  **Reclining Figure and Red Rocks**  1942 (entry on p.121)

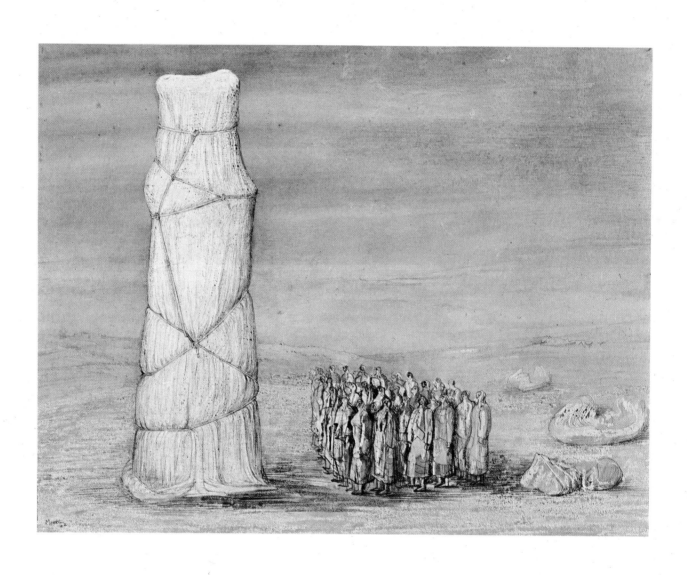

193 **Crowd Looking at a Tied-up Object** 1942 (entry on p.122)

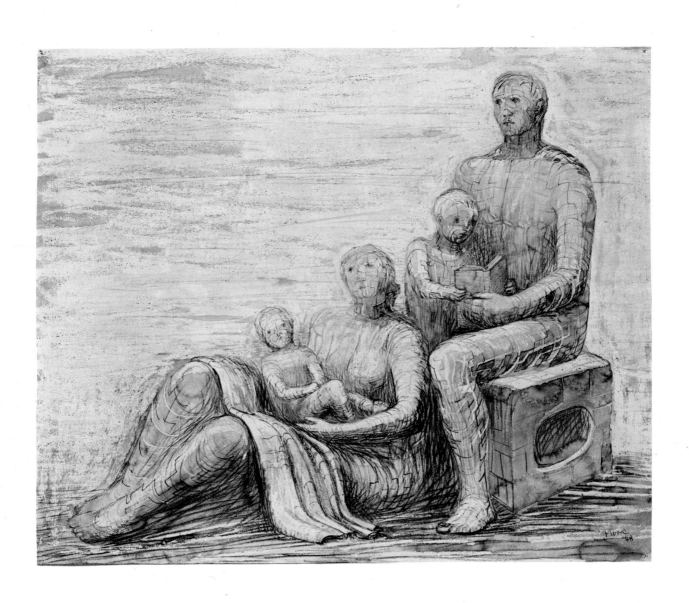

212 **Family Group** 1948 (entry on p.128)

228 **Two Reclining Figures** 1961 (entry on p.133)

Fig.61 Henry Moore,
*Studies for UNESCO Reclining
Figure*, 1956

dozen known sheets of studies, such as Fig.61 of 1956, was a definitive sketch in the way that the drawing for the Tate Gallery 'Recumbent Figure' of 1938 was closely followed in the maquette. When asked if the maquette for 'UNESCO Reclining Figure' of 1956 (L.H.414) was based on the drawings, the artist hesitated, and could not say with any degree of certainty. Some, he said, could have been done before the maquette; others might be drawings of the maquette: 'Does it really matter?' The uncertainty in Moore's own mind was surely indicative of the watershed that had been reached in the mid-1930s, when the drawings were no longer used as a means of generating ideas for sculpture. Henceforth one must look elsewhere, usually among the natural forms in the artist's studio, for the genesis of many of the sculptures of the last twenty years.

From 1921 to the mid-1950s, drawing was of immense importance as an intermediate step in the creation of sculpture. The selection of drawings for sculpture in this exhibition should indicate how consistently Moore used drawing for this purpose. We have seen that in making a sculpture from a single drawing, the initial view drawn became the important one. As his sculpture became less representational, and began to have 'an organic completeness from every point of view', he found working from a sketch showing a sculptural idea from a fixed and single view was contradictory to his aims. In fact he now maintains, 'to make a drawing beforehand would inhibit me'. His method of work has altered to meet the new demands of his sculpture:

> Because now I am aiming at sculpture that is truly three-dimensional, I want it to vary from whatever angle I look at it. Although it is a unified idea, it is not symmetrical. To explain its shape by drawing I should require at least twenty or thirty drawings. . . . I need to know it from on top and from underneath as well as from all sides. And so I prefer to work out my ideas in the form of small maquettes which I can hold in my hand and look at from every point of view.[9]

In 1937 Moore remarked:

> This is what the sculptor must do. He must strive continually to think of, and use, form in its full spatial completeness. He gets the solid shape, as it were, inside his head – he thinks of it, whatever its size, as if he were holding it completely enclosed in the hollow of his hand. He mentally visualizes a complex form from all round itself; he knows while he looks at one side what the other side is like. . . .[10]

When Moore made drawings for sculpture, and sculpture from the drawings, he was forced to 'mentally visualize' the two-dimensional image in three dimensions. Now, with the form in front of him on a turn-table, real and in the round, what need is there of illusory images on the flatness of a sheet of paper?

## Studies for Graphic Work and Recent Drawings 1957-77

In the late 1950s and in the 1960s, Moore concentrated almost exclusively on his sculpture and produced relatively few drawings. He continued making preparatory drawings for his graphic work, a practice which dates from the late 1930s. 'Spanish Prisoner' of 1939 No.129, is the study for the lithograph of the same title (C.G.M.3). Some of the other drawings in this exhibition which were subsequently used for prints are: 'Head of Prometheus' of 1949 (No.219, for C.G.M.22), 'Reclining Figures: Drawing for Metal Sculpture' of 1954 (No.226, for C.G.M.38); 'Reclining Figures' of 1963 (No.231, for C.G.M.48); 'Log Pile' of 1972 (No.239, for C.G.M.189),

Page 45:   First paragraph, line 9 should read:-                    [45]
          ... watershed that had been reached in the
          mid-1950s ...

and three of the four sheep drawings shown here (Nos.242 and 243, for
C.G.M.196, 201 and 228). Other studies for graphic work are discussed in
the catalogue notes.

Although Moore was no longer using drawing as a means of generating
ideas for sculpture, the sculptural studies of the early 1960s are certainly
related in a general way to the bronzes of the period. For example, the
ponderous, chunky forms of 'Two Reclining Figures' of 1961 (No.228),
recalls the bronze 'Three Piece Reclining Figure No.1' of 1961–2 (L.H.500,
Fig.62). In other drawings (and in a number of prints of the 1960s)
Moore drew completed maquettes, as in 'Reclining Figure: Bunched' of
1961 (No.230), based on the maquette of the same title and date as the
drawing (L.H.489).

Moore's renewed interest in drawing and printmaking during the past
seven or eight years dates from late 1969, when he began work on the series
of etchings of an elephant skull which he had been given by Sir Julian
Huxley.[11] He made a few notebook studies prior to working directly on
the copper plates. In 1970 he made a series of pen exercises, of which
three are shown here (Nos.235–37). In these spontaneous sketches, one
senses that Moore is limbering up, as it were, getting his hand in again.
With their kind of calligraphic shorthand, the pen exercises depict a range
of subject matter which was to be prophetic of the iconography of the
1970s: sculptural motives (No.237), the mother and child theme, as well
as pictorial subjects such as 'Storm at Sea' (No.236), and 'Horsemen
Crossing a Mountain Crevasse' (No.235). There is no doubt that the style
of the pen exercises owes a debt to Rembrandt's drawings. It would
appear, for example, that 'Storm at Sea' (No.236) was based on
Rembrandt's drawing 'Christ in the Storm on the Sea of Galilee' of
1654–5 (Kupferstichkabinett, Dresden).

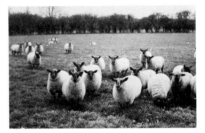

Fig.65 Sheep at Hoglands

Commonplace rural scenes around Moore's Hertfordshire estate have
been the subject of a number of drawings of the 1970s: the log pile beside
the coal shed (Fig.63, No.239); the old gnarled and twisted hedge separat-
ing the two fields which Moore rents out to a local farmer (Fig.64,
No.255); and Irina Moore's bonfire behind Gildmore studio where she
burns waste paper from the office and garden rubbish (No.259).

Perhaps the finest drawings Moore has produced since the war are the
studies of sheep in the field behind the maquette studio at the bottom of
the garden (Fig.65). One is reminded of Turner's watercolour 'Sheep
Grazing on Salisbury Plain' of c.1825, in the British Museum, or the
sheep in Palmer's work of the Shoreham Period, such as 'The Flock and
the Star' of 1831–2, in the Ashmolean Museum, Oxford. When the
sheep etchings (based on the drawings) were published in 1975, many
thought that this was a new subject for Moore. This was not so. Fifty
years earlier, in No.2 Notebook of 1921–2 (Fig.66), he had made studies
of sheep during the summer in Norfolk.

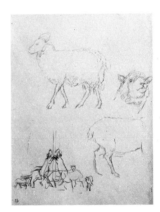

Fig.66 Henry Moore,
*Page 91 from No.2 Notebook*, 1921–2

Recent drawings include flights of fancy, like 'Shipwreck' of 1973
(No.250). He has reinterpreted earlier pictorial ideas in 'Figures in
Settings' of 1975 (Fig.67), based on the small compositions of figures in a
cave, and two towers in 'Page from Sketchbook' of 1937 (Fig. 38). Like
the transformation drawings of natural forms of the early 1930s, 'Reclining
Figure' of c.1974 (No.252) was drawn from three flint stones which Moore
had arranged on a turn-table in his studio (Fig.68). To the stone at left,
he had added a small bit of clay or plasticine to form the head. The last
two drawings in this exhibition (Nos.260 and 261), from a 1969–77
sketchbook, are of the artist's hands.

One senses in the recent drawings a feeling of total freedom, almost of

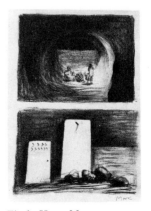

Fig.67 Henry Moore,
*Figures in Settings*, 1975

Page 46:   First paragraph should read:-
... and three of the four sheep drawings shown
here (Nos.242, 243 and 244 ...

liberation. For many years drawing had been a means to an end, to be used for immediate exploitation for sculpture. Having in the late 1950s and in the 1960s made a complete break between his sculpture and drawing, so they could exist independently, Moore has taken up drawing again with renewed vigour. He has said recently: 'I now feel free to draw when I please. I can enjoy it and appreciate it for its own sake, independent of anything else'.

# Life Drawing

38

1  **Head of an Old Man** 1921
Pencil, $6 \times 6\frac{1}{4}$ (15.2 × 15.8)
Inscribed upper right 'Moore' (early),
lower right 'Moore 21' (recent)
*Art Gallery of Ontario*, Gift of Henry Moore, 1974
Henry Moore's earliest surviving life drawings date
from his first term at the Royal College of Art in the
autumn of 1921. Among these are six sheets of draw-
ings of an old man, which include clothed and nude
studies, and four portrait heads. The artist has des-
cribed the Toronto study as 'portrait drawing of the
purely academic type'. In this exercise in tonal values,
the volumes are defined by hatchings and cross-
hatchings. The staring eyes are given particular
emphasis, so that the head has, in the artist's own

words 'a sense of life', which is absent in another
drawing 'Portrait Head of an Old Man', also of 1921. In
the latter study, the eyes have been left out, which gives
the head the appearance of a plaster cast. These
drawings were done in the modelling class in the
Sculpture School and not in the life class in the
Painting School. The clay 'Portrait Bust' of 1921
(L.H.1) was based on the same model.

2  **Standing Male Nude** 1921
Pencil, $14 \times 11\frac{1}{16}$ (35.5 × 28.1)
Inscribed lower right 'Moore 21' (recent)
*Private collection*
Of the hundreds of life drawings of the 1920s and 30s
only fifteen studies of the male nude are known, all

executed between 1921 and 1925. The model for this carefully worked academic drawing was not, the artist said, the old man in No.1, but a much younger man. Moore has compared this drawing 'to an early Seurat', an artist whom he regards as one of the truly great draughtsmen. The pencil lines in front of and beside the feet are the only contact the figure has with the ground. In drawing a standing figure, Moore said, instead of beginning with the head and working down, there came a time 'when I realized that in a standing figure particularly, the connection with reality begins with the feet, and I would start with the feet flat on the ground and draw upwards'. He remarked on the way in which Signorelli and Piero della Francesca managed to anchor the feet of their figures so firmly to the ground.

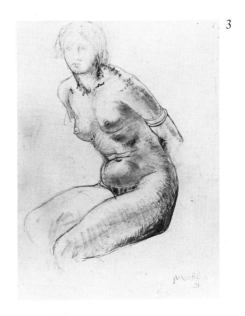

3   **Seated Woman** 1921
    Pencil, pen & ink and wash, 12×9 (30.5×23)
    Inscribed lower right 'Moore 21' (recent)
    *Trustees of the British Museum*

Also dating from his first term at the Royal College of Art, this drawing is one of Moore's earliest surviving studies of the female nude, the subject of almost all his drawings and sculpture. He was soon to abandon the delicate pencil shading found in Nos.1 and 2 for a broader, freer treatment, using several media. The figure was first drawn in pencil, and the wash and crisp pen and ink outlines added subsequently. The two bangles worn on the left arm, the artist pointed out, show the section around the arm. In recent years the drawing has been reworked: the eyes and mouth, eyebrows and hair were given sharper definition, and the shading was added above the line of the chin and jaw. This is one of seventeen drawings given by the artist to the British Museum between 1969 and 1974.

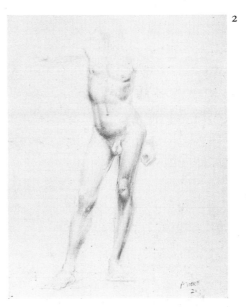

4   **The Artist's Sister Mary: Head and Shoulders**
    *c*.1922
    Pencil, brush & ink and finger rub, 10⅛×8¹³⁄₁₆
    (25.7×22.4)
    Inscribed upper centre 'Moore'; to the right of
    this, the inscription '22' has been erased
    *Henry Moore Foundation*

The earliest of five known studies of the artist's sister Mary (see Nos.28 and 29), this boldly executed wash drawing was probably done in Norfolk in the summer of 1922. The artist described it as 'a bit Cézannesque – Cézanne often emphasized the outline of the figure'.

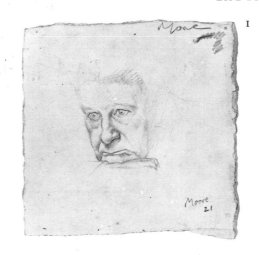

5   **Standing Nude Girl: One Arm Raised** 1922
    Pen & ink, chalk and wash, 13¼×6⅛ (33.6×15.6)
    Inscribed upper right 'Moore' (early); at lower
    right 'Moore 22' (recent)
    *Private collection*

One of the characteristics of Moore's life drawing was the use of mixed media: pencil, pen and ink, chalk and wash, three of which were employed in this work. The dramatic contrast between the light areas of the body where the white paper has been left blank, and the

4

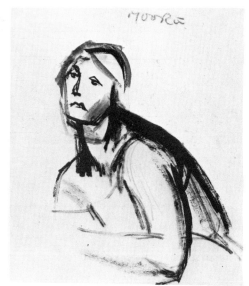

5

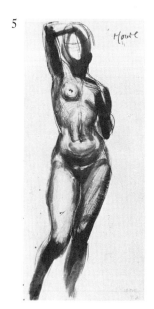

6

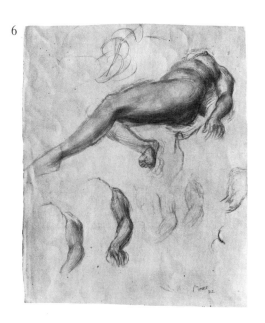

dark chalk and blue wash modelling, emphasizes the three-dimensional character of the figure. The oval head, without facial features, gives the model the impersonality of a manikin.

6 **Reclining Nude** 1922
Pencil and wash with finger rub, $17\frac{1}{2} \times 14\frac{1}{2}$
$(44.3 \times 37)$
Inscribed lower right 'Moore 22' (recent)
*Henry Moore Foundation*
The reclining pose, which by the late 1920s had become one of the major motifs of Moore's sculpture, is rare among the life drawings. Also unusual is the low view point and the extreme foreshortening of the torso in the present drawing. For the most part the modelling in pencil consists of slightly curved lines running across the torso and down the limbs parallel to the contours. In the life drawings studied details of the anatomy are rarely to be found, which here give this work something of the appearance of an Old Master drawing.

7 **Male Figures** 1923
Pencil, pen & ink and chalk, $12\frac{3}{8} \times 11\frac{1}{8}$
$(31.5 \times 28.2)$
Inscribed at lower right 'Moore 23' (recent)
*Private collection*
The upper portion of this sheet of studies of the male figure has been torn off. The figure at left was first outlined in pencil, with the pen and ink and chalk added subsequently, whereas in the other study the outline and modelling were done in chalk. Referring to the latter figure, the artist commented 'I was beginning to draw the section', referring to the oval line in pen and ink on the left leg and the curved sweeping strokes beneath the navel. Eight of the fifteen known drawings of the male nude are dated 1923.

8 **Standing Figure** 1923
Pencil, chalk and watercolour, $16 \times 8\frac{1}{4}$
$(40.6 \times 20.8)$
Inscribed lower right 'Moore 23' (recent)
*Private collection*
Of this beautiful early drawing Moore said: 'I was beginning to think of sculpture and of a pose which was simple and natural', qualities which characterize many of the life drawings of standing and seated figures. The same model, with her short hair (Eton crop), appears in No.9, and in another drawing in the collection of Mary Moore.

9 **Nude with Clasped Hands** 1923
Pen & ink, wash and chalk, $20\frac{1}{2} \times 7\frac{1}{4}$ ($52 \times 18.4$)
Inscribed lower left 'Moore 23' (recent)
*Art Gallery of Ontario*, Gift of Henry Moore, 1974
The same model as No.8. This drawing was reworked in the early 1970s. With pen and ink, firmer definition was given to the eyes, nose, mouth and hands. Additional shading was added under the chin. Another addition was the pen and ink shading between and beside the feet, giving the figure a ground to stand on.

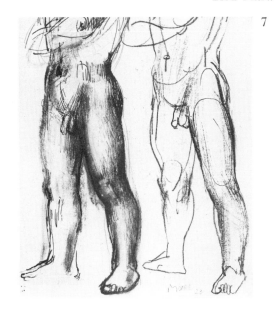

7

The artist said recently: 'If I have a criticism of this drawing, it would be that I haven't got the boniness of the different parts, the knees and the area above the breasts. This is a weakness – there is no contrast between the hardness and softness'.

**10 Standing Nude** *c*.1923
Pen & ink, chalk and wash, $14\frac{5}{16} \times 9\frac{3}{4}$ (36.3 × 24.8)
Inscribed upper left 'Moore'
*Private collection*

As Moore's personal style developed during his student years, the handling in the life drawings became progressively freer and more robust. Here the swirling modelling in chalk has replaced the more controlled meticulous shading of earlier drawings. About this time, the artist said, 'I began to like bulky models, sturdy wide figures rather than thin ones'.

**11 Kneeling Nude** 1923
Pen & ink, charcoal and wash, $12\frac{3}{4} \times 19\frac{13}{16}$
(32.3 × 50.4)
Inscribed lower left 'Moore 23'
*Art Gallery of Ontario*, Gift of Henry Moore, 1974

Although almost all the life drawings from his student years were made in the Painting School at the Royal College of Art, Moore occasionally drew in the modelling classes in the Sculpture School (see No.1). This unusual study was done in the Sculpture School, and the artist himself set the pose. He said recently that Sir William Rothenstein, the Principal of the Royal College of Art, had seen and admired this drawing.

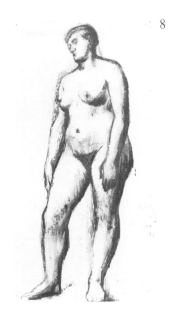

8

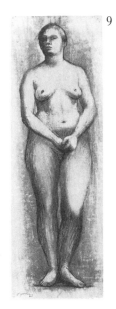

9

**12 Standing Figure** 1923
Pencil, pen & ink and wash, $11\frac{5}{8} \times 6\frac{7}{8}$ (29.5 × 17.5)
Inscribed lower right 'Moore 23' (recent)
*Private collection*

When shown this work, the artist remarked that a drawing is usually begun with the outline of the figure, but that here the reverse procedure was followed. He started, in his own words, 'drawing from the inside out', that is to say beginning within the figure and extending the hatchings and zigzag lines to the point where the outer limits of the figure had been reached. The contours in pen and ink were added later, following the somewhat uneven hatchings, though in certain areas, the outer edge of the left arm and the inner edge of the left leg, pencil hatchings alone define the contours of the limbs. Moore's remark 'Outline should be the outcome of the inside form, the edge of form not the silhouette', recalls Degas' statement: 'Form is not in the contour; it lies within the contour'.[1]

**13 Standing Girl** 1924
Pen & ink, chalk and finger rub, wash with scraping, $19\frac{15}{16} \times 7$ (50.9 × 17.8)
Inscribed lower right 'Moore 24' (recent)
*Henry Moore Foundation*

This unfinished study is of particular interest in showing the way a drawing evolves using several media. The initial outlines are clearly visible, particularly the

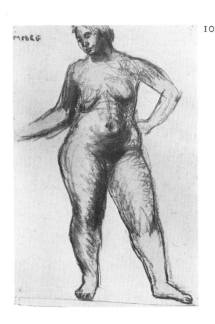

10

11

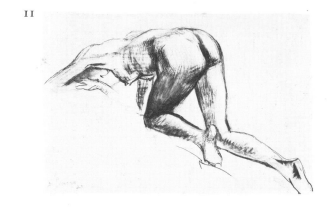

12

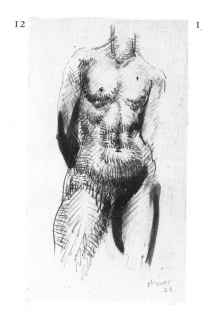

13

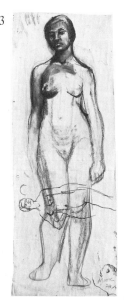

14

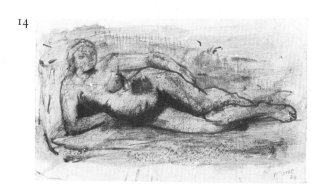

15

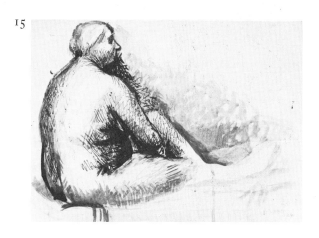

pentimenti above the shoulder and beside the right arm. Once established, the outlines were gone over with a broader, heavier chalk line. Characteristically, pen and ink were used to give sharper definition to facial features, to outline the head and neck, upper torso and breasts, and also to provide greater density in the shaded areas of the head, neck and right breast. A wash, probably rubbed with the finger, has been applied to the head, chest and right arm. The right breast and the area beneath the right eye have been scraped. No doubt the pen and ink and wash would have been used throughout the rest of the figure, had it been completed. With the sheet turned ninety degrees to the right, is a pen and ink study of the same model in a slightly different pose. At lower right (with the sheet turned one hundred and eighty degrees) is a sketch of the left shoulder, breast and arm of the model.

14  **Reclining Nude** 1924
Pencil, wash and gouache, $8\frac{1}{2} \times 15$ (21.6×38.1)
Inscribed lower right 'Moore 24' (recent)
*Trustees of the British Museum*
Like the life drawings of standing and seated figures, the few studies of the reclining figure show the model in relaxed, uncomplicated poses, as in this rare early drawing. The artist remarked that the 'boldness of line on the left leg and hip has something of the freedom of the Paris drawings' (see Nos.31–36).

15  **Seated Woman** 1924
Pen & ink, chalk and wash, $12\frac{13}{16} \times 18$ (32.5×45.7)
Inscribed lower right 'Moore 24' (recent)
*Private collection*
Moore's preference for the bulky, weighty figure type is in evidence both in his life drawings and in his copies of works of art. He made several drawings of the Palaeolithic 'Venus of Grimaldi' (No.69), and some six copies of figures from Rubens' paintings (Figs.112 and 114). In explaining his admiration for the small Cézanne oil 'Trois Baigneuses' of 1873–7 (Fig.69), in his own collection, Moore said: 'Perhaps another reason why I fell for it is that the type of woman he portrays is the same kind as I like. . . . Not young girls but that wide, broad, mature woman. Matronly'.[2] This massive seated figure with the broad expanse of back, is one of a number of drawings of backs, from the mid-1920s (see Nos.16, 22, 23 and 25). One of Moore's earliest and most important tactile sensations was, as a boy, rubbing his mother's back with liniment, to ease the pain of her rheumatism. Years later, Moore said that while working on the large original plaster for 'Seated Woman' of 1957 (L.H.435, Fig.70), '. . . I found that I was unconsciously giving to its back the long-forgotten shape of the one I had so often rubbed as a boy'.[3] This is one of four drawings of the same model (see also No.16), who may well have reminded Moore of the matronly figure of his mother.

16  **Standing Figure: back view** 1924
    Pen & ink, brush and ink with finger rub and
    chalk, 17¾ × 11 (45 × 28)
    Inscribed lower right 'Moore' (recent)
    *Henry Moore Foundation*

The same model as in No.15. The similar rough
modelling in pen and ink suggests that the two draw-
ings may have been executed on the same day.

17  **Standing Figure** 1924
    Pen & ink, chalk and wash, 14⅛ × 9⅜ (35.8 × 23.8)
    Inscribed lower left 'Moore 24' (recent)
    *Private collection*

As in so many of the life drawings, there is nothing sur-
prising or unusual in this straightforward standing
pose. Our interest focuses on the technique and media.
The artist said of this drawing: 'One was learning about
the technique of drawing, concentrating on the round
section of the figure', a reference to the swirling maze of
pen and ink lines, and the curved motion of the brush
strokes. The combination of pen and ink, chalk and
wash creates one of the most dense and heavily worked
of all Moore's life drawings.

18  **Nude Study of a Seated Girl** *c.*1924
    Chalk and watercolour, 16¾ × 13¾ (42.5 × 35)
    Inscribed lower right 'Moore'
    *Whitworth Art Gallery, University of Manchester*

The gentle rounded contours of the model give this
drawing a sensuous quality not often found in Moore's
nude studies. The artist commented that the bobbed
hair of the model was fashionable at the time. The
Renoiresque quality of the drawing is mentioned in the
introduction. Stylistically this drawing is closely
related to another study of the same model, 'Seated
Nude' in the collection of Mrs Tosswill.

19  **Standing Woman** *c.*1924
    Pencil, chalk, brush & ink, 22 × 8 9/16 (55.9 × 21.8)
    Inscribed lower right 'Moore'
    *Private collection*

The artist said of this drawing: 'It reminds me of the
pose of Eve in Masaccio's 'Expulsion' in the Brancacci
Chapel, Florence. She has the same sad, downcast,
weightiness.' During his visit to Florence in 1925,
Moore spent fifteen or twenty minutes every day in the
Brancacci Chapel, studying the Masaccio frescoes.

20  **Life Drawing: Seated Man** *c.*1925
    Pen & ink and chalk, 22 × 16 (55.9 × 40.6)
    Inscribed upper left 'Moore'
    *Private collection*

One of the finest of Moore's drawings of the male
figure, the unmistakable suggestion of dejection is
reminiscent of Rodin's 'Thinker'. The light and shade
modelling in chalk, with pen and ink highlights, is
finely controlled. The back, left arm and leg, flooded
with light from above, contrast with the gradations of
shading in the triangular area formed by the arm, leg
and torso.

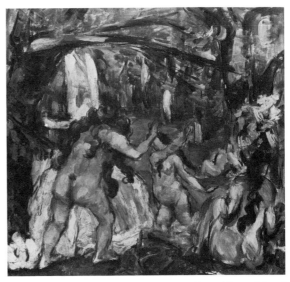

Fig.69  Paul Cézanne, *Les Trois Baigneuses*, 1873–7 (Henry Moore)

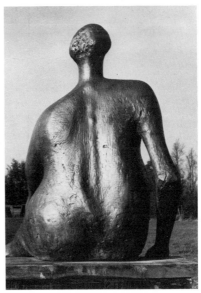

Fig.70  Henry Moore, *Seated Woman*, 1957

16

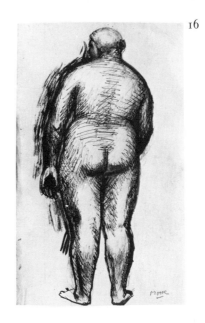

17

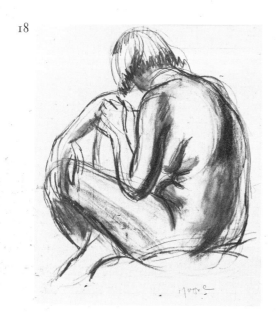

18

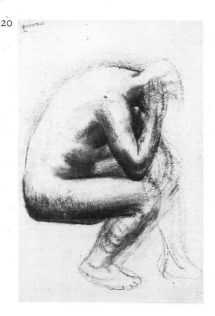

20

**21 Standing Nude** *c.*1925
Pen & ink, chalk and wash, $16\frac{1}{2} \times 7$ (42 × 17.8)
Inscribed lower right 'Moore'
*Art Gallery of Ontario*, Gift of Sam and Ayala
Zacks, 1970

The artist has suggested that this drawing and No.22
may be of the same model, Moore gave this drawing to
his friend Raymond Coxon, with whom he had studied
at the Leeds School of Art and at the Royal College of
Art. It was later bought by Sam and Ayala Zacks of
Toronto, who presented it to the Art Gallery of
Ontario in 1970, as part of their magnificent gift of
19th and 20th century paintings, sculptures and
drawings.

**22 Standing Nude** *c.*1925
Pen & ink, chalk and wash, $22 \times 9\frac{1}{2}$ (56 × 24)
Inscribed upper right 'Moore'
*Tate Gallery*, (5950)

This is probably the same male model found in the
Toronto drawing (No.21). All the known drawings of
the male figure were executed between 1921–5. The
present drawing, and Nos.20 and 21 above, are the last
drawings of the male nude in this exhibition.

**23 Standing Figure** 1926
Pencil, pen & ink, chalk and wash, 17×8
(43.2×20.5)
Inscribed lower right '1926' (probably recent),
above this 'Moore'
*Private collection*

One of Moore's most powerful and monumental studies
of the female figure, this drawing has the bold, aggres-
sive handling found in many of the life drawings. Des-
cribing the sculptor's obsession with form and shape,
Moore has remarked on '. . . the strong, solid fleshiness
of a beech tree trunk'[4], a fitting description of this
massive seated figure. Above the signature with the
sheet turned ninety degrees to the right, is a study of the
back, right arm and breast of the model. Below this,
possibly another study of a breast and torso.

**24 Seated Nude Life Drawing** 1927
Pen & brush & ink, chalk and finger rub,
$16\frac{1}{2} \times 13\frac{3}{8}$ (41.6×34)
Inscribed lower right 'Moore 27'
*Mr and Mrs Gordon Bunshaft*

Of this beautiful unfinished study, Moore said: 'One
began drawing the parts of the figure nearest you and
then drew the rest of the figure.' The left arm, rises up
like a column or flying buttress to support the body.
This strongly modelled arm in the foreground, and the
way in which the legs and torso, faintly outline, recede
into the picture space, anticipate the drawings of the
artist's wife of 1932–5 (Nos.52–55).

**25 Figures with Arms Outstretched** 1927
Pen & ink, chalk and wash, $11\frac{3}{8} \times 17\frac{3}{4}$ (29×45)
Inscribed upper right 'Moore 27'
*M. F. Feheley*

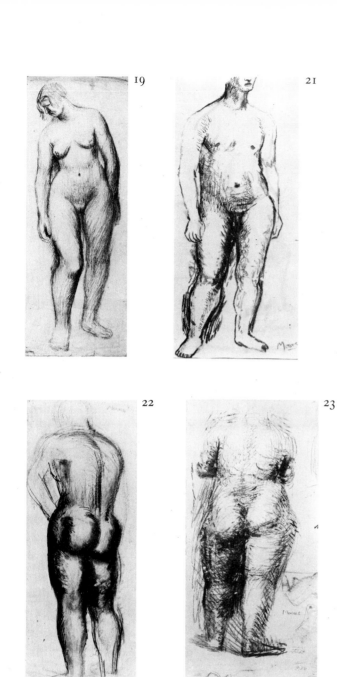

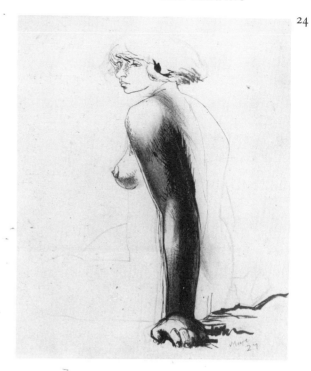

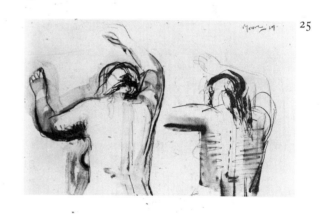

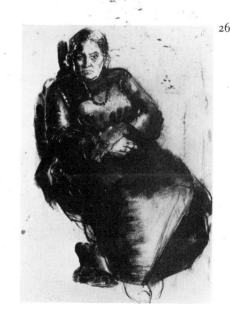

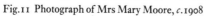
Fig.11 Photograph of Mrs Mary Moore, *c.*1908

27

28

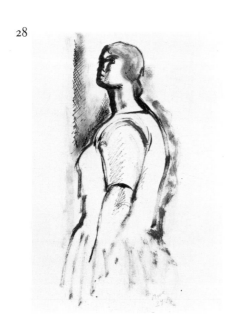

29

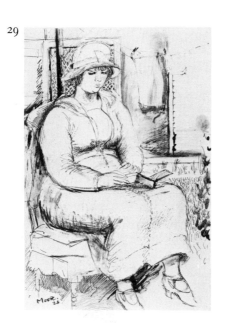

This drawing is one of the earliest surviving Paris drawings. No doubt based on a five minute pose, the figures were first outlined in chalk, with the pen and ink and wash applied subsequently. A detailed discussion of the Paris drawings appears in the introduction, see pp.15–16.

26 **Portrait of the Artist's Mother** 1927
Pencil, pen & ink, finger wash and scraping,
$12\frac{1}{4} \times 7$ (31.1 × 17.8)
Inscribed lower left 'Moore'
*Private collection*

Undoubtedly Moore's most compelling portrait, this is one of six known drawings of the artist's mother, Mrs Mary Moore (née Baker). Born in 1860, she was sixty-seven when she sat for this portrait. A comparison with a photograph taken in 1908 (Fig.11) shows what a remarkable likeness has been achieved. The hands and face are luminous against the intense black of her satin dress, which the artist said 'was particularly difficult to get right'. Looking at us with resolute determination, this probing study is one of the few drawings in which we feel the presence and personality of the sitter (see No.27).

27 **The Artist's Mother** 1927
Pen & ink, wash, and chalk, $10\frac{1}{2} \times 8\frac{3}{8}$ (26.6 × 21.4)
*Henry Moore Foundation*

This is one of four drawings on newspaper (*The Essex County Standard*) of the artist's mother, probably done at the same time as No.26. The drawings almost certainly date from the summer of 1927 (the newspaper used in another study includes an article entitled 'Ninety Years Ago July 14, 1837'). One of the four drawings is in the Art Gallery of Ontario. A stylistically related drawing to those on newspaper appears on p.39 of 'No.6 Notebook'.

28 **Sister of Henry Moore** 1927
Pen & ink and wash, $14\frac{3}{4} \times 10\frac{1}{2}$ (37.5 × 26.7)
Inscribed beneath the dress 'Moore 27'
*M. F. Feheley*

This, one of five known drawings of the artist's sister Mary (see Nos.4 and 29), was probably done about the same time as the drawings of the artist's mother (Nos. 26 and 27), during the summer of 1927.

29 **The Artist's Sister** 1928
Pen & ink and wash, $13\frac{13}{16} \times 9\frac{1}{2}$ (35.2 × 24.2)
Inscribed lower left 'Moore 28'
*Private collection*

The last of the five known studies of the artist's sister Mary, this charming drawing was done in the garden of her bungalow in Colchester. One of the first drawings in which the model is placed in a clearly defined setting, it anticipates the series of drawings of the artist's wife of 1929–35, when she posed in the sitting room of their Hampstead flat. A more delicate, less fully worked pen and ink version of this subject is in the collection of Mary Moore. (See also Nos.4 and 28). The

owner of this drawing has suggested that it dates from 1926.

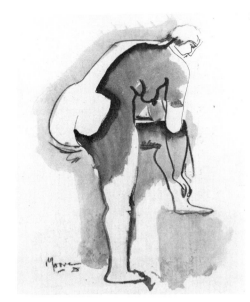

**30  Standing Nude** 1928
Pen & ink, chalk and wash, 14¾ × 12½ (37.5 × 31.7)
Inscribed lower left 'Moore 28'
*Trustees of the British Museum*

Related in style and technique to No.31, this drawing shows dramatic contrast between the part of the back and buttocks which have been left blank, and the areas of wash and chalk. The pen and ink, wash and chalk band which runs down the back and curves around the right buttock may be read as a continuous sectional line. The freely applied wash, both on and around the figure, is reminiscent of Rodin's late wash life studies. A similar drawing, possibly of the same model and done on the same day, was sold at Sotheby's, 20 November 1974, Lot 174.

**31  Standing Woman** 1928
(Vertical Sectional Line)
Pencil, ink, chalk and wash, 20 × 11¾ (50.8 × 29.8)
Inscribed lower right 'Moore 28'
*Private collection*

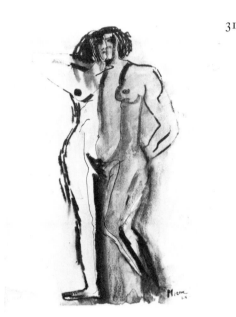

The Paris drawings are discussed in the introduction on pp.15–16.

**32  Seated Nude** 1928
Pen & ink, chalk and wash, 17 × 13½ (43 × 34.2)
Inscribed lower left 'Moore 28'
*M. F. Feheley*

One of the most sculptural of all the Paris drawings, the artist described the model as 'a big hefty one'. A green wash used here, is also found in a number of other life drawings of 1928 (see Nos.37 and 38). In the following two years, green oil was employed in several studies of the artist's wife (No.44).

**33  Seated Woman** 1928
Brush & ink, watercolour and wash,
16½ × 12¼ (42 × 31.1)
Inscribed beside the left foot 'Moore 28'
*Private collection*

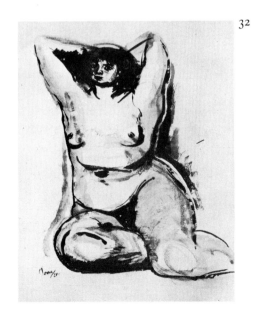

Not all the Paris drawings were of the nude figure. This drawing, which the artist described as 'Matisse-like', is in its broad handling closely related to another Paris drawing of the same model, 'Standing Woman with Handbag', in the collection of Mary Moore.

**34  Standing Female Nude I** 1928
Brush and wash, 17 × 11⅝ (43.2 × 29.5)
*Private collection*

This drawing, and another of the same model and pose (No.35), are characteristic of those Paris drawings executed from a one- or two-minute pose, in which the brush strokes summarize the outline of the figure. They show Moore's ability to observe and record quickly the essence of the model, and as such recall Rodin's late pencil and wash drawings.

33

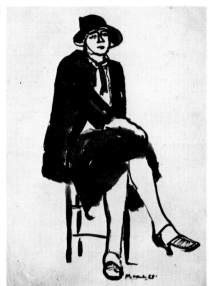

34

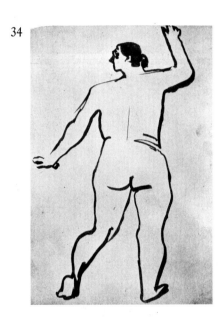

35

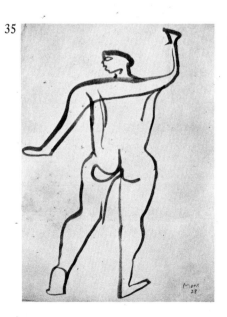

**35 Standing Female Nude II** 1928
Brush and wash, 16$\frac{15}{16}$ × 12$\frac{7}{16}$ (43×31.6)
Inscribed lower right 'Moore 28' (recent)
*Private collection*
A study of the same model and pose as No.34, this drawing exhibits to an even greater degree the speed of execution, with the freely flowing, continuous line across the shoulders, neck and arms, and below it the line across the back, joining the hands of the outstretched arms.

**36 Reclining Nude** 1928
Chalk and wash, 12$\frac{1}{8}$ × 16$\frac{1}{2}$ (30.8×42)
Inscribed lower left 'Moore 28' (recent)
*Art Gallery of Ontario*, Gift of Henry Moore, 1974
This drawing is related both in pose and style to another Paris drawing of the same year, 'Reclining Nude', (Fig.13, see p.16).

**37 Life Drawing: Reclining Nude** 1928
Pen & ink, chalk and wash, 13$\frac{1}{4}$ × 16$\frac{1}{2}$ (33.3×42)
Inscribed lower right 'Moore 28'
*Private collection*
The year 1928 was, the artist said, 'a very good, rich period for the life drawings'. With the experience of nearly ten years of figure drawing, Moore was now producing works of the quality of this rare study of a reclining nude. The modelling in pen and ink, chalk and green wash is under perfect control. One of the most beautiful passages is the left arm and hand. Above the figure, the chalk and wash background is reminiscent of the brush work in Rembrandt's 'Woman Asleep', in the British Museum.

**38 Girl Resting** 1928
Pen & ink, chalk and wash, 15$\frac{1}{4}$ × 19$\frac{1}{2}$ (38.4×49.5)
Inscribed upper right 'Moore 28'
*Ralli Foundation*
In this, one of the most beautiful green wash drawings of the 1920s, the model rests her arm and head on the corner of table. The wash creates broad tonal intervals on the arms and torso, and is handled with great subtlety on the face. Absorbed in her own thoughts, the model's expression is almost one of sadness.

**39 Standing Nude** 1928
Chalk, brush and wash, 22 × 11$\frac{3}{4}$ (55.8×29.3)
Inscribed lower right 'Moore'
*Private collection*
This drawing is discussed in detail in the introduction on p.16.

**40 Drawing from Life: Seated Woman** 1928
Chalk, brush and wash, 21$\frac{1}{4}$ × 13$\frac{3}{8}$ (54×33.5)
Inscribed at lower right 'Moore 28'
*Private collection*
Moore has long considered this study of a seated woman as one of his most successful life drawings. It was reproduced in the first book published on the artist, Herbert Read's *Henry Moore Sculptor*, London, 1934.

After he had completed his course at the Royal College of Art in 1924, Moore and his colleagues often hired a model and drew at home in their studios. He recently recalled that Norman Dawson shared this model. The double image of the head, in profile to the right, with the left side brought round into the picture plane, is a feature one usually associates with the work of Picasso of 1925-7. The artist, however, has suggested that the head of the Virgin in the Michelangelo cartoon 'The Holy Family with Saints', in the British Museum (Fig. 71) was a more likely source. To show how, in the cartoon, the right side of the head has been brought round into the picture plane, Moore covered (in a reproduction) this part of the face, which reveals that the remainder of the head is, in fact, a three-quarter view to the left.

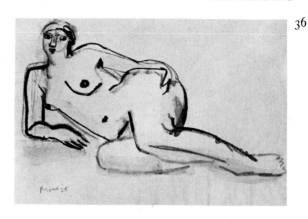

36

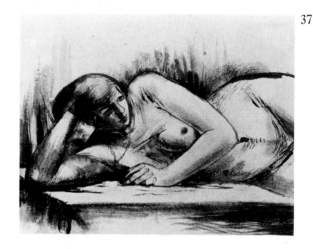

37

**41 Standing Figure** 1928
Pen & ink, chalk and wash, $12\frac{1}{4} \times 13\frac{3}{4}$ (31.1 × 34.9)
Inscribed lower right 'Moore 28'
*Private collection*

This drawing, one of Moore's finest studies of the standing female nude, shows the confidence and assurance of a mature draughtsman. As in many subsequent sculptures the small head serves to emphasize the massiveness of the body. In her proud bearing, the model has something of the nobility which one finds in Moore's best drawings of the female nude. Both in style and technique it is closely related to the 1929 drawing of the artist's wife (No.42).

**42 Seated Female Nude** 1929
Pencil, pen & ink, chalk and wash,
$19\frac{3}{8} \times 12\frac{1}{4}$ (49.2 × 31.1)
Inscribed lower right 'Moore 29'
*Private collection*

In July 1929, Henry Moore married Irina Radetzky, a painting student whom he had met at the Royal College of Art. During the next six years his wife often posed for the life drawings in their Hampstead flat, 11a Park-hill Road. This drawing, one of the earliest studies of the artist's wife, dates from the second half of 1929. It is also one of the first nude studies in which the model is shown in a clearly defined setting, in this case the sitting room of the Moores' flat.

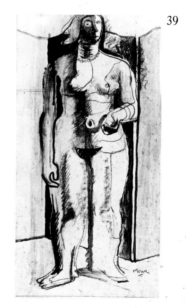

39

**43 Head of a Woman** 1929
Wash and chalk, $15\frac{5}{16} \times 13\frac{5}{16}$ (38.9 × 33.9)
Inscribed lower right 'Moore 29'
*National Gallery of Canada, Ottawa*

The focus of attention is on the head of the sitter whom the artist described as 'a big eyed pretty model – in the eyes I was exaggerating'. The model in this drawing was not the artist's wife.

**44 Seated Female Nude** 1929
Oil on paper, $22\frac{1}{4} \times 15$ (56.5 × 38)
Inscribed lower left 'Moore 29'
*Whitworth Art Gallery, University of Manchester*

Page 60:    Illustration No.42 should be No.44 and <u>vice versa</u>.

40

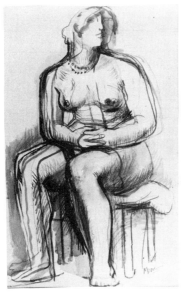

42

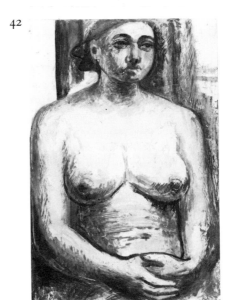

Fig.71 Michelangelo,
*Epifania*, *c.* 1550–53 (detail)
(British Museum)

43

41

44

Pages 60–61:    Illustration No.43 should be No.45 and <u>vice versa</u>.

Only in 1929 and 1930, in a series of some six life studies of the artist's wife, does Moore appear to have experimented with medium of oil, usually thinned with turpentine. The handling has the same boldness and vigour of execution that characterizes the chalk and wash drawings. Here the shading is in green, the lighter areas in white. The face, with its sombre expression, approaches a portrait study, whereas the head in No.48 is more mask-like and impersonal. Beside the right ear, the form of the hair resembles similar features in the 1929 'Mask' (L.H.62, Fig.22, see p.18).

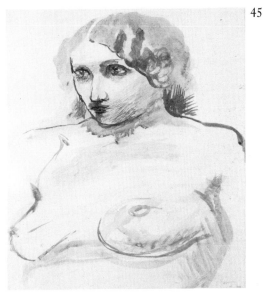

45

**45    Seated Woman with Clasped Hands** *c.*1929
Gouache, 21¾ × 15½ (55.2 × 39.3)
*Auckland City Art Gallery*

Although undated, this study of the artist's wife is so close in style and media to No.49 as to suggest a similar date, late 1929 (or possibly early 1930). Reference has already been made (see introduction p.17) to the mask-like appearance of the face, which may well have been influenced by the cast concrete 'Mask' of 1929 (L.H.62, Fig.22, see also No.49). The hair, however, is closer to the two protuberances in the green stone 'Mask' of 1930 (L.H.77). The medium of oil is handled with great assurance, in this, one of the most sculptural of all Moore's studies of the female nude.

**46    Standing Figure** *c.*1929
Charcoal, wash and oil, 20⅛ × 15⅜ (51 × 39)
Inscribed upper left 'Moore'
*Victoria and Albert Museum*

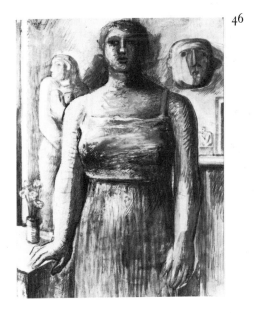

46

The most pictorial of the life drawings, in this study of the artist's wife three sculptures are included in the composition. At left is the stone 'Standing Woman' of 1926, destroyed (L.H.33) and at upper right the cast concrete 'Mask' of 1929 (L.H.62, Fig.22). The influence of the latter is evident in the mask-like faces in Nos.45 and 49. The small figure below the mask has not been identified. This is the only known life drawing which includes works of sculpture.

**47    Seated Woman** 1929
Chalk and wash, 20½ × 11½ (52 × 29.2)
Inscribed lower left 'Moore 29'
*Trustees of the British Museum*

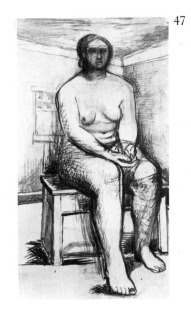

47

In this drawing of the artist's wife, several characteristics emerge which were to become features of the series of drawings of the same model of 1933–5 (Nos.52–55). These are the low view point and the way in which the legs are more heavily worked than the rest of the figure. Here the low view point and exaggerated perspective are very marked, so that the model, of such seemingly enormous proportions in relation to the setting, appears to fill the entire height of the room.

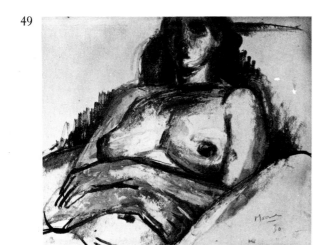

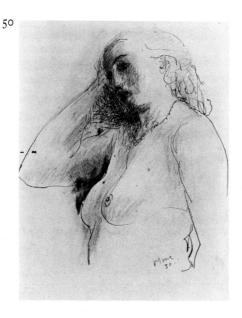

**48  Seated Female Nude** 1930
Pen & ink, charcoal, brush and ink wash,
$16\frac{13}{16} \times 13\frac{3}{8}$ ($43 \times 34$)
Inscribed behind the left foot 'Moore 30'
*Henry Moore Foundation*

In this drawing of the artist's wife, her round face and wide, staring eyes resemble the stone 'Mask' of 1929 (L.H.61), of which Moore wrote: 'In this mask I wanted to give the eyes tremendous penetration and make them stare, because it is the eyes which most easily express human emotion.'[5] Behind the head, the square and rectangular forms emphasize the angular outline of the hair. In fact, this is one of the few instances in which the hair can be accurately described as a 'cubic bun' (see introduction, p.17). These angular forms echoed in the shapes behind the figure, which the artist described as a 'bit of architectural background'. The drawing at upper right anticipates the square form sculptures and drawings of the mid-1930s (Fig.33, see p.25). Note the three sectional lines around the right leg, and the single one around the left leg above the knee.

**49  Woman in Armchair** 1930
Oil on paper, $13\frac{1}{2} \times 16$ ($34.3 \times 40.6$)
Inscribed lower right 'Moore 30'
*Private collection*

The mask-like face, similar to that in the Auckland drawing (No.45), may also reflect the influence of the 1929 'Mask' (Fig.22).

**50  Drawing of the Artist's Wife** 1930
Pencil, pen & ink, $16\frac{1}{2} \times 13\frac{1}{4}$ ($42 \times 33.6$)
Inscribed right on figure 'Moore 30'
*Dr and Mrs Henry M. Roland*

This delicate pencil and pen and ink drawing is in marked contrast to the more characteristic, strongly modelled oil or chalk and wash studies of the artist's wife. Hurriedly sketched in pencil, the outlines of the figure, facial features, hair and necklace, and shaded areas were subsequently gone over in pen and ink. Recently, the artist raised doubts as to whether his wife was in fact the model, although the drawing has long been known by its present title.

**51  Life Drawing: Seated Figure** 1930
Ink, pastel, pencil and charcoal, $14 \times 11$ ($35.5 \times 28$)
Inscribed lower right 'Moore 30'
*Envoy Apartments Ltd, Toronto*

This is one of the few known drawings of the artist's wife in which she is shown seated on the floor. Nevertheless, it prefigures the superb series of drawings which follow (Nos.52–55), in the low view point and in the way in which the legs project forward from the rest of the figure. The feeling of space and depth behind the model is created by the diagonal wall or curtain, a feature which appears in several drawings of 1937, of sculptures in cell-like, windowless rooms.

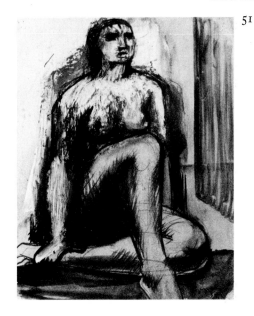

51

**52   Seated Figure** 1933
Pencil, pen and brush and ink and watercolour,
23 × 15½ (58.4 × 39.4)
Inscribed right, below the chair, 'Moore 33'
*Private collection*

The masterful drawings of the artist's wife, made
between 1932 and 1935, mark the culmination of
Moore's development as a draughtsman of the female
nude (Nos.53–55). All but three (see No.53) of some
fourteen known drawings in the series are variations on
a single pose; the model seated in or on the arm of a
chair. Reference has already been made to several
earlier studies of seated figures (Nos.47 and 51) which
foreshadow two of the most striking features of the
present series: the low view point and the way in which
the legs, darker and more heavily worked, project
forward from the body. In the artist's own words: 'I
wanted the legs to come forward from the pelvis – the
closest parts were drawn more strongly.' Although
Moore set the pose, chose the low view point, and he
said, deliberately went in close to exaggerate the
perspective, the extraordinary sense of immediacy has
another rather simple explanation. In the small room in
which his wife posed, Moore said, he was unable to
draw from any great distance, and his model seemed to
loom up in front of him as he worked.

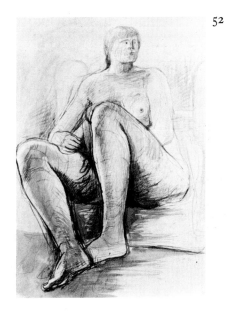

52

The remarkable sense of depth created by the legs
projecting forward, allows one, the artist has suggested,
to read the composition in terms of landscape: the legs
may be read as foreground, the head and torso the
middle distance, and the back of the chair and the
faintly indicated wall as background.

Numerous pentimenti provide a fascinating record
of the changes in the pose. The general outlines were
drawn first in pencil, and one can see an earlier position
of the head in profile to the left, and several different
positions of the right leg and foot. But once the pose
and outlines were established, how assuredly the build-
up of pencil and wash led to the final realization.

The human figure in repose is the subject of Moore's
life drawings, yet here, in a static pose, there is move-
ment within the body: the dramatic thrust of the legs,
(one of the most beautiful passages in all the life draw-
ings), which turn away to our left, and the counter
movement of the head, with its alert watchfulness.

**53   Reclining Nude** *c.*1934
Ink and wash, 10¼ × 18⅜ (26 × 46.6)
Inscribed lower left 'Moore'
*Victoria and Albert Museum*

This is one of three known drawings of the 1932–5
series, showing the artist's wife in a reclining pose. The
position of the legs, particularly the way in which the
left one is suspended above the right, recalls the
numerous studies for the 'North Wind' relief of 1928
(L.H.58, Fig.83) in the 1928 'Sketchbook for the Relief
on the Underground Building', and the larger sheets of
studies for it, one of which is shown here (No.79).

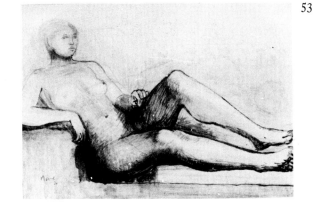

53

54

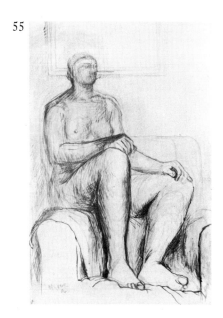

55

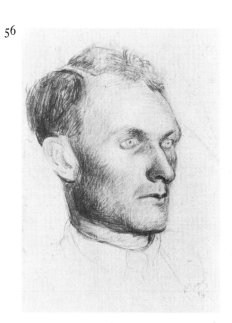

56

**54 Study for a Seated Female Nude** 1935
Pen & ink and wash, $21\frac{5}{8} \times 15$ ($55 \times 38$)
Inscribed bottom left 'Moore/35'
*Leeds City Art Galleries*

Even more pronounced than in No.52 is the contrast between dark pen and ink and wash shading of the legs, and the much fainter, more delicately drawn head, arms and torso. In this drawing, the model sits on the arm of a chair, in a pose which, apart from a variation in the position of the arms, is almost identical to No.55. Behind the legs, the head and torso emerge as if out of a mist.

**55 Seated Figure: Life Drawing** 1934
Pen & ink, pencil and wash, $21\frac{7}{8} \times 15$ ($55.5 \times 38$)
Inscribed lower left 'Moore 34'
*Arts Council of Great Britain*

This drawing of great dignity, and No.54 above, are among the last in the series of studies of the artist's wife. The pose is in fact very close to that in No.54, although the modelling and shading are applied uniformly throughout the figure, without the strong contrast between the legs and the rest of the body.

To describe the character of Moore's late life drawings, his own words about the life-size female figures in the Archaic Greek room in the British Museum, which he had first seen as a student in the early 1920s, could hardly be bettered. He has described them as '... seated in easy, still naturalness, grand and full like Handel's music'....[6]

**56 Portrait of Stephen Spender** 1934
Pencil and chalk, $14\frac{1}{4} \times 10\frac{1}{2}$ ($36.2 \times 26.7$)
Inscribed lower right 'Moore 34' (recent)
*Private collection*

One of four known drawings of the poet Stephen Spender, who had asked Moore to do these portrait studies.

**57 Mother Suckling Child** 1946
Pen & ink, $8 \times 6\frac{1}{4}$ ($20.3 \times 15.8$)
Inscribed lower left 'Moore 46'
*Wendy Baldwin*

It was not until the birth of his daughter Mary in 1946 that Moore again took up figure drawing, the two principal subjects now being the naked baby, and drawings of the mother nursing her child. Of the twenty-two known pen and ink studies of 1946 of the latter subject, this is perhaps the finest and certainly the most fully worked. The hurried outlines and shading give a sense of directness and spontaneity. As the artist said of the series: 'It would have been impossible to do finished drawings, as the poses quickly changed.'

During the previous twenty-five years the mother and child theme had been one of the two most important subjects of Moore's drawings and sculpture. In the drawings for sculpture, the artist has said, it was as if he were conditioned to see this subject emerge from random 'doodles' on the page: '... I could turn every little scribble, blot or smudge into a Mother and Child.'[7]

Now his own family life afforded him the opportunity to draw directly one of the subjects that has dominated his work. In this drawing he has, with great economy, expressed the all-absorbing love of his wife for their child.

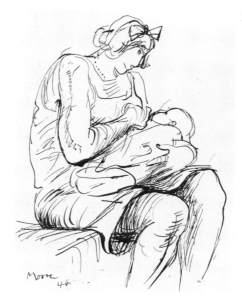

58    **Child Studies (Mary)** 1946
    Pen & ink, $8 \times 6\frac{7}{16}$ (20.4 × 16.3)
    Inscribed lower right 'Moore 46'
    *Henry Moore Foundation*

In these two charming spontaneous studies of the baby after her bath, the child is shown lying on her stomach supported by the mother's arm, and below this lying on her back. Moore has spoken of his fascination with very young babies, '. . . the big head, the frog-like quality of the body, and their kicking vitality'[8], characteristics which are rendered in this delightful little drawing.

59    **Mother Nursing Child** 1946
    Pencil, $14\frac{13}{16} \times 10\frac{7}{8}$ (37.7 × 27.7)
    Inscribed lower right 'Moore 46'
    *Private collection*

This is the largest of nine pencil studies of 1946 of Moore's wife and daughter. The five individual drawings of the head suggest that it held a particular fascination for the artist. A similar drawing is owned by the Arts Council of Great Britain.

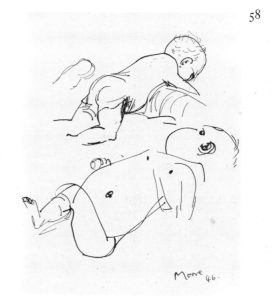

58

60    **Studies of the Artist's Child** 1947
    Pencil, pen & ink, watercolour and wax crayon,
    $11\frac{5}{8} \times 9\frac{1}{2}$ (29.5 × 24)
    *Private collection*

In addition to the pen and ink, and the pencil studies of 1946, there are four known drawings in which several media were used, in this work pencil, pen and ink, wax crayon and watercolour. Mary was also the subject of a number of drawings of the 1950s: two portrait sketches of 1954, and a series of nine studies of 1956 at her desk doing her homework.

61    **Seated Nude** 1954
    Pencil, brush & ink, wash and watercolour,
    $17\frac{7}{8} \times 12\frac{3}{4}$ (45.3 × 32.3)
    Inscribed lower right 'Moore 54'
    *Art Gallery of Ontario*, Gift of Henry Moore, 1974

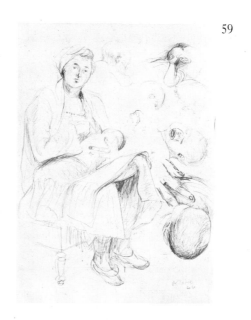

59

No drawings of the female nude are known to have been executed between 1935, the year of the last in the series of the artist's wife, and 1954. During a brief visit to London in 1954, Moore hired a model and made a series of life studies at Swan Court, Hampstead, in the flat of Peter Gregory where he was staying. Like most of the life drawings of the 1920s and 1930s, the poses in the thirteen known drawings are of standing (four) and seated figures (eight). There is only one reclining figure in the series. Originally drawn in pencil, No.61 is one of the six drawings which were reworked in the early 1970s, and transformed from hurried sketches into more fully realized, three-dimensional drawings.

    Moore has recently remarked on the extremely pretty

60

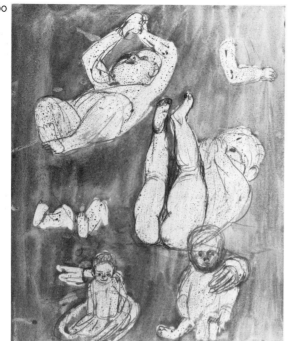

model who posed for these drawings: 'I couldn't ignore this prettiness – I couldn't make these drawings detached.' In No.61, the seated pose, with the raised right leg, is reminiscent of the drawings of the artist's wife of 1932–5 (Nos.52, 54 and 55).

61

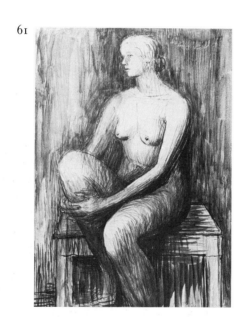

# Copies of Works of Art

62 **Studies of Figures from Cézanne's 'Les Grandes Baigneuses'** c.1922 (Verso)
Pencil, $9\frac{9}{16} \times 6\frac{5}{16}$ (24.3 × 16)
*Henry Moore Foundation*

During a visit to Paris at Whitsun in 1922 Moore and his friend, Raymond Coxon, saw the Pellerin Collection, which included Cézanne's 'Les Grandes Baigneuses' of 1898–1905, now in the Philadelphia Museum of Art (Fig.72). The figure at left in the Moore drawing is of the reclining female nude in the right foreground of the Cézanne. The other two studies are of the two standing figures which appear behind the reclining figure. Moore said recently that this drawing was not done in Paris directly from the painting, but was executed later from a reproduction or photograph.

63 **Page 105 from No.3 Notebook** 1922–4 (Recto)
Pencil, $9 \times 6\frac{3}{4}$ (23 × 17.2)
Inscribed top to bottom down right side of sheet: 'Twisted form / Negro Sculpture / more pointed/ from front / small abstract carving / masses redesigned'; to the left of the largest figure: 'bad drawings / twist in arms / curved arms / badly drawn / light'; above the sketch at lower left: 'angles'
*Henry Moore Foundation*

All the studies of Primitive art and artifacts on this sheet appear to have been made in the Ethnographic rooms of the British Museum. The two large standing figures are copies of the 'Standing Figure of a Woman', Mumuye, Northern Nigeria (Fig.73). The two sketches at centre right are almost certainly of a club with the head in the form of a bird, from New Caledonia, of which there are several examples in the British Museum.

Mr William Fagg has suggested that the drawing at lower right may be of a carving from the Solomon Islands, although the exact source has not been identified. At lower left is a sketch of a woodcarving of a human head from the Baga of French Guinea, in the British Museum. (See 'Copies of Works of Art', note 17).

64 **Page 128 from No.4 Notebook** 1925 (Recto)
Pencil, $8\frac{15}{16} \times 7\frac{1}{8}$ (22.7 × 18)
Inscribed left above and beside the figure 'Single figures' and 'head too small'; beside the figure at right 'this hip lower'
*Henry Moore Foundation*

The female figure at left is a copy of one of the Wise Virgins, second from the right, on the north portal of

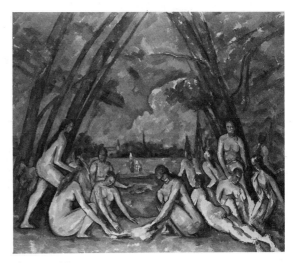

Fig.72 Paul Cézanne,
*Les Grandes Baigneuses*, 1898–1905
(Philadelphia Museum of Art)

63

Fig.73 Standing figure of a woman, Mumuye
(British Museum)

64

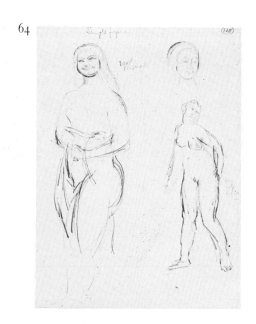

Fig.74 Wise Virgins, north portal of
Magdeburg Cathedral, c.1240–50
(Photo. Courtauld Institute of Art)

65

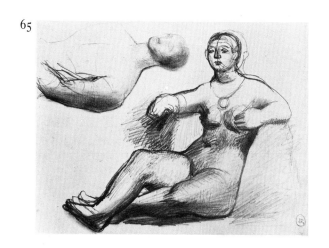

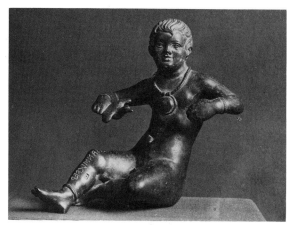

Fig.75 Figure of a young boy, Etruscan, 3rd Century B.C.
(Vatican, Museo Etrusco Gregoriano)

Magdeburg Cathedral (Fig.74). The other studies may also be copies, but the originals have not been identified.

66

**65    Page 15 from No.5 Notebook** *c.*1925  (Recto)
Pencil, faint grey wash, $8\frac{3}{4} \times 6\frac{11}{16}$ (22.2 × 17)
*Henry Moore Foundation*
With the notebook turned ninety degrees to the right is a copy of a third century B.C. Etruscan figure of a young boy (now in the Vatican, Museo Etrusco Gregoriano). This sketch was based on an Alinari photograph which is still in the artist's possession (Fig. 75). With the addition of breasts, the sex of the figure has been changed. The heavy pencil shading beneath the right hand obscures the bird held in that hand. The half-figure of a man at left may also be a copy, though the original has not been identified.

**66    Copies of Figures from 'The Visitation',
      anonymous early 15th century drawing,
      Uffizi, Florence** 1925
Pencil, pen & ink, wash, $13\frac{3}{8} \times 9\frac{5}{8}$ (34 × 24.5)
Inscribed lower left 'Moore' (recent)
*Art Gallery of Ontario*, Gift of Henry Moore, 1974
One of three drawings in this exhibition done in Italy in 1925 on his travelling scholarship (see also Nos.67 and 68). This sheet includes six of the seven figures in the Uffizi drawing (Fig.76). They are in the upper half of the sheet, from left to right: the elderly woman fourth from the left; the woman carrying a basket; the elderly woman third from the left; Mary; a face in profile to the left, probably of the woman standing in the doorway of Elizabeth's house, the aged Elizabeth. The other two large figures are, at left, the aged Elizabeth bending forward and grasping Mary's arm, and just right of centre the young woman standing in the doorway of Elizabeth's house. The two studies of heads in the lower third of the page, which do not appear in the Uffizi drawing, have not been identified. The copies from the Uffizi drawing were almost certainly done from a photograph or book illustration.

Fig.76 Anonymous Florentine,
*The Visitation*, 15th Century
(Uffizi)

**67    The Two Thieves, St. John and Roman
      Soldiers** 1925
Pen & ink, $8\frac{1}{8} \times 9\frac{5}{8}$ (20.7 × 24.5)
Inscribed lower right 'Moore Italy 1925' (recent)
*Art Gallery of Ontario*, Gift of Henry Moore, 1974
This drawing, done in Italy in 1925, was copied from an as yet unidentified drawing or painting of the Crucifixion, probably a northern Italian work from the second half of the 15th century. The faintly indicated figure at centre has not been identified.

**68    Copy of One of the Huntsmen Holding a
      Falcon from 'Les Trois Morts et les Trois
      Vivants', attributed to Jacopo Bellini,
      Louvre, Paris** 1925
Pen & ink, $8\frac{1}{4} \times 5\frac{15}{16}$ (21 × 15.1)
Inscribed lower left 'Moore 25' (recent)
*Private collection*

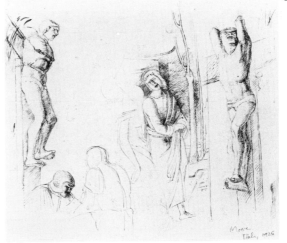

67

68

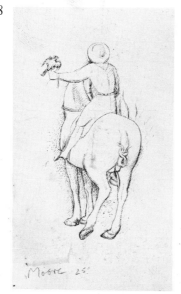

Fig.77 Jacopo Bellini, *Les Trois Morts et Les Trois Vivants* (Louvre)

This very beautiful copy of one of the huntsmen holding a falcon, from the Louvre sketchbook, attributed to Jacopo Bellini (Fig.77), was probably drawn from a photograph of the original.

**69   Page 73 from No.6 Notebook** 1926 (Verso)
Pencil, black chalk at upper right an imprint from p.74 recto, $8\frac{3}{4} \times 6\frac{3}{4}$ (22.2 × 17.2)
Inscribed top 'Figure-wide across'
*Henry Moore Foundation*

The two figure studies on this sheet were based on the Palaeolithic steatite 'Venus of Grimaldi' (Fig.78) which is reproduced, plate 1, in Herbert Kühn's *Die Kunst der Primitiven* (1923). Other drawings of this sculpture appear on pp.74 and 76 of this notebook. For other copies of Prehistoric art taken from illustrations in Kühn, see 'Copies of Works of Art', p.143.

**70   Ideas for Crucifixion Sculpture** 1954
Pencil and wash, $10\frac{11}{16} \times 9\frac{7}{16}$ (27.1 × 24)
Inscribed top 'Do carving of only the essential expression – such as hand'; centre left, above arm 'longer'; lower right 'Moore 54' (probably a recent inscription)
*Henry Moore Foundation*

One of nine drawings based on photographs in the artist's possession of a Styrian sculpture – a wooden Crucifixion of *c*.1515–20 from Dramlje, near Celje, Yugoslavia, now in the National Gallery of Ljubljana (Fig.79). Dr Walter Hussey, who had commissioned the 'Madonna and Child' of 1943–4 (L.H.226) for the Church of Saint Matthew, Northampton, asked Moore several times if he would consider doing a sculpture of the Crucifixion. He did a series of preliminary drawings based on the Styrian sculpture, but the project never went beyond these studies.

**71   Drawing based on Dürer's 'Portrait of Conrad Verkell'** 1974
Pencil, $18\frac{1}{4} \times 12\frac{3}{4}$ (46.3 × 32.3)
Inscribed between head and landscape 'Durer's portrait of Conrad Verkell', and below landscape 'Moore 74'
*Henry Moore Foundation*

This is one of two drawings based on Dürer's 'Portrait of Conrad Verkell', in the British Museum (Fig.80). At centre is a freely drawn study of the Dürer portrait, and below this a landscape study inspired by the rugged topography of Conrad Verkell's face. Copying the face was, Moore said 'almost like drawing a landscape of rolling hills'. In the landscape sketch, he pointed out how the hill at the centre of the sheet corresponds to the nose, the contours to the right of this to the cheek and the hill on the horizon line to the forehead. In addition to the present drawing is a sectional line portrait study based on the Dürer drawing.

69

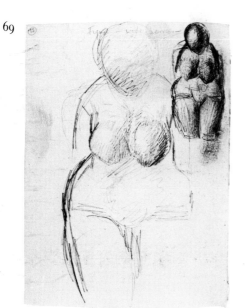

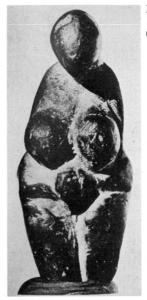

Fig.78 Palaeolithic steatite,
*Venus of Grimaldi*
(Musée de Saint Germain)

70

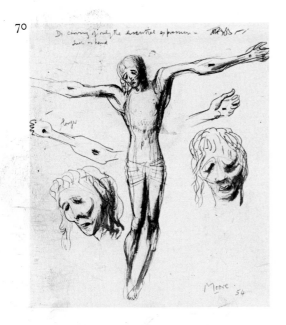

Fig.79 Crucifixion, *c.*1515–20 from Dramlje, near Celje,
Yugoslavia
(National Gallery of Ljubljana)

71

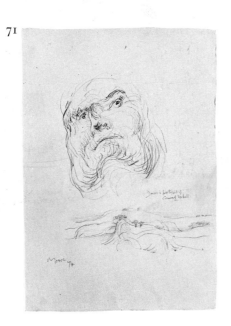

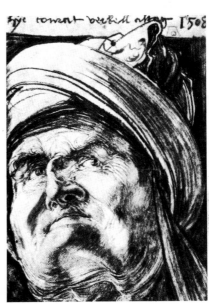

Fig.80 Albrecht Dürer,
*Portrait of Conrad Verkell*
(British Museum)

72

72    **Study from Giovanni Bellini's 'Pietà'** 1975
Pencil, chalk, crayon and watercolour,
$16\frac{1}{4} \times 12\frac{5}{8}$ (41.3×32.1)
Inscribed lower right 'Moore 75'
*Henry Moore Foundation*

The Director of the Pinacoteca Nazionale di Brera,
Milan, the late Franco Russoli, invited a number of
artists to choose a favourite painting from the Brera
and do interpretative studies of it. Moore made four
studies of Giovanni Bellini's 'Pietà' (Fig.81), No.72 and
another similar version. He also made two drawings
from the same painting of the hands of Christ and of
the Virgin Mary. In addition there are two drawings
of 1975 of Bellini's Madonna and Child in a Landscape.

Fig.81  Giovanni Bellini,
*Pietà* 1463–8
(Pinacoteca di Brera)

# Drawings 1921–40

**73  Page 81 from No.2 Notebook** 1921–2
Pencil, pen & ink, $8\frac{13}{16} \times 6\frac{3}{4}$ (22.4 × 17.2)
Inscribed upper right '81/Composition in stone'
*Henry Moore Foundation*

This, the earliest of the six surviving notebooks from
the 1920s, dates from Moore's first year at the Royal
College of Art. The author has catalogued all six, and
identified most of the projects for term work at the
Royal College, studies for sculpture (which include a
number of drawings for carvings which have since been
lost or destroyed), and copies of works of art.[1] Of the
five notebooks of the 1920s shown in this exhibition,
Notebook No.6 of 1926 has been reproduced in
facsimile.[2]

Much of the first half of No.2 Notebook is taken up
with studies for 'monthly comps' as they were called,
projects at the Royal College of Art which included
such subjects as 'Springtime', 'Frieze for the decoration
of an Emporium', 'The History of Merchandise' and
'Sport'. In the second half of the notebook appear a
number of drawings of sculptural ideas, such as the
eight studies on p.81 for the small marble 'Snake' of
1924 (L.H.20, Fig.25). The drawings embody those
characteristics mentioned in the inscription on p.80;
'eternal/grinding and interlacing of forms'. Also on
p.80 is the address of an hotel in Paris, undoubtedly
connected with Moore's first visit: 'Raymond Coxon
and I went to Paris, probably for the first time at Easter
1922'. This was when he saw in the Pellerin Collection
Cézanne's 'Les Grandes Baigneuses' of 1898–1905
(Fig.72), now in the Philadelphia Museum of Art. The
Cézannesque studies on pp.80 and 81 were made soon

73

Fig.25 Henry Moore,
*Snake*, 1924

after he had seen the large composition of bathers. About this time he copied three of the figures from the Cézanne oil (See No.62).

If the date of 1924 given in the Lund Humphries catalogue for the marble 'Snake' is correct, then the carving was made two years after the preparatory studies for it on p.81.

74   **Page 155 from No.3 Notebook**
**Study for 'Manchester Mother and Child'**
1924
Pencil, pen & ink, charcoal, $6\frac{9}{16} \times 6\frac{13}{16}$ (16.6 × 17.3)
Inscribed left of squared study 'poising of weights/ $(2\frac{1}{2})/5 \times 3 \times 3$'
*Art Gallery of Ontario*, Gift of Henry Moore, 1974
This fragment (a strip $1\frac{1}{2}$" high has been cut from the top of the page) from No.3 Notebook of 1922-4 includes the definitive study for the Hornton stone 'Mother and Child' of 1924-5 (L.H.26, Fig.27), City Art Gallery, Manchester. Moore began work on the carving in the autumn of 1924 and left it unfinished when he left for Italy on a travelling scholarship in January 1926. He returned to England in mid-July and completed the sculpture that autumn.

There are six known sheets of studies for the Manchester carving.[3] Probably the first drawing in the series was the pencil sketch on p.154 from No.3 Notebook, showing, as the inscription states, 'man carrying child' (Fig.82). This section of p.154 has recently been destroyed.[4] Other sketchbook studies are to be found on p.141 of No.3 Notebook, pp.23 and 47 of No.4 Notebook. The large 'Mother and Child' drawing (No.75) was based on the sketch at the bottom of p.23 of No.4 Notebook.

How closely did Moore follow a drawing in translating an idea into three dimensions? In the carvings of the 1920s he often hesitated, in his own words, ' . . . to make the material do what I wanted until I began to realize that this was a limitation in sculpture so that often the forms were all buried inside each other and heads were given no necks. As a result you will find that in some of my early work there is no neck simply because I was frightened to weaken the stone'.[5] The limitations imposed by the materials in the carvings were not, of course, present in the drawings. In the definitive sketch for the Manchester carving (No.74), the forms of both figures – the heads, necks and arms – are clearly defined. In other words, the original conception was far less block-like than the forms appeared in the completed carving. This drawing gives some indication of the appearance the sculpture might have taken had Moore felt freer to release the forms from the material. (See also No.75 below.)

75   **Mother and Child** 1924
Black chalk, brush and water, 22 × 15 (55.8 × 38.1)
Inscribed lower right 'Moore' (recent)
*Private collection*
This drawing was based on the sketch at the bottom of p.23 of No.4 Notebook. Here the child, instead of

perching on the shoulder as in No.74, sits astride with both feet wrapped around the mother's neck. Apart from the head, which is turned sharply to the left, the composition is symmetrical. This was probably why Moore rejected these drawings and based the carving on the asymmetrical pose in No.74, a more compelling composition. Moore's preference for asymmetry is discussed in his article for *Unit One*, London 1934.[6] In fact, the earliest known inscription, at the top of the inside front cover of No.2 Notebook of 1921-2 notes: 'Carving with unsymmetrical [sic] design'.

76 **Two Female Nudes** *c*.1923-4
 Pencil, pen & ink, $9\frac{3}{4} \times 13\frac{7}{16}$ (24.8 × 34.1)
 Inscribed lower left 'Moore' (recent)
 *Art Gallery of Ontario*, Gift of Henry Moore, 1974
On pp.28, 30 and 54 of No.3 Notebook are Cézannesque studies of female bathers which the artist has said were done after he had seen the Pellerin Collection. That one of the studies on p.28 was squared for transfer indicates that larger drawings were based on the notebook studies. The present drawing, squared in pencil, was doubtless based on a smaller composition in a notebook.

 The Toronto drawing recalls Picasso's pen and ink studies of bathers of the early 1920s – works such as 'Deux Baigneuses' of 1920 (Zervos IV, 181).

77 **Ideas for Sculpture: Study for Torso** *c*.1925
 Pencil, pen & ink, brush & ink, $9\frac{3}{16} \times 11\frac{9}{16}$
 (23.3 × 29.4)
 Inscribed lower right 'Moore' (recent)
 *Art Gallery of Ontario*, Gift of Henry Moore, 1974
Moore has identified the sketch at upper left as the drawing for the cast concrete 'Torso' ? 1926 (L.H.37). In this study the angular rhythms of the figure, the flat plane beneath the right hand, and the diagonal placing of the breasts suggest the influence of Cubist sculpture, particularly the work of Lipschitz. There are three sheets which are stylistically closely related to the Toronto drawing: 'Six Studies for Sculpture', dated 1925, in the British Museum; 'Ideas for Sculpture' of *c*.1925, Henry Moore Foundation; and 'Studies' of *c*.1925, in a private collection.

78 **Drawing for Sculpture: Studies for Reclining Figure with a Child** 1928
 Pen & ink, with finger rub, $13 \times 16\frac{3}{4}$ (33 × 42.5)
 Inscribed centre right 'Moore 28'; right of study lower left 'Drawing for Sculpture'
 *Henry Moore Foundation*
This is one of seven known drawings of 1928-9 of the reclining mother and child theme. Some of these, like the present drawing, consist of a large central image, surrounded by much smaller related studies of the same subject. Large drawings were based on the sketch at lower left and on the two above the central study. No sculptures were done at the time of the reclining mother and child. In two drawings of 1933, Nos.94 and 96, the composition of each is organized in a

Fig.82 Henry Moore,
*Page 154 from No.3 Notebook*, 1922-4

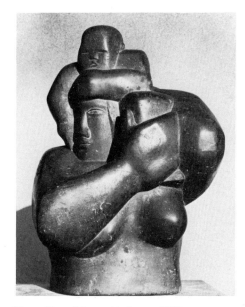

Fig.27 Henry Moore, *Mother and Child*, 1924-5
(Manchester City Art Galleries)

75

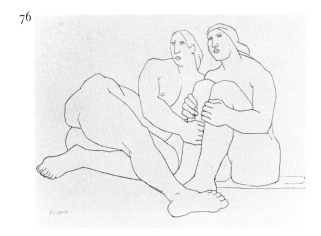

76

77

similar manner: a large central image surrounded by smaller, thematically related subjects.

**79    Ideas for North Wind Sculpture** 1928
Pen & ink, brush & ink, and watercolour,
$14\frac{3}{8} \times 8\frac{7}{8}$ (36.5 × 22.5)
*Art Gallery of Ontario*, Gift of Henry Moore, 1974
In 1928 the architect Charles Holden commissioned seven sculptors to carve architectural decorations for his new building, the headquarters of London Transport at St. James's Park Station. Epstein did two large groups entitled 'Day' and 'Night'. Henry Moore, Eric Gill, A. Wyon, A. Aumonier, A. E. Gerrard and F. Rabinovitch were asked to do eight reliefs of horizontal figures representing the four winds, for the central tower of the building. Gill carved three of them; the other five sculptors each did one.

Moore was somewhat reluctant to accept his first public commission. Relief sculpture was the antithesis of the full spatial richness he was striving for in his own work. But Holden was very persuasive, and Moore began a series of preparatory drawings in the 1928 'Sketchbook for the Relief on the Underground Building'.[7] In the first fifteen pages of this sketchbook, the static poses, and simplified naturalism of the figures are reminiscent of some of the life drawings of the period (Fig.19), and of the cast concrete 'Reclining Woman' of 1927 (L.H.43, Fig.18). These studies were superseded by drawings showing the reclining figure in motion, in keeping with the subject of the commission, a relief personifying the 'North Wind' (L.H.58, Fig.83).

None of the many studies of reclining figures in the sketchbook was used as the definitive drawing for the Portland stone carving. In addition to the sketchbook (owned by the Henry Moore Foundation), three large drawings and two smaller sheets of studies are known: the present drawing (No.79), one in the collection of the Arts Council of Great Britain, and another belonging to the Henry Moore Foundation. The Toronto drawing includes the study at lower left in which the definitive pose for the relief is established.

The numerous sketchbook studies for 'North Wind', as well as the larger drawings, which comprise in all well over one hundred sketches of reclining figures, mark the beginning of Moore's total obsession with this motif. He had made, it is true, a number of drawings of reclining figures in Notebooks 2–6, as well as five earlier sculptures of this theme (L.H.24, 30, 31, 38 and 43). But with the profusion of studies for 'North Wind', the subject seems to have taken hold. Moore has explained the importance of the reclining figure as a dominant theme in his work:

The vital thing for an artist is to have a subject that allows [him] to try out all kinds of formal ideas – things that he doesn't yet know about for certain but wants to experiment with, as Cézanne did in his 'Bathers' series. In my case the reclining figure provides chances of that sort. The subject-matter is *given*. It's settled for you, and you know it and like it, so that within it, within the subject that you've

done a dozen times before, you are free to invent a completely new form idea.[8]

By March 1929, when he began work on the Leeds 'Reclining Figure' (L.H.59, Fig.21), it is evident that Moore had found his subject: 'The subject-matter is given'. (See No.122, a drawing for another project commissioned by Charles Holden.)

### 80 Study for Leeds Reclining Figure 1928

Pencil (cut out and mounted), $4\frac{3}{4} \times 7\frac{1}{8}$ (12.1 × 18.1)
Inscribed lower left on sheet on which figure is mounted 'Moore 28' (recent)
*Art Gallery of Ontario*, Gift of Henry Moore, 1974

This would appear to be the definitive drawing for the brown Hornton stone 'Reclining Figure' of 1929 (L.H. 59), in the Leeds City Art Gallery (Fig.21). This carving was the first sculpture to reflect the 'Chacmool' reclining figure (Fig.28), which Moore has described as 'undoubtedly the one sculpture which most influenced my early work'. A detailed discussion of the evolution of both the Leeds 'Reclining Figure' and the Ottawa 'Reclining Woman' of 1930 (L.H.84), and the influence of the 'Chacmool', will appear in the author's forthcoming article for the National Gallery of Canada Bulletin. An abbreviated version is given here.

The accounts of when Moore first became aware of the 'Chacmool' reclining figure vary considerably. Herbert Read dates his initial contact with the Mexican sculpture to a visit to Paris in 1925[9] when Moore saw a plaster cast of the work in the Musée du Trocadéro (now the Musée de l'Homme). The process of assimilation was, Read has suggested, a gradual one, and '... it was four years before the 'shock of recognition' that had been experienced in the Trocadéro found complete expression in the 'Reclining Figure' of 1929'[10] (Fig.21).

David Sylvester has noted that Moore remembers seeing an illustration of the 'Chacmool' in Walter Lehmann's *Altmexikanische Kunstgeschichte* (1922) in Zwemmer's bookshop, probably around 1927: 'He looked at the plaster cast of the same statue in the Musée du Trocadéro in Paris only after completing the 1929 carving'.[11]

Both these accounts have overlooked the invaluable evidence of the notebooks of the 1920s. The two small studies of a reclining figure at the bottom of p.93 of No.2 Notebook of 1921-2 (Fig.84) are quite clearly related to the pose of the 'Chacmool'. When shown the sketch, the artist remarked: 'Here is the first bit of influence of the Mexican reclining figure. I might have seen a plaster cast of it in the Musée de l'Homme.' In the notes for No.73, p.81 of the same notebook, mention was made of the name and address of a Paris hotel which appear on p.80, and of the Cézannesque studies on pp.80 and 81, made soon after Moore had seen 'Les Grandes Baigneuses' in the Pellerin Collection (Fig. 72), on his first visit to Paris in 1922. Likewise the two sketches of a reclining figure on p.93 (Fig.84) were almost certainly done from memory at about the same time. Another, though less likely possibility, is that the

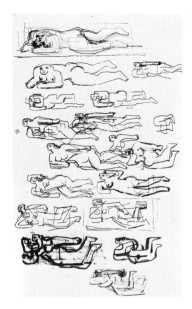

79

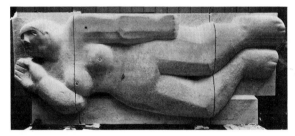

Fig.83 Henry Moore, *North Wind*, 1928

80

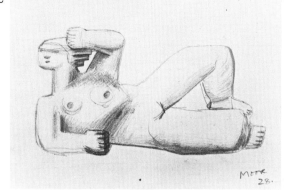

Fig.84 Henry Moore,
*Page 93 from No.2 Notebook*, 1921-2 (detail)

Page 78:    Fig.84 should be reversed.

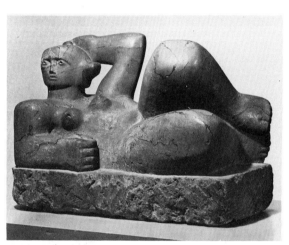

Fig.21 Henry Moore,
*Reclining Figure*, 1929
(Leeds City Art Galleries)

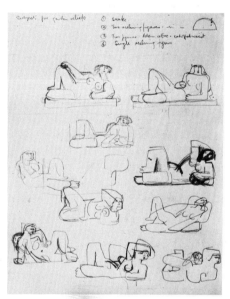

Fig.85 Henry Moore,
*Page 58 from Sketchbook for the Relief
on the Underground Building*, 1928

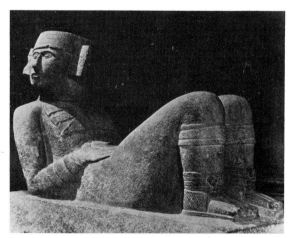

Fig.28 'Chacmool', Toltec-Maya, 11th-12th century A.D.
(Museo Nacional de Antropología, Mexico)

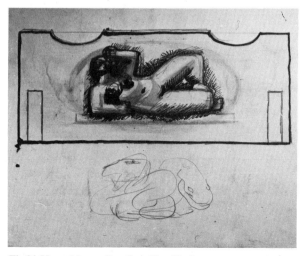

Fig.86 Henry Moore, *Page from Sketchbook
for the Relief on the Underground Building*, 1928

[78]

two drawings on p.93 were executed after Moore had seen the illustration of the Mexican carving in Lehmann's book, which was published in 1922. Whatever the source had been, the plaster cast in Paris, or the illustration in Lehmann, it is now possible to date Moore's initial contact with the 'Chacmool' to 1922, although as Read has pointed out the 'shock of recognition' did not occur until the Leeds 'Reclining Figure' of 1929, or, more accurately, until the series of preparatory drawings for it of 1928.

It is impossible to understand the genesis of the Leeds carving without first analysing the drawings for a relief for the back of a garden bench[12] which appear towards the end of the 1928 'Sketchbook for the Relief on the Underground Building'. It was from these studies that the Leeds sculpture ultimately developed. On p.58 (Fig.85) are ten studies of reclining figures, the fourth subject for garden reliefs (see inscription 'single reclining figure'). These are among the most important drawings for sculpture from the first decade of Moore's career. Although the drawings were made as preparatory studies for the garden bench relief, they are of great significance not only because they anticipate the Leeds carving, but also because they mark the sudden re-emergence of the 'Chacmool' reclining figure. (The influence of the Mexican sculpture is apparent in a number of studies in Notebooks 3 and 5 of 1922–5 and 1925–6 respectively[13], but these are isolated examples.) The drawings on p.58 (Fig.85) are in a sense a continuation of the numerous studies in the sketchbook for the 'North Wind' relief. The major change is in the position of the arms and legs. In the study at centre right, the figure reclines on her left side with the left leg bent at the knee. The right leg is raised up, with the foot resting on the left leg. The right arm is also raised and bent at the elbow, with the hand resting on the back of the head. This establishes the basic pose of the Leeds 'Reclining Figure'. It was surely Moore's re-awakened interest in the 'Chacmool' that accounts for the angular, more geometric approach in most of the ten studies on p.58. Also, the way in which the head is turned at right angles to the body is directly related to the Mexican carving. But it was from the reclining figure on another page from the same notebook (Fig.86), shown on the back of a garden bench, that the Toronto drawing (No.80) evolved.

The basic differences between the 'Chacmool' and the Leeds 'Reclining Figure' are immediately apparent. The Mexican sculpture represents a male figure (a rain spirit of the Toltec-Maya culture); the Leeds figure is female. In contrast to the almost symmetrical pose of the 'Chacmool', with the weight of the body resting on the elbows, buttocks and feet, Moore has turned the body on its side, leaving the left side clear of the ground, so that the weight is supported by the right elbow and lower arm, and by the whole right side of the body. This pose leaves the left leg and arm free to assume a number of possible positions. But the head, turned sharply at right angles to the body was a feature borrowed directly from the 'Chacmool'. When asked

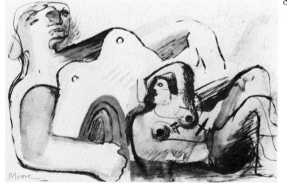

81

82

why the Mexican figure had made such a tremendous impact on him, Moore replied: 'Its stillness and alertness, a sense of readiness – and the whole presence of it, and the legs coming down like columns.'

In the Leeds 'Reclining Figure' the full impact of the 'Chacmool' had crystallized to declare new, far-reaching possibilities of great weight and originality. The sculpture is certainly Moore's most important carving of the 1920s, and as the progenitor of many subsequent reclining figures, it must be regarded as one of the seminal works of his formative years.

**81 Two Recumbent Nudes** 1928
Charcoal, wash and collage, $9 \times 14$ ($22.8 \times 35.5$)
*Dr and Mrs Henry M. Roland*
This, the earliest known collage, is one of three from the late 1920s and early 1930s included in this exhibition (see Nos.84 and 86). The smaller of the two studies was probably one of the preparatory drawings for the Leeds 'Reclining Figure' of 1929. The larger drawing, on the other hand, is connected in a general way to the Ottawa 'Reclining Woman' of 1930 (L.H.84), for which no definitive study has been found. The head, which is less mask-like in appearance than that of the Leeds carving, is stylistically related to the double image of the head in one of Moore's finest nude studies of the late 1920s, 'Drawing from Life: Seated Woman' of 1928 (No.40). Two other collages of reclining figures of 1928 are known one of which is signed and dated 'Moore 28'.

**82 Ideas for Sculpture: Masks** *c.*1929
Pencil with two crayon marks lower left,
$5\frac{1}{4} \times 5\frac{1}{2}$ ($13.3 \times 14$)
*Art Gallery of Ontario*, Gift of Henry Moore, 1974
In volume one of the Lund Humphries catalogue of Moore's sculpture, eight masks are listed for the years 1928–9. For the previous seven years only four masks are catalogued. Moore's interest in the subject in the late 1920s may well have been stimulated by a book he acquired in 1928, *L'Art Précolombien* by Adolphe Basler and Ernest Brummer (Paris, 1928)[14], which includes numerous illustrations of masks. As well as the eight masks Moore executed in 1928–9, the heads in several carvings of the period, for example the Leeds and Ottawa reclining figures, and in some of the life drawings of 1929–30 (Nos.45 and 49) have mask-like features.

In addition to the Toronto drawing, two other studies are known: 'Drawing for Mask Carving' of 1929 in the collection of Mary Moore, and 'Studies of Heads' of 1929, Staatsgalerie, Stuttgart.

**83 Seated Figure** 1929 (1928?)
Pencil, chalk and wash, $16\frac{15}{16} \times 11\frac{11}{16}$ ($43 \times 29.8$)
Inscribed lower left 'Moore 29' (recent)
*Art Gallery of Ontario*, Gift of Henry Moore, 1974
In contrast with drawings such as the disquieting 'Study for Sculpture' of 1926 (Fig.87) and those sculptural ideas nourished by archaic and primitive art,

83

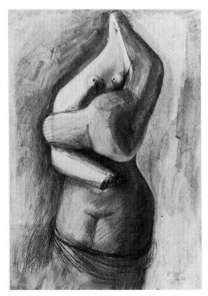

Fig.87 Henry Moore,
*Study for Sculpture*, 1926
(British Museum)

Moore made in the 1920s a number of drawings and modelled sculptures (L.H.29, 40, 43, 50) which were closely related to the naturalism of his figure studies of the period. The Toronto drawing, one of the finest examples of Moore's classical style, has obvious affinities to Picasso's heavy limbed, monumental figure studies of 1920-1, such as the 1921 oil 'Nu assis et Draperie' (Zervos IV, 329). Moore himself has stated that he was familiar with Picasso's 'Pompeiian' nudes.

No.83 would appear to be related both in style and pose to the 1928 terracotta 'Study for Wall-Light' (L.H.50) and if so may date from 1928. The drawing has only recently been signed and dated 'Moore 29'. The same figure type appears in 'Figure on Steps' of 1930 (No.87).

84 **Mother and Child Studies** *c.*1929
   Pen & ink, brush & ink, chalk, wash and
   watercolour, $18\frac{5}{8} \times 14\frac{1}{8}$ (47.3 × 36.2)
   Inscribed lower right 'Moore'; and bottom centre
   'To Joseph from Henry/Montage by Irena' (an
   alternative spelling of Irina).
   *Art Gallery of Ontario*, Purchase 1976

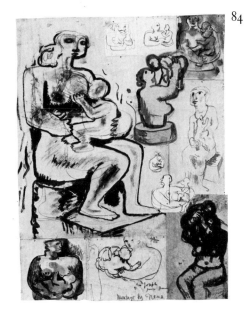
84

This was the first and only collage of mother and child studies, and indeed the first collage which was assembled by the artist's wife Irina (spelt Irena in the inscription in her hand at the bottom of the sheet). She cut from Moore's notebooks all but the largest of the small mother and child studies shown here, and arranged them in their present order, before pasting them down on board. The big seated mother and child, which is much larger than the dimensions of any of the known notebooks of the 1920s, is related to but not the definitive study for the green Hornton stone 'Mother and Child' of 1932 (L.H.121). The sketch at lower left is the study for the small verde di prato 'Mother and Child' of 1929 (L.H.75). Of the three sketches at the top of the drawing, the central pen and ink study is for the Ancaster stone 'Mother and Child' of 1930 (L.H.82). Not all the studies in the Toronto drawing were done at the same time. For example, the two studies of the mother holding the child above her head are stylistically related to a number of drawings of 1925-6, whereas the studies for L.H.75 and 82 date from 1929-30.

Four other collages assembled by Irina Moore are known: No.86 of *c.*1930; 'Montage of Reclining Figures and Ideas for Sculpture' of 1932, private collection; 'Montage of Reclining Figures' of 1933, L.H. Volume I, p.187, in a private collection in Australia, and not as stated, in the National Gallery of Victoria, Melbourne; and 'Montage of Ideas for Sculpture' of 1933, private collection'.

85 **Drawing for Figure in Concrete** 1929
   Chalk, 12 × 9 (30.5 × 22.8)
   Inscribed lower right 'Moore 29' (recent)
   *Arts Council of Great Britain*

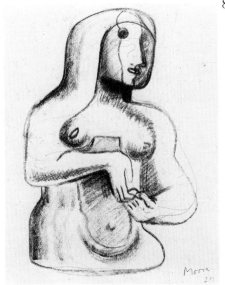
85

This would appear to be the definitive study for the cast concrete 'Half-Figure' of 1929 (L.H.67). Only two

87
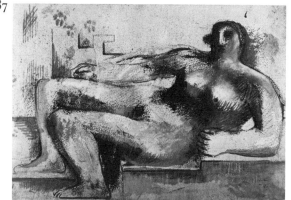

casts of this work were made, and are owned by the British Council and Sir Philip Hendy. In the drawing the fingers of both hands are just touching, whereas in the sculpture the palms of the hands lie flat against each other. 'Half-Figure' is of particular interest as a transitional work in which Moore begins to cut deeply into the figure, hollowing out the central portion of the body from between the breasts to below the navel. This was in fact anticipated two years earlier in 'Standing Nude' of 1927 (Fig.12) in which the artist had, in his own words, 'begun to experiment sculpturally with the hole'.

### 86 Studies for Sculpture: Reclining Figures

*c*.1930

Collage, $16\frac{1}{2} \times 22\frac{1}{4}$ (41.9 × 56.5)

*National Gallery of Victoria*, Felton Bequest, 1948

Like the 'Mother and Child Studies' of *c*.1929, this collage was assembled by Irina Moore (see notes for No.84 above). The artist has recently suggested a date of *c*.1930 for the Melbourne collage, but pointed out that the studies his wife cut from the notebooks may not have been done in the same year. Indeed, the group of five small reclining women beneath the large figure are closely related to the alabaster 'Reclining Figure' of 1929 (L.H.71), whereas the fragment of a reclining figure to the immediate left of this group may have been a study for the Ottawa 'Reclining Woman' of 1930 (L.H.84).

86
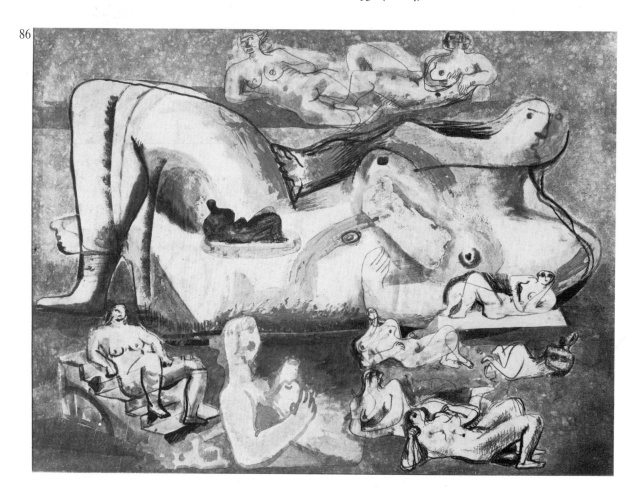

There are three other known studies of the period related to the figure on the steps at lower left: No.87 below; 'Seated Nude on Steps' of 1930, in the British Museum; and 'Ideas for Sculpture' of *c*.1930 (inscribed 'figure seated on steps') in a private collection.

**87    Figures on Steps** 1930
Chalk, wash and body colour, 15×22 (38.1×55.9)
Inscribed lower right 'Moore 30'
*Private collection*

Like 'Seated Figure' of 1929 (No.83), this drawing reflects the continued influence of Picasso's neo-classical paintings of 1920–1. Whereas the heavy limbs and general proportions of the body have a kinship with Picasso, the reclining pose is very much Moore's own. The geometrical background above the right leg is a feature which appears in a life drawing of 1930 'Seated Female Nude' No.48.

This is the only known drawing of the period of a reclining figure on steps. For studies of seated figure on steps, see notes for No.86 above.

**88    Page from No.1 Drawing Book** 1930
Pencil, $6\frac{3}{8} \times 7\frac{15}{16}$ (16.2×20.2)
Inscribed lower left 'Moore 30' (recent)
*Henry Moore Foundation*

The drawing at right is the definitive study for the enigmatic blue Hornton stone 'Composition' of 1931 (L.H.99, Fig.29), one of the seminal works of Moore's career. All his previous sculptures were given straightforward titles – mother and child, head, torso, reclining figure – and the subject of each is readily identifiable. The 1931 carving is the first of many works of the 1930s in which Moore is unwilling to give anything away in the title. This sculpture and the series of preparatory drawings mark a sudden and radical new departure which allies Moore's work to the form-language of Surrealism, to the biomorphic abstractions current in the work of Arp, Miró, Tanguy, and above all, Picasso.

Most writers on Moore have remarked on the similarities between the 1931 'Composition' (Fig.29) and Picasso's sculpture 'Metamorphosis' of 1928 (Fig.30) which was reproduced in *Cahiers d'Art* in 1928.[15] The similarities between the two works are certainly striking, particularly the small heads with incised circles, and the holes beneath. But Moore was no doubt also familiar with Picasso's drawings done in the summer of 1927 (see Zervos VII, 94). In other words, it is probably a mistake to suggest a single work by Picasso as the direct source for the 1931 'Composition'. The fascinating series of preparatory drawings for the carving, one of which is shown here No.88, illustrates the way in which the carving develops from the suckling child motif.

The definitive sketch at right in No.88 is an amalgamation of the forms and motifs which were explored in the other drawings on this sheet and in the other four notebook pages of related studies. Of the four sketches to the left of the definitive study, three are of

88

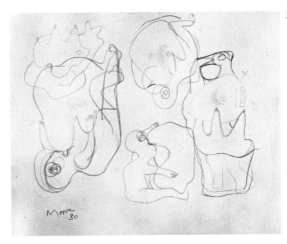

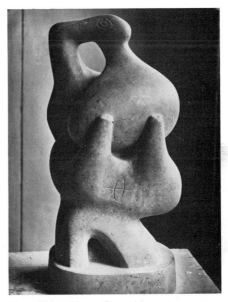

Fig.29 Henry Moore, *Composition*, 1931

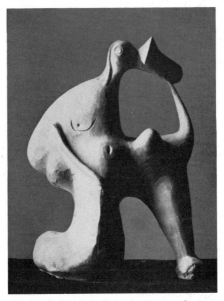

Fig.30 Pablo Picasso, *Metamorphosis*, 1928
© S.P.A.D.E.M. Paris, 1977

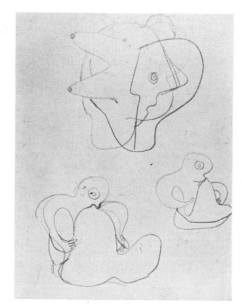

Fig.31 Henry Moore,
*Page from No.1 Drawing Book*, 1930-1

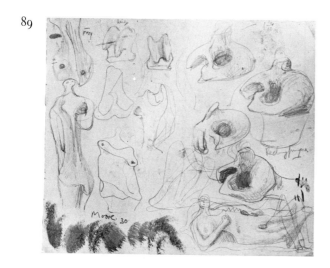
89

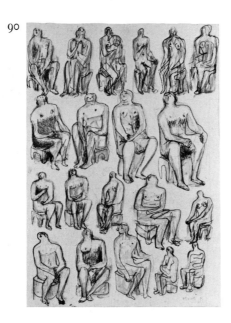
90

a suckling child clinging to the breasts of the mother. A carving of 1930, 'Suckling Child' (L.H.96), may well have been based on one of these drawings in which the mother is reduced to full rounded breasts forms. The study at upper left shows the upward pointed breasts forms, a motif explored in the other four related sheets. The study for 'Composition' is a composite of three parts. The bottom section, which functions as a base or support, resembles truncated legs, a feature more pronounced in the carving than in the drawing. Above this, the torso with pointed breasts was based on the drawing at upper left and studies in the four related drawings. This central section, which supports the upper portion of the figure, is composed of a large egg-shaped form surmounted by a small head and the suggestion of a curved arm. Here, although the literal identity of the suckling child motif has been lost, having been radically altered and abstracted, the breast forms and the oval form which lock into the middle section of the carving can, nevertheless, be read as a transformation of the original motif. The hole near the top is related to the space between the child's arm and the breast in one of the other studies (Fig.31). The large oval shape below may be read as either the head of the child, greatly enlarged and buried in the breasts, or a kind of egg form. The head above the hole, with the circle at centre, may also derive from the child's head in the related drawings.

The preparatory drawings demonstrate the way the carving evolved from identifiable motifs, leaving us with an evocative and somewhat baffling image.

89 **Transformation Drawing: Ideas for Sculpture** 1930
Pencil, wash beneath signature, $7\frac{7}{8} \times 9\frac{3}{8}$ (19.7 × 23.8)
Inscribed lower left 'Moore 30'; upper left, with page inverted 'head'; beside this 'hair'; upper right '1 [?] $1\frac{1}{4}$/10'; centre right 'Reclining figures'
*Art Gallery of Ontario*, Gift of Henry Moore, 1974
This is the earliest known transformation drawing of natural forms (see introduction p.24). At upper left with the sheet inverted, the sketch of a bone has suggested a head. Below this Moore has transformed the bone form into a standing figure. It is interesting to follow the original outlines of the natural forms, and work out the additions – in this example the head, left arm, and the bottom portion of the figure. The reclining figure at bottom right appears to have evolved from a jaw bone. The four studies above this are studies for the Cumberland alabaster 'Composition' of 1931 (L.H.102). For other transformation drawings and studies of natural forms in this exhibition see Nos.92 and 93.

90 **Seated Figures** 1931
Pen & ink, chalk and wash, $14\frac{3}{4} \times 10\frac{3}{4}$ (37.5 × 27.3)
Inscribed lower right 'Moore 31'
*Private collection*

On p.22 of the introduction, the artist describes how he would sometimes begin a drawing with a definite idea in mind, such as a seated figure, which would lead to variations of the same theme. The present drawing, with twenty-two seated figures, is a good example of this approach to generating ideas for sculpture. These studies are related to the Anhydrite stone 'Seated Figure' of 1931 (L.H.110), though none was the definitive study for it. Two pendants to this drawing are known: one is in the collection of Irina Moore; the other is reproduced in L.H. Volume I, p.184.

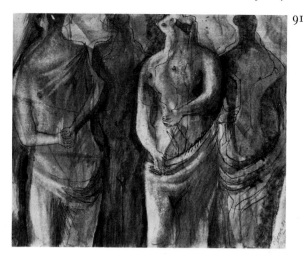

91

91 **Draped Standing Studies** 1931
Pen & ink, chalk and wash, $16\frac{1}{2} \times 18\frac{1}{2}$ (42 × 47)
Inscribed lower right 'Moore 31'
*Campion Hall, Oxford*

It is sometimes assumed that drapery did not appear in Moore's work until the shelter drawings of 1940–1. It is, however, in evidence in a number of drawings and in at least two sculptures of the 1930s; the alabaster 'Seated Figure' of 1930 (L.H.92) in the Art Gallery of Ontario, and the lead 'Reclining Figure' of 1939 (L.H. 203). The present drawing is one of the earliest examples in which drapery was used, granted in a very minor way. Similarly drapery appears in a drawing of 1938 'Projects for Reliefs for Senate House, University of London' (No.122), in the seated figure at lower right. However, it was of little importance until the series of drawings of draped seated women of 1940 (No.135), which prefigure the style of the shelter drawings.

92

92 **Page from Sketchbook: Studies of Lobster Claw** 1932
Pencil, pen & ink, $10\frac{7}{8} \times 7\frac{3}{16}$ (27.6 × 18.3)
*Private collection*

In these straightforward studies of a lobster claw, no attempt has been made to alter or transform the shapes into human forms.

93 **Transformation Drawing: Ideas for Sculpture** 1932
Pencil, $12\frac{1}{2} \times 10$ (31.7 × 25.4)
*Private collection*

Like No.89, this is a transformation drawing of bones. To all but the three upright forms at bottom right human features have been added. There are three standing figures in the bottom half of the sheet, six half figures above and at centre right, and a reclining figure at upper right. Most of the transformation drawings date from 1932.

It was not until the 1960s that Moore again used the knife edge thinness of certain bone forms, particularly the breast bones of birds. Such a bone was used at the point of departure for 'Working Model for Standing Figure: Knife Edge' of 1961 (L.H.481).

93

94 **Reclining Figure and Ideas for Sculptures** 1933
Pencil, pen & ink, chalk and wash, 22 × 15 (56 × 38)
*Private collection*

94

At centre is a large reclining figure, with much smaller sculptural ideas around the perimeter of the drawing, a compositional device which first appeared in the mother and child studies of 1928 (No.78). The cage-like forms down the left side of the sheet anticipate certain sculptures and drawings of 1939–40, such as the stringed 'Bird Basket' of 1939 (L.H.205), and the internal forms in 'Two Women: Drawing for Sculpture Combining Wood and Metal' of 1939 (No.127). At right just below centre, the lines connecting the heads of the double figure prefigure the stringed figure mother and child ideas in No.123, also of 1939.

95 **Mother and Child: Ideas for Sculpture** 1932
Pencil, $11\frac{13}{16} \times 9\frac{3}{8}$ (30.1 × 23.7)
Inscribed lower right 'Moore 33' (recent)
*Henry Moore Foundation*

This is a good example of the kind of automatism described on p.21–2 of the introduction, in which Moore began drawing '. . . with no preconceived problem to solve, with only the desire to use pencil on paper . . .'. Three random jottings have been abandoned. That the study at centre is for the alabaster 'Mother and Child' of 1932 (L.H.126) suggests the drawing was executed in 1932 and not, as the recent dating states, in 1933.

95

96

96 **Mother and Child: Ten Studies** 1933
Pen & ink, chalk and watercolour, $14\frac{3}{4} \times 10\frac{3}{4}$
(37.4 × 27.4)
*Private collection*

This is one of four drawings of 1933 in which a large study of a mother and child is surrounded by smaller versions of the same theme.

97 **Figure Studies** 1933
Pencil, pen & ink and wash, $14\frac{1}{2} \times 21\frac{1}{4}$ (36.7 × 54)
Inscribed lower right 'Moore 33'
*Art Gallery of Ontario*, Purchase 1976

This delicate and sensitive drawing includes the major motifs of Moore's figurative work: standing, sitting and reclining figures, and the mother and child theme. At centre, two groups of four women sit facing each other, as if attending a ritualistic gathering. At upper left, the three figures standing behind a reclining woman anticipate the three figure compositions of the 1940s, culminating in 'Three Standing Figures' of 1947–8, in Battersea Park, London (L.H.268). The diagonal brush lines are found in four other drawings of 1933 (see No. 98 below).

98 **Drawing for Sculpture** 1933
Pen & ink and wash, $14\frac{5}{8} \times 10\frac{3}{4}$ (37.2 × 27.3)
Inscribed lower left 'Moore 33'
*Cottesloe Trustees*

The three forms above the reclining figure may have derived from the shape of sea worn pebbles which influenced Moore's work in the 1930s. The following year he carved the ironstone 'Two Forms' (L.H.146), which closely resembles the shapes at upper left in this drawing. The smooth bulging forms in a number

97

of Moore's carvings of the early 1930s – the African wonderstone 'Composition' of 1932 in the Tate Gallery (L.H.119), the carved concrete 'Composition' of 1933, in the collection of the British Council (L.H.133) – recall the biomorphism of Arp, such as his marble 'Torso' of 1931. Another drawing closely related to No.98, entitled 'Figure Studies', was also executed in 1933.

**99   Reclining Figure** 1933
Pen & ink, chalk and wash,
$10\frac{7}{8} \times 14\frac{15}{16}$ (27.6×38)
Inscribed lower right 'Moore 33' (recent)
*Private collection*

One of the most interesting aspects of Moore's drawings and sculpture of 1931-4 is the way in which they reflect the work of his contemporaries in Paris – Arp, Giacometti and above all Picasso. A subject which has to date received little attention is Moore's affinity with the Surrealist movement. Although he exhibited in the International Surrealist Exhibition in London in 1936, Moore was never totally to embrace the aims of the movement as a whole. One looks in vain in Moore's work for some of the more significant features of Surrealism; the role of the unconscious and of dreams, the overt often aggressive sexual imagery, the importance of chance, and the disquieting juxtaposition of totally disparate objects. Although his work was enriched by borrowings from specific sculptures, drawings and paintings by Arp, Giacometti and Picasso, his own interpretation of them was entirely personal, as for example, in 'Composition' of 1931, discussed above in the notes for No.88.

'Reclining Figure' of 1933 (No.99), one of Moore's most Picassoesque drawings, is clearly indebted to Picasso's drawings made during the summers of 1927 and 1928. Here the vertical form with the circular base may have derived from two similar forms beside the upward pointed breast in Picasso's 'Dessin au Fusain' of the summer of 1927 (Zervos VII, 94), while the head and torso strongly echo the two oval shapes in a Picasso drawing of the following year, 'Dessin à l'Encre de Chine', July 1928 (Zervos VII, 203). This is not to suggest that Moore worked directly from reproductions of the Picasso drawings in question, but rather had assimilated the forms and made of them something very much his own.

98

**100   Ideas for Sculpture: Studies for Two Forms
    and Carving** 1934
Pencil, $7\frac{3}{4} \times 7$ (19.7 × 17.8)
Inscribed top of sheet 'Symbolic Humanitarian ideas'; below this 'th . . . [?]'
*Art Gallery of Ontario*, Gift of Henry Moore, 1974

In 1934, a year of cardinal importance in Moore's development, he executed a series of two, three and four piece compositions (L.H.140 and 149-154). Some are clearly composed of individual forms which, though organically related, are not dislocated parts of a single figure; others represent dismembered elements of a

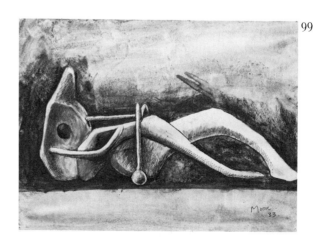

99

100

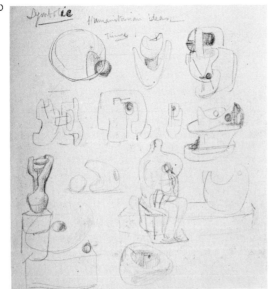

Fig.88 Henry Moore,
*Two Forms*, 1934
(Museum of Modern Art, New York)

single human figure. These carvings have much in common with such works as Arp's 'Bell and Navel' of 1931, Giacometti's 'Project for a Square' of 1931, 'Suspended Ball' of 1930-1, and 'Woman with her Throat Cut' of 1932. (Moore's 'Composition' of 1934, L.H.140, would appear to have been directly inspired by the latter.) The Moore carvings are also related in a general way to Picasso's drawings of the summer of 1928, such as Zervos VII, 203, which are discussed in the note for No.99 above.

The Toronto drawing (No.100) includes, to the immediate left of the seated woman holding a child, the sketch for the pynkado wood 'Two Forms' of 1934, in the Museum of Modern Art, New York (L.H.153 Fig.88). At bottom centre is the sketch for 'Carving', also of 1934 (L.H.148). The titles of these works, as with many carvings of the 1930s, are neutral and offer no assistance in interpreting the sculpture. When confronted with Moore's seemingly abstract work of the mid-1930s it is worth keeping in mind a statement he made in 1937:

Each particular carving I make takes on in my mind a human or occasionally animal, character and personality, and this personality controls its design and formal qualities, and makes me satisfied or dissatisfied with the work as it develops.[16]

It was in this respect that Moore's art differed from Barbara Hepworth's sculpture of the mid-thirties. During this period, as Alan Bowness has pointed out, she created 'pure abstract forms that existed in their own right without reference to anything outside themselves'.[17] Moore's work never reached such a degree of abstraction.

Another sheet of studies related to the 1934 'Two Forms' (L.H.153) leaves us in no doubt that the mother and child theme was the human character which controlled the design and formal qualities. 'Drawing for Sculpture' of 1934 includes studies of the mother and child theme, represented by a torso with full, swelling breasts arching above the small embryonic form of the child. In the Toronto drawing, the definitive study for 'Two Forms' continues this basic relationship of a large and small form, but on a more abstract level. The hole is indicated through the larger form, which appears to protect and shelter the embryo, yet simultaneously evokes feelings of menace, with associations of a devouring orifice.

In 1937 Moore wrote:

My sculpture is becoming less representational, less an outward visual copy, and so what some people would call more abstract; but only because I believe that in this way I can present the human psychological content of my work with the greatest directness and intensity.[18]

Far from being an outward visual copy, 'Two Forms' should be read, as Moore wrote at the top of the Toronto drawing, on a 'symbolic' level. Years later he wrote of the carving: 'Perhaps it can be thought of as a Mother and Child. I just called it 'Two Forms'. The bigger form has a kind of pelvic shape in it and the

smaller form is like the big head of a child.'[19]

No.101 below is a more finished drawing of ideas for two piece compositions.

**101 Ideas for Two Piece Composition** 1934
  Pen & ink, chalk and wash, watercolour,
  $14\frac{7}{8} \times 22$ (37.9 × 55.9)
  Inscribed lower right 'Moore 34'
  Rijksmuseum Kröller-Müller, Otterlo

This is the largest and most finished sheet of studies of two piece compositions. Although none of the forms was translated into sculpture, the ideas are closely related to the carvings of 1934. The sketch at centre in the bottom row has obvious affinities with 'Two Forms' of 1934 (Fig.88), although here the larger form is suggestive of arms and shoulders, reaching out to protect and shelter the vulnerable embryonic form. Perhaps the drawing at lower right may also be read as the mother and child theme. The single line connecting the two heads looks forward to the stringed figure drawings of 1937–9, particularly to the mother and child studies in 'Ideas for Sculpture in Metal and Wire' of 1939 (No.123).

**102 Sheet of Studies for Several Piece**
  **Composition** 1934
  Pencil and black chalk, $16\frac{9}{16} \times 10\frac{7}{16}$ (42.2 × 26.5)
  Inscribed. Two sheets, each with a fold down the the centre, are shown together, one mounted above the other. The inscriptions are, top of right half upper sheet 'Head end of several piece'; top left side bottom sheet 'legs for several piece sculpture'; just below centre left side bottom sheet 'body and one leg or body alone'; top of right half bottom sheet 'Head and end [?]'
  *Henry Moore Foundation*

Few preparatory drawings are more revealing of the genesis and evolution of a sculpture than these fascinating sheets of studies for one of Moore's finest carvings of the mid-1930s – the Cumberland alabaster 'Four Piece Composition: Reclining Figure' of 1934 (L.H.154), recently acquired by the Tate Gallery (Fig.32). The drawings show the way in which Moore made separate studies of the various dismembered parts of the human anatomy he intended using – the head, the body and the legs – before assembling them together to form a multi-part composition. It would appear that he considered using only three parts – head, body and one leg. However, in the drawings in the left half of the top sheet, in which the component parts are arranged together on a base, three of the six studies include a small circular form, which was included in the carving itself.

The lines and circles drawn on some of the forms in the drawings appear as incised lines in the Tate Gallery carving, and in a number of sculptures of the mid-1930s. Both John Russell and David Sylvester have remarked that the linear incisions in certain Moore carvings of the period (L.H.164 and 167) may owe something to the paintings and reliefs of Ben Nicholson.[20]

101

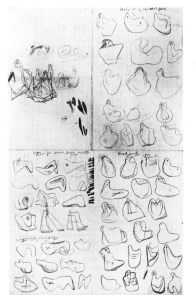

102

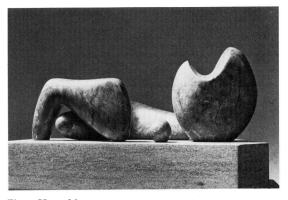

Fig.32 Henry Moore,
*Four Piece Composition : Reclining Figure*, 1934
(Tate Gallery)

Fig.89 Pablo Picasso,
*Musical Instruments*, 1924
© S.P.A.D.E.M. Paris, 1977

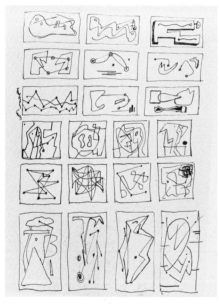

Fig.90 Henry Moore,
*Page from Sketchbook : Ideas for Reliefs*, 1934
(Art Gallery of Ontario)

103

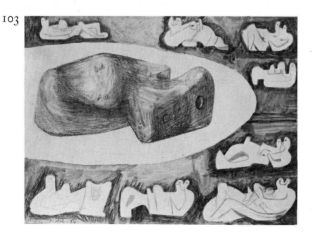

Perhaps even more relevant were Picasso's pen and ink drawings of 1924 (Zervos V, 276-279), which Alfred Barr has described as 'constellations of dots connected by lines or, better lines with dots where the lines cross or end' (Fig.89).[21] Moore's 'Page from Sketchbook: Ideas for Reliefs' of *c*.1934 (Fig.90) proves conclusively that he was familiar with Picasso's line and dot drawings.

Two other drawings of 1934 are related to the Tate Gallery carving: 'Drawing for Four Piece Composition' (the Henry Moore Foundation) includes the definitive study for it; and 'Study for Reclining Figure as Four Piece Composition' (L.H. Volume I, p.192), which has been lost or destroyed.

**103  Study for Recumbent Figure** 1934
 Chalk and wash, $10\frac{7}{8} \times 15\frac{1}{4}$ (27.7 × 38.7)
 Inscribed lower left 'Moore 34'
 *Art Gallery of Ontario*. Gift from The Junior Womens' Committee Fund, 1961.

The strange form floating in the empty oval space is suggestive of a primordial creature long extinct. As in many of Moore's most abstract works of the mid-thirties, there are clues that suggest the animal or human world – in this drawing, the small eyes. In 'Studies for Sculpture' of 1934, in the Museum of Modern Art, New York, the modelled, sculptural forms are related to the central image in the Toronto drawing (see 1977 Paris catalogue No.144).

**104  Ideas for Metal Sculpture** 1934
 Pen & ink, black and coloured chalks,
 brush and water, $10\frac{7}{8} \times 24\frac{3}{4}$ (27.6 × 62.9)
 Inscribed lower right 'Moore 34' (recent)
 *Art Gallery of Ontario*, Gift of Henry Moore, 1974

These four impersonal constructions, reminiscent of the welded metal forms in contemporary sculpture, reflect the continued influence of Picasso, in particular 'An Anatomy' of 1932 (Fig.91). The Moore forms are, however, more mechanical, with none of the highly charged, sometimes witty sexuality found in the Picasso drawing.

Two of the four forms in the Moore drawing were based on studies in 'Ideas for Metal Sculpture' of 1934 (private collection). In the latter, the arrangement of four rows of studies, each with four figures, is also reminiscent of the regular ordering of the forms in Picasso's 'An Anatomy'. 'Drawing for Metal Sculpture', also of 1943 (in the collection of Irina Moore), contains two large studies which are closely related to those in the Toronto drawing.

**105  Drawing for Sculpture: Head** 1934
 Pen & ink, black and coloured chalks,
 brush and water, $11 \times 15$ (28 × 38)
 Inscribed lower right 'Moore 42'
 *Private collection*

In 1934-5, Moore made about half a dozen drawings which have a geometric severity unlike anything to be found in his previous or subsequent work. (See

background in No.106 below, and 'Abstract Drawing' 1935 (Fig.33) in L.H. Volume I, p.196). It would appear that the straight lines in No.105 were not drawn with the aid of a ruler.

**106 Drawing** 1935
Charcoal and white chalk on two sheets, one mounted on the other,
$13\frac{1}{2} \times 16\frac{1}{2}$ (34.2×41.8)
Inscribed bottom right central sheet 'Moore 35' (recent)
*Tate Gallery* (T.270)

The two forms, which the artist said recently were related to ironstone pebbles, are set against a grid of vertical horizontal lines. In this drawing they appear to have been drawn with the aid of a ruler.

**107 Drawing for Sculpture: Reclining Figure** 1935
Pen & ink, chalk and wash, $15 \times 21\frac{11}{16}$ (38×55)
Inscribed lower right 'Moore 35'
*Private collection*

The pen and ink lines connecting dots and circles, a design which first appeared in several drawings of 1934 (Fig.90), enliven the flat patterns of the drawing surface. At left, just above the centre, the oval shape inscribed on two sides recalls Nicholson's work of the mid-thirties, 'such as white relief: circle and square' of 1934 (Fig.92).[22]

**108 Drawing** 1936
Pen and wash, $14 \times 17\frac{1}{2}$ (35.5×44.5)
Inscribed lower left 'Moore 36'
*Lord Clark*

The form at lower right, one of Moore's few abstract drawings, is like a wall relief with a small platform for a sculpture, as in 'Three Motives against Wall' Nos.1 and 2 of 1958–9 (L.H.441 and 442). It would appear that the larger study evolved, with the additional drawing at the top, from an abstract rectangular shape to its present form, with the unmistakable suggestion of a figure rising out of a sarcophagus. Both studies were probably based on two of the five square and rectangular forms in 'Ideas for Stone Sculpture' of 1936 (private collection). See the related drawing No.109 below.

**109 Square Form Reclining Figures** 1936
Black chalk and wash, $21\frac{3}{4} \times 15\frac{3}{8}$ (55.2×39)
Inscribed lower right 'Moore 36'
*Private collection*

In this drawing, related to No.108 above, all seven studies of reclining figures have the block-like, square form rhythm to be found in a number of drawings of the mid-thirties.

**110 Square Forms** 1936
Chalks and watercolour, $17\frac{3}{4} \times 11\frac{1}{2}$ (45×29.2)
Inscribed lower left 'Moore 36'
*Private collection*

The standing forms in this dense and fully worked drawing, more abstract than the reclining figures in No.

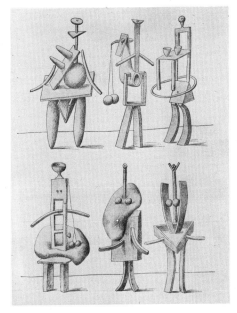

Fig.91 Pablo Picasso,
*Page from 'An Anatomy'*, 1932
© S.P.A.D.E.M. Paris, 1977

105

106
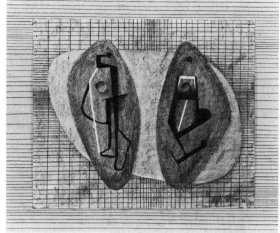

107
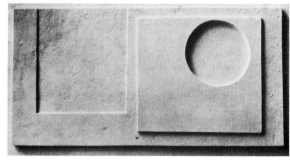

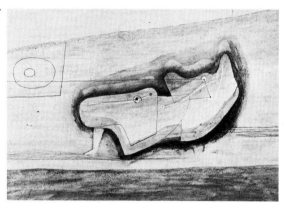

Fig.92 Ben Nicholson,
*White relief: Circle and square,* 1934

108
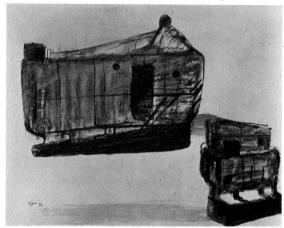

109
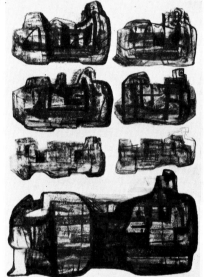

110
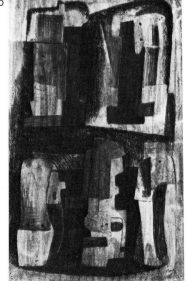

109 above, are reminiscent of ancient weather-worn menhirs.

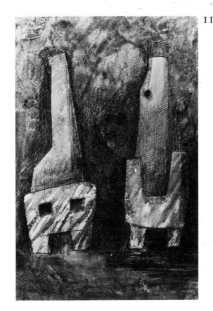

111

### 111  Two Stone Forms 1936
Pen & ink and wash, $18\frac{1}{2} \times 13\frac{3}{4}$ (47×35)
Inscribed lower right 'Moore 36'
*Lord Clark*

The two stone forms were based on the small study inscribed 'statues' in 'Page from Sketchbook' of 1935 (private collection). Between the two forms, a mask hangs suspended in mid-air.

### 112  Figures in a Cave 1936
Black chalk, brush and water, 15×22 (38×56)
Inscribed lower left 'Moore 36'
*Private collection*

Probably based on the small compositional sketch in 'Page from Sketchbook', Fig.38 (possibly dating from 1936) which in turn was derived from a photograph in Leo Frobenius' *Kulturgeschichte Afrikas* (1933), showing a tomb or grave in a cave of a small hill in Southern Rhodesia (Fig.39). The scene in the photograph served as the model for the setting; the figures in the Moore drawing were his own invention. In a drawing of 1975 'Figures in Settings' (Fig.67), the upper composition was based on the small study in Fig.38 of standing figures in a cave.

### 113  Stones in Landscape 1936
Pen and wash, 22×15 (55.9×38.1)
Inscribed lower right 'Moore 36'
*Private collection*

This, and 'Figures in a Cave' (No.112), are among Moore's finest early pictorial compositions. A drawing of 1972 'Rock Landscape with Classical Temple' (No. 248) is somewhat reminiscent of the present drawing.

### 114  Nine Figures: Drawing for Metal Sculptures 1936
Coloured chalks and brush and water,
$14\frac{15}{16} \times 21\frac{7}{8}$ (37.9×55.5)
Inscribed lower right 'Moore 36'
*Private collection*

Moore explained recently that the media used in this drawing were not, as it might appear, chalks and water-colour, but chalks which have been gone over with a brush wetted in water.

In two of the nine studies, the way in which straight lines cut across empty spaces, joining the projecting shapes, anticipates almost inadvertently the stringed figure drawings and sculpture of 1937–9 (see No.123).

### 115  Drawings for Stone Sculpture 1937
Chalk and watercolour, 16×21 (40.7×53.3)
Inscribed lower left 'Moore 37'
*Gérald Cramer*, Mies, Suisse

This beautiful study may well have been inspired by the blocks of roughly hewn stone in the garden behind Moore's cottage in Kent (Fig.40). The drawing is somewhat reminiscent of Paul Nash's 'Landscape with

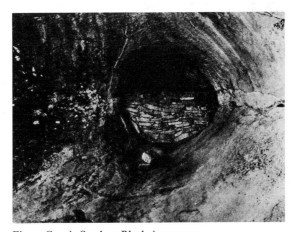
112

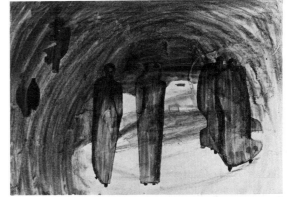
Fig.39  Cave in Southern Rhodesia

113

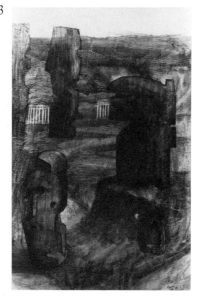

114

115

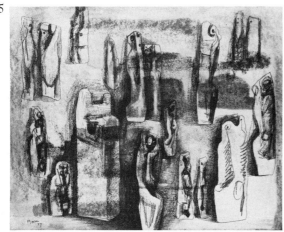

Megaliths' of 1937, which was based on his photograph of the stones at Avebury.

### 116 Five Figures in a Setting 1937
Black and coloured chalks, brush and water,
$14\frac{5}{8} \times 21\frac{3}{4}$ (37.2 × 55.2)
Inscribed lower right 'Moore 37'
*Private collection*

The earliest drawings in which sculptural ideas are placed in front of rectangular slotted walls is dated 1936 (see 'Drawing for Sculpture' L.H. Volume 1, p.197). No.116 is one of eight known large finished drawings of 1937–9, some of which show sculptures in cell-like rooms with diagonal walls leading into the picture space. (See studies in No.126). Similar settings occur in a number of drawings of the 1940s (Nos.194 and 208). 'Eight Variations of Figures in a Setting' of 1950 (private collection) appears to be the last drawing of figures in rooms with slotted walls, although such a background was used in a number of sculptures, notably 'Three Motives against Wall' Nos.1 and 2 of 1958–9 (L.H.441 and 442).

The five sculptural ideas in No.116 were almost certainly based on small notebook studies. For example, the upright form at left first appeared in the rough sketch 'Ideas for Sculpture' of 1937 (Beyeler, No.36). The large form at centre also appears in another large finished drawing, 'Sculpture in a Setting' of 1937 in the collection of Irina Moore. The stringed figure to the left of this, one of the studies for L.H.207, is also to be found in No.123.

### 117 Four Forms, Drawing for Sculpture 1938
Ink, chalk and gouache, 11 × 15 (28 × 38)
Inscribed lower right 'Moore 38'
*Tate Gallery* (T.271)

Four forms have been arranged on a platform, with the suggestion of a tunnel at centre, spiralling deep into the picture space. In his large finished drawings of the late thirties, Moore sometimes drew from completed sculptures. The stringed head to the left of the tunnel may have been based on the elmwood 'Head' of 1938 (L.H.188), which in turn was probably made from a less finished notebook sketch.

### 118 Reclining Figure 1938
Black and green chalk, brush and water,
$16\frac{1}{2} \times 14\frac{1}{2}$ (42 × 36.8)
Inscribed lower left 'Moore 38'
*Lord Clark*

This drawing, probably based on the small 'Reclining Figure' of 1938 (not in L.H., see 1977 Paris catalogue, No.29), was one of the first to include a sculptural background behind the figure. Here the hollowed-out form echoes the rhythm of the arms and shoulders of the reclining figure. (See also Nos.189 and 190.)

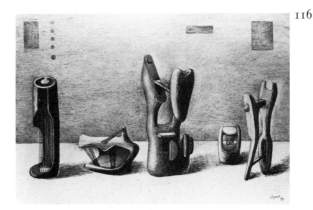

116

**119  Ideas for Metal Sculpture** 1938 [?]
Chalk, pen and wash, 15 × 22 (38 × 56)
Inscribed lower left 'Moore 38'
*Lord Clark*

Although dated 1938, this drawing may have been executed in the following year. The figure at right appears in three less finished drawings of 1939, which include many ideas for sculpture. If, in fact, the present drawing was made in 1939, the large reclining figure in question may have been either the definitive study for the lead 'Reclining Figure' of 1939 (L.H.204), or possibly based on the sculpture itself. The figure at left appears in one of the 1939 sheets of ideas for sculpture.

117

**120  Ideas for Sculpture: Study for Tate Recumbent Figure** 1938
Pencil and chalk, 11 × 7½ (28 × 19)
Inscribed upper right: 'a sheet of drawings of reclining figures'; lower left 'Moore 38'
*Private collection*

The drawing at the top of this sheet is the study for the green Hornton stone 'Recumbent Figure' of 1938 (L.H.191) in the Tate Gallery (Fig.34). This would appear to have been the first large carving to be preceded by a small maquette (L.H.184), which in turn was based on the study in No.120. Likewise, Moore first made a maquette (L.H.185, 1938), also based on a preparatory sketchbook drawing (Fig.36), before embarking on the large elmwood 'Reclining Figure' of 1939, in the Detroit Institute of Arts (L.H.210).

118

In the Tate Gallery carving, the gentle curving rhythm of the figure rises and falls, like an undulating landscape of hills. In fact, the sculpture was originally made for a landscape setting in the south of England. The architect Serge Chermayeff had asked Moore if he could visualize one of his figures on a site in Sussex where he was building a house for himself. He wanted to place a sculpture at the intersection of the terrace and garden. Moore has written:

> It was a long low-lying building and there was an open view of the long sinuous line of the Downs. There seemed no point in opposing all these horizontals, and I thought a tall, vertical figure would have been more of a rebuff than a contrast, and might have introduced needless drama. So I carved a reclining figure [Fig. 34] for him, intending it to be a kind of focal point of all the horizontals, and it was then that I became aware of the necessity of giving outdoor sculpture a far-seeing gaze.[23]

When Chermayeff sold his house, the 'Recumbent Figure' was bought by the Contemporary Art Society, and presented to the Tate Gallery in 1939.

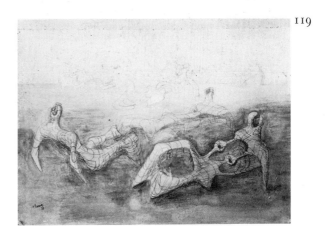

119

**121  Pictorial Ideas and Settings for Sculpture**
*c.*1938
Pen & ink, pencil, crayon and watercolour, 10 × 17 (25.3 × 43.2)
Inscribed above each of the three studies at left, from top to bottom: 'crowds of people round a tied-up object/Two men and a horse/Two Forms';

120

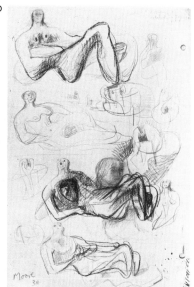

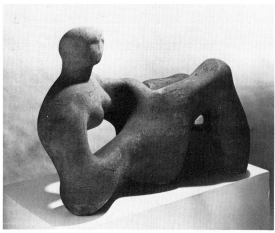

Fig.34 Henry Moore,
*Recumbent Figure*, 1938
(Tate Gallery)

121

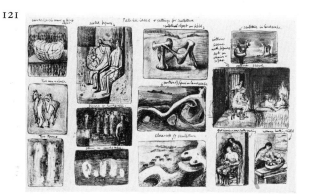

above each of the three studies to the right of this: 'seated figures/figures in landscape/stones in landscape'; at top of page at centre 'Pictorial ideas and settings for sculpture'; above each of the three studies down the centre of the page 'sculptural object in field/portion of figure in landscape/close-up of sculpture'; above and to the left of study at upper right 'sculpture in landscape/interior scene with figures sat in chairs and sofas'; above each of the other three studies at right 'interior scene/girl leaning over sister reading/woman bathing child'
*Gordon Onslow Ford*

This fascinating drawing is the most important sheet of studies of the late thirties of pictorial ideas and settings for sculpture. 'Sculptural object in field' is the preparatory sketch for one of Moore's best-known pre-war drawings 'Sculptural Object in Landscape' of 1939 (No.124). Below this, the detail of a reclining figure was probably drawn from the maquette (L.H.185) for the Detroit 'Reclining Figure' of 1939 (L.H.210). 'Stones in Landscape' may well have been inspired by a photograph in Leo Frobenius' *Kulturgeschichte Afrikas*, pl.140, showing five ritualistic stones from Abyssinia, in an open field. (See similar compositions in No.126.) The drawing at upper left, of a crowd round a tied-up object, anticipates the subject of Moore's most famous pictorial drawing (No.193). The study at left 'Two Men and a Horse' appears again in a drawing of 1939 (No.126). On the right of the sheet the three interior scenes look forward to the large drawings of domestic life of 1946-8 (Nos.207 and 209).

**122 Projects for Relief Sculptures on London University** 1938
Pen & ink, chalk and wash, $14\frac{1}{2} \times 10\frac{1}{4}$ (36.8 × 26)
Inscribed bottom 'Project for relief-sculptures on London University'; lower right 'Moore 38'
*Art Gallery of Ontario*, Purchase 1975

The architect, Charles Holden, who had commissioned in 1928 the 'North Wind' relief (see No.79), approached Moore again in 1938 and asked if he would consider doing a series of relief sculptures for Senate House of London University. Moore has said recently that at the time he had a prejudice both against doing relief sculpture and against sculpture being used on buildings as decoration. Holden left Moore to think about his proposal, and said if he changed his mind, perhaps he would indicate the shape of block he would require. Moore made a number of preparatory studies of which the Toronto drawing was the most fully realized. On one of the four known, less finished sheets of studies is the following inscription: 'Think of subject matter/Mother and Child – the University the mother – child the students. . . .' In each of the six studies in the Toronto drawing, the subject matter is a seated female figure holding a book, which Moore said was an appropriate symbol for a university. From this, Holden and Moore worked out the proportion for the

six blocks. The project got as far as boasting (rough surfacing) six stone blocks and placing them on the Senate House, where they have remained unfinished to this day.

**123 Ideas for Sculpture in Metal and Wire** 1939
   Blue pencil, pen & ink and watercolour,
   $10\frac{3}{4} \times 15$ (27.3 × 38)
   Inscribed upper left 'Mother and Child'; lower right 'Moore 39'
   *Private collection*

'Undoubtedly', Moore has said, 'the source of my stringed figures was the Science Museum. Whilst a student at the R.C.A. I became involved in machine art, which in those days had its place in modern art'.[24] He became particularly fascinated by the mathematical models in the Science Museum, which he has described as '. . . hyperbolic paraboloids and groins and so on, developed by Lagrange in Paris, that have geometric figures at the ends, with coloured threads from one to the other to show what the form between would be. I saw the sculptural possibilities of them and did some. I could have done hundreds.'[25]

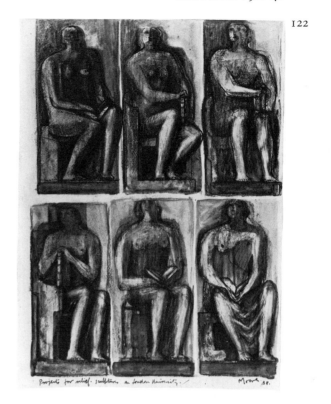

122

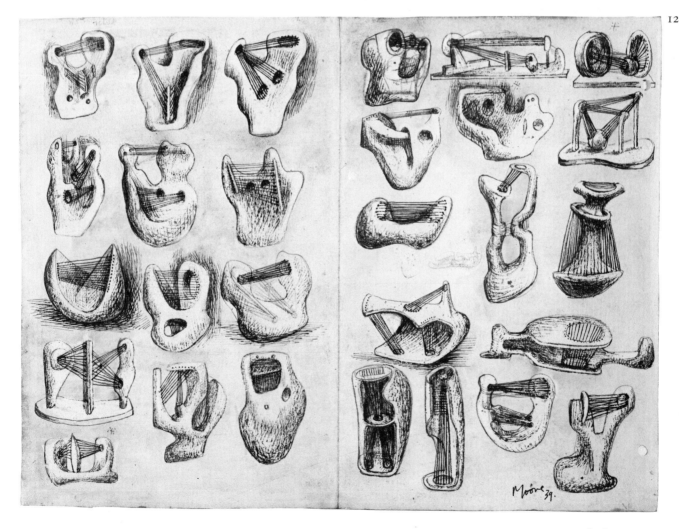

123

Although all the stringed figure drawings and sculptures were executed between 1937 and 1940, they were anticipated in a number of earlier studies (see notes for No.94 and 101) in the way in which lines cut across the empty space between two projections.

The present drawing is indicative of how freely Moore could invent variations of stringed figure ideas. 'In one afternoon', he has said, 'I could draw fifty or sixty ideas, all of which would, if I had carried them out, have been interesting and intricate, so much so that it was more a matter of invention than imagination'.[26]

The date of this drawing is somewhat problematic in that the mother and child (top right in the left half of the sheet) would appear to be a study for the lead and wire 'Mother and Child' of 1938 (L.H.186), unless this sketch was actually based on the completed sculpture, which in turn had been made from an earlier drawing. In the right half of the sheet, the figure on the left, second row from the bottom, appeared in a drawing of 1937 (No.116). In the sculpture itself, 'Stringed Figure' of 1939 (L.H.207), which was probably based on the study in the present drawing, the strings from the head to the circular area carry on through to the bottom of the figure.

In describing the mother and child sculpture of 1938 (L.H.186), which was probably based on the drawing discussed above, Erich Neumann wrote: 'The streams connecting the child's eyes with those of the mother are like ghostly, spiritual bridges. . . . Simultaneously a current of desire, like lines of force, streams from the mouth of the child to the mother's breasts whose non-bodily yet dynamic presence sets up the diagonal connection that vivifies the conjoined masses of mother and child'.[27]

One is reminded of the beautiful image of the lovers in John Donne's poem 'The Extasie':

Our hands were firmly cimented
With a fast balme, which thence did spring,
Our eye-beams twisted, and did thred
Our eyes, upon one double string.[28]

Moore's last stringed figure sculptures were done in 1939. He enjoyed doing them but found they were ' . . . too much in the nature of experiments to be really satisfying. . . . Others, like Gabo[29] and Barbara Hepworth have gone on doing it. It becomes a matter of ingenuity rather than a fundamental human experience'.[30]

124 **Sculptural Object in Landscape** 1939
Pen & ink, coloured chalks, wax crayon and wash, 12¾ × 19½ (32.4 × 49.6)
Inscribed lower right 'Moore 39'
*University of East Anglia*, The Robert and Lisa Sainsbury Collection

This, one of Moore's finest drawings of sculpture in landscape, was based on the small study inscribed 'sculptural object in field' in No.121. In the present drawing the horizon line is set further back. The setting for the enormous bone-like object was inspired

124

Fig.40 Stone in garden at Burcroft

by the view from Moore's garden in Kent, which appears in a photograph taken by the artist in 1936 (Fig.40).

125 **Seated Figure and Pointed Forms** 1939
Pencil, chalks, wax crayon and watercolour, 17×10 (43×25.5)
Inscribed lower right 'Moore 39'; at top of sheet 'Lubetkins pillars (caryatids)'; just above centre left, with sheet inverted 'points meeting'; below line drawn across centre of sheet, from left to right '. . . [?]/Dra[?] . . . solid forms (draw mother and child string one)'; below last phrase 'S.P.'
*Private collection*

125

This and its pendant 'Pointed Forms' of 1940 in the Albertina, Graphische Sammlung (L.H. Volume I, p. 221) were the two major drawings of pointed forms. As the Albertina drawing includes the study for 'Three Points' of 1939 (L.H.211), it would appear to have been incorrectly dated 1940. None of the ideas in the present drawing was translated into sculpture, although the large upright form above the signature appeared again in 'Figures in a Landscape' of 1942, in the Santa Barbara Museum of Art (No.191). The form at lower left reappears in a landscape setting in a drawing of 1940 'Pointed Forms: Drawings for Metal Sculpture' (private collection). Moore began using wax crayon in this and other pre-shelter drawings of 1939-45. (See for example, Nos.130 and 136.)

126 **Pictorial Ideas and Settings for Sculpture** 1939
Pencil, pen & ink, and wash, 11½×16 (29.2×40.6)
Inscribed lower right 'Moore 39'; left half of sheet, left of the composition at centre, second row from the top 'or blue sky'; right half of the sheet, below composition at right, second row from top 'two sculptures'
*Dr S. Charles Lewsen*

126

In the left half of the sheet are seven studies of sculptural ideas in cell-like rooms (see notes for No.116). In the left half of the sheet, the composition at centre, third row from the top signature at lower right, was almost certainly based on a photograph in Leo Frobenius' *Kulturgeschichte Afrikas*, showing five ritualistic stones in a landscape (see related drawing of same subject in No.121). In the right half of the sheet, the composition at left, third row from the top, is another version of 'Two men and a horse', also found in No. 121.

127 **Two Women: Drawing for Sculpture Combining Wood and Metal** 1939
Black and coloured chalks, brush and water, 16½×14½ (42×36.8)
Inscribed lower right 'Moore 39'
*Lord Clark*

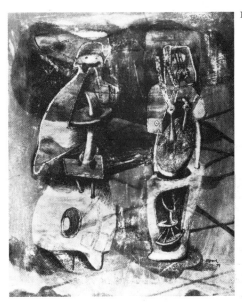

127

Moore has long considered this to be one of his finest drawings for sculpture. It was based on a pencil study 'Ideas for Lead Sculpture' of 1939 in the collection of

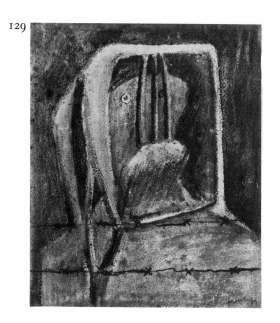

128

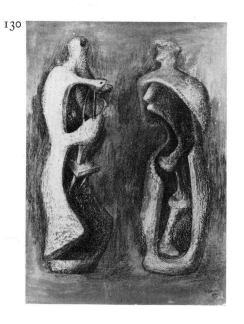

129

130

Mary Moore. If the figure had been realized in three dimensions, no doubt the tubular forms, more reminiscent of exposed plumbing than of the internal organs of the body, would have been made of metal, and the flat and hollowed-out forms of wood.

A variation of the head of the figure at right appears in another drawing of 1939, 'Spanish Prisoner' (No. 129). For other figures related to the two in this drawing see Nos.130–132.

**128  Two Heads: Drawing for Metal Sculpture**
1939
Pen with black and coloured inks, black chalk, brush and water, $10\frac{7}{8} \times 15\frac{1}{8}$ (27.6 × 38.3)
Inscribed lower right 'Moore 39'
*Private collection*

This, and the less finished 'Heads: Drawing for Metal Sculpture' also of 1939 (L.H. Volume 1, p.212) were the earliest drawings of the internal/external form helmet head motif. The first sculpture – 'The Helmet' of 1939–40 (L.H.212, Fig.35) – was based on the central sketch in the bottom row of the less finished drawing (L.H. p.212). This was not only the first helmet, but also the first internal/external form sculpture.

The helmet head idea may well have been suggested by two prehistoric Greek implements or utensils (Fig. 93) which Moore copied in a 1937 sketchbook (Fig. 94). In all probability the single hole at the back of 'The Helmet' derived from the holes which appear in each of the Greek bronzes.

**129  Spanish Prisoner** 1939
Black and coloured chalks, brush and water, $14\frac{1}{2} \times 12\frac{1}{4}$ (36.8 × 31.1)
Inscribed lower right 'Moore 39'
*Private collection*

This, one of four preparatory studies, was the definitive drawing on which the lithograph 'Spanish Prisoner' of *c.*1939 (C.G.M.3) was based. Although the lithograph was never editioned (only a few trial proofs were printed), it was to have been sold to raise money for Republican soldiers who had fled across the border and had been interned in the south of France. The present drawing is a variation of the head of the figure at right in 'Two Women: Drawing for Sculpture Combining Wood and Metal' of 1939 (No.127). In No.127 the head was already imprisoned behind the bars of the cage-like structure. Here the barbed wire reminds us of the plight of the Spanish prisoners.

**130  Two Standing Figures** 1940
Pen & ink, black and coloured chalks, wax crayon and watercolour, 22 × 15 (55.9 × 38)
Inscribed lower right 'Moore 40'
*Lord Clark*

One of four drawings of 1939–40 in this exhibition (see also Nos.127, 131 and 132) of standing figures which have been opened out to reveal their strange internal organs. In the figure at right, the rounded shell of the body and the internal forms within anticipate to a

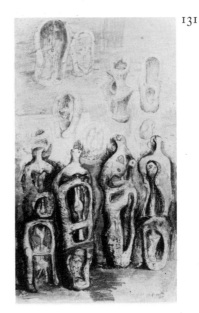

remarkable degree the internal/external form sculptures of 1951–3 (L.H.293a–297). These two figures were based on two of the six studies in 'Page from Sketchbook' of 1939, in the collection of Mary Moore.

**131 Standing Figures** 1940
Pencil, wax crayon and watercolour, 17 × 10
(43 × 25.5)
Inscribed lower right 'Moore 40'
*Jeffrey H. Loria Collection*, New York
These studies of internal/external forms are related to
Nos.127, 130 and 132. (See also 'Standing Figures' of
1940, 1977 Paris catalogue No.167).

**132 Standing Figures** 1940
Pencil, pen & ink, wax crayon and watercolour,
$10\frac{3}{8} \times 7\frac{1}{8}$ (26.3 × 18)
Inscribed lower left 'Moore 42'
*Tate Gallery* (5210)
Moore often included in the titles of his drawings the material which he thought would be suitable for the forms he had drawn, were he to realize the ideas in sculpture.

Not only are the drawings of 1939–40 among the most richly inventive of all Moore's studies for sculpture, they are among his most beautiful coloured drawings. One could not better Geoffrey Grigson's description of Moore's use of colour:

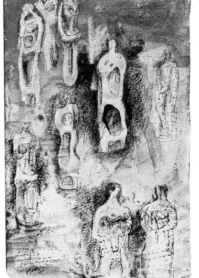

The lovely effectiveness of colour in drawings by Henry Moore is much fed, of course, from his appetite for the colour in Nature, the lichen on the grey rock, the coloured texture of weather-worn stone, the firey black and red of igneous formations or burning coal...'[31]

**133 Drawing for Sculpture** 1940
Pen & ink, chalk and watercolour,
$9\frac{15}{16} \times 17$ (25.2 × 43)
Inscribed lower right 'Moore 40'; top of sheet
'The human body is sculptural/but that is all the
more reason [. . . erased and illegible] for it to be
a subject for/sculpture, it means that the sculptor
cannot be a copyist,/but has to make changes and
recreate it [another line erased and illegible]';
below upper row of figure studies 'The human
body is what we know most about, because/ its
ourselves: and so it moves us most strongly we
can make complete/identity with it./We kick out
from the past two or three painters, one or two
sculptors/It is the integrity dynamic which
counts, as though his intention was so/
tremendously important to him that it comes
through [a line through last word] shining
through without being anywhere near achieved'
*Visitors of the Ashmolean Museum*, Oxford
In a number of drawings for sculpture of 1940, which
pre-date the shelter drawings, Moore simultaneously
worked in two different styles. In the row of studies at
the top of the Oxford drawing, the hollowed-out
figures were a continuation of the more abstract style

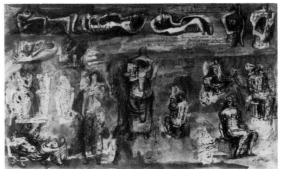

134

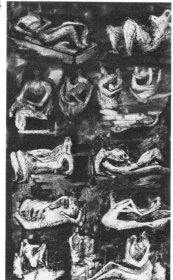

of the drawings for sculpture of 1939–40 (Nos.131 and 132), whereas the draped reclining figure at lower left, and the four seated figures above the signature, were to anticipate the naturalism of the shelter drawings.

**134  Ideas for Sculpture** 1940
Pen & ink, and watercolour, $16\frac{7}{8} \times 10$ (42.8 × 25.5)
*Perry T. Rathbone*
Whereas many of Moore's early watercolours have faded with the passage of time, the deep blue background in this drawing appears to have lost none of its freshness and intensity.

**135  Two Seated Figures** 1940
Pen & ink, crayon, gouache and wash, $7\frac{1}{8} \times 10\frac{5}{8}$
(18 × 27)
Inscribed lower right 'Moore 40'
*Tate Gallery* (5208)
This is one of seven known drawings of 1940 (see No. 136 below, and 'Two Seated Women', 1940 L.H. Volume 1, p.224) of seated and standing figures, which marks the emergence of a naturalistic style which was continued and further developed in the shelter drawings. In these two seated women, imbued with an air of sweetness, the distortions of much of Moore's more experimental work of the 1930s have given way to a calm and relaxed naturalism. A pendant to the present drawing, entitled 'Two Seated Women' (1940), is also in the Tate Gallery.

135

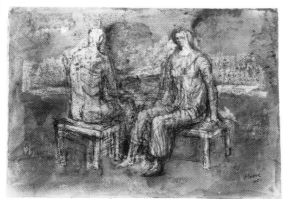

**136  Artist and Model** 1940
Pencil, watercolour, body colour, black ink with surface scratching, wax crayon, $14\frac{1}{2} \times 11$ (36.8 × 28)
Inscribed lower left 'Moore 40'
*Whitworth Art Gallery, University of Manchester*
This drawing, stylistically related to the series discussed in No.135 above, appears to be the only example in the whole of Moore's oeuvre of the theme of artist and model. The head of the artist is without features: those of the model seem to express something of the stoicism found in many of the shelter drawings which followed.

136

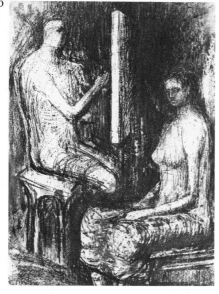

# Wartime Drawings 1940–42

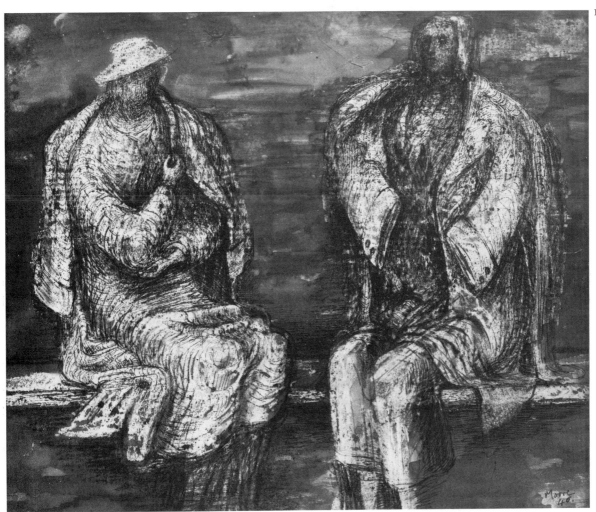

137 **September 3rd, 1939** 1939
Chalk, pen & ink, crayon, pencil and watercolour,
$12 \times 15\frac{5}{8}$ ($30.5 \times 39.6$)
Inscribed lower left 'Moore Sept 3rd/1939'
*Private collection*

On 3 September, the day war was declared, the Moores
were bathing off the Shakespeare Cliffs at Dover. He
remembers hearing an air raid siren, an ominous
prelude to the day and night warnings in London a year
later during the Blitz. In this recreated scene of bathers
with the cliffs in the background, the strange heads of
the figures, evoking the world of science fiction, were
probably suggested by the familiar form of gas masks.
Standing chest high in the water, these forbidding
women, alert and watchful, look across the Channel
towards the French coast.

138 **18 War Sketches** 1940
Pen & ink, chalk, wax crayon and watercolour,
$10\frac{3}{4} \times 14\frac{7}{8}$ ($27.3 \times 37.8$)
Inscribed above the upper four drawings from
left to right 'searchlights/Flashes from ground/
Gun shells bursting like stars/Night and day-
contrast'; above second row 'devastated houses/
bomb crater/contrast of opposites/contrast of
peaceful normal with sudden devastation'; above
third row 'disintegration of farm and machine/fire
at night/Haystack and airplane/Nightmare/con-
trast of opposites/Burning cows'; above bottom
row 'spotters on buildings/barbed wire/Cows
and Bombers/Bombs bursting at sea'; lower right
'Moore 40'.
*Henry Moore Foundation*

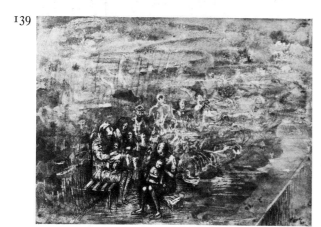

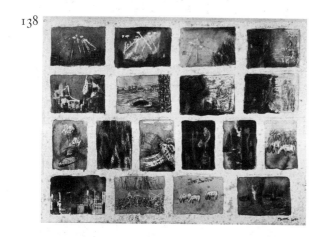

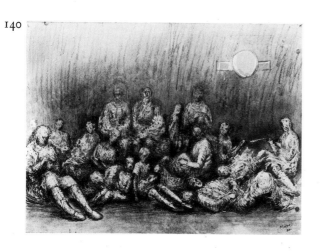

On page 45 of the 'First Shelter Sketchbook' is a list of possible subjects for war drawings, several of which are found among these eighteen war sketches: night and day contrast at upper right; below this, contrast of peaceful normal with sudden devastation; below this, burning cows; to the left of this, contrast of opposites. The traditional war subjects depicted in these eighteen studies were of little interest to Moore, but they do recall the work of other artists of the Second World War: Nash's paintings of crashed bombers in landscape, and Sutherland and Piper's scenes of bombed buildings.

139  **Women and Children in the Tube** 1940
      Pen & ink, chalk and wash, 11 × 15 (28 × 38)
      Inscribed lower right 'Moore 40'
      *Trustees of the Imperial War Museum*

Probably the first drawing of shelterers in the London Underground, this study was made soon after Moore's initial contact with shelter life in September 1940. See introduction, p.28.

140  **Grey Tube Shelter** 1940
      Pen & ink, chalk, wash and gouache,
      11 × 15 (28 × 38)
      Inscribed lower right 'Moore 40'
      *Tate Gallery* (5706)

This very beautiful early shelter drawing was based on a study of the same size in the collection of Irina Moore, but includes many more figures, notably those seated on a bench against the tunnel wall. The blue grey tonality is to be found in many shelter drawings. The drapery and curved wall are highlighted in yellow. Another characteristic feature is the delicate pen and ink outlines and shading of the figures. Stylistically the Tate Gallery drawing is closely related to 'Brown Tube Shelter', also of 1940, in the collection of the British Council.

141  **Shadowy Shelter** 1940
      Pen & ink, chalk, wax crayon and watercolour,
      10 × 17 (25.5 × 43.2)
      Inscribed bottom left 'Moore 40'
      *Sheffield City Art Galleries*

During the first few months of the Blitz in the autumn of 1940, it was the spontaneous, chaotic appearance of the shelters which particularly fascinated Moore. Few drawings better illustrate these conditions than this fine example dating from 1940. Reclining and several seated figures recede diagonally into the picture space, a 'sea of sleepers' as an inscription reads on page 62 of the 'Second Shelter Sketchbook'. A drawing related in composition and handling is 'Group of Shelterers', also of 1940, University of East Anglia (The Robert and Lisa Sainsbury Collection).

142 **Three Seated Figures** 1940
Pen & ink, coloured crayons and watercolour,
11⅝×15 9/16 (29.5×39.5)
Inscribed lower right 'Moore 40'
*Art Institute of Chicago*, Gift of Mr and Mrs Joel
Starrels

A number of drawings, such as this and No.151, depart in certain respects from the naturalism which characterizes the shelter drawings as a whole. Here the heads are more related to Moore's pre-war drawings and sculpture than to observed figures in the shelters. A similar drawing, dated 1941, is entitled 'Three Fates'. Stylistically a pre-shelter drawing of 1940 'Three Seated Figures' (L.H.I. p.224) anticipates the Chicago drawing.

143 **Air Raid Shelter: Two Women** 1941
Watercolour, ink and chalk, 16¾×20⅜ (42.5×51.9)
Inscribed bottom right 'Moore 41'
*Leeds City Art Galleries*

Solemn and dignified, two women sit in a shelter, absorbed by their own thoughts. Moore emphasizes the passive and helpless plight of the civilian population in wartime, the hours of waiting in the Underground, with the knowledge of something happening above which was beyond their control. He ignored the more anecdotal aspects of shelter life which one finds, for example, represented in Edward Ardizzone's drawings: the sing-songs, card games, cups of tea and the friendly cockney humour.

144 **Two Women on a Bench in a Shelter** 1940
Pen & ink, wax crayon, chalk and wash
13¼×15¾ (33.7×40)
Inscribed lower right 'Moore 40'
*Art Gallery of Ontario*, Purchase 1974
The study for this drawing appears on p.40 of the 'First Shelter Sketchbook'.

145 **Morning after the Blitz** 1940
Pencil, pen & ink, wax crayon, chalks and wash
25×22 (63.5×56)
Inscribed lower left 'Moore 40'
*Wadsworth Atheneum, Hartford*, The Ella Gallup
Sumner and Mary Catlin Sumner Collection

Scenes of devastated houses and buildings appear in the two large drawings of 1940 which probably pre-date the 'First Shelter Sketchbook': 'Air Raid Shelter Drawings: Gash in Road' (Fig.43), and 'Standing, Seated and Reclining Figures against Background of Bombed Buildings' (Fig.42). Although there are some six studies in the two shelter sketchbooks of devastated buildings and wreckage in the streets, 'Morning after the Blitz' appears to be the only large drawing of this subject. The artist said that this street scene was in the vicinity of Liverpool Street Station. The fact that this drawing was based on the study on p.60 of the 'Second Shelter Sketchbook' suggests that it may date from 1941. Several sheets from a third shelter sketchbook (which was broken up) are known, including 'Falling Buildings' of 1941, (Beyeler catalogue No.61).

141

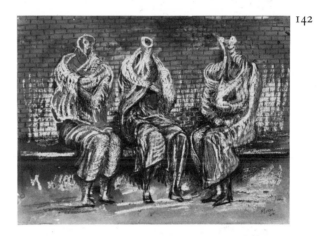

142

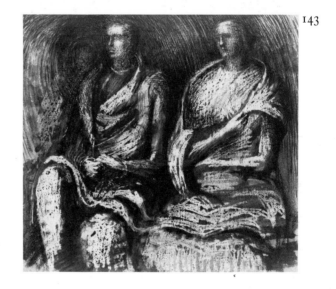

143

Page 105:

Catalogue No.143. The title and details should read as follows:-
Shelter Scene : Two Seated Figures
Watercolour, ink and chalk, 14¾ x 16⅜ (38 x 42.8)
Leeds City Art Galleries, Gift by H.M. Government through the War Artists' Advisory Committee, 1947.

145

146

147

**146 Page from Shelter Sketchbook: Standing Figure Draped and Sleeping Scene 1941**
Pencil, chalk, watercolour wash and wax crayon,
$7\frac{7}{8} \times 6\frac{1}{4}$ (20 × 16)
Inscribed top 'standing figure draped',
'Sleeping [?] Scene'; lower left 'Moore'
*Henry Moore Foundation*

A sheet from the third (dismembered) shelter sketch-book, of which several pages were exhibited at Galerie Beyeler in 1970 (catalogue Nos.57, 58, 59, 61 and 62). Also in the Beyeler catalogue are two numbered (9 and 19) sketchbook pages, catalogue Nos.53 and 60. Although their dimensions vary slightly (possibly an error, or one sheet may have been trimmed), it would appear that they formed part of a fourth shelter sketch-book. In addition, a number of larger sheets are known (Beyeler Nos.63 and 65), measuring approximately $11\frac{1}{2} \times 9\frac{1}{2}$ (29.2 × 24.2), and Nos.147 and 159 below.

**147 Shelter Drawing 1941**
Pencil, chalk, wax crayon and watercolour,
$11\frac{5}{16} \times 9\frac{5}{16}$ (28.8 × 23.6)
*Henry Moore Foundation*

This is one of two sheets in this exhibition (see also No.159) of a slightly larger format than the loose pages from the two sketchbooks mentioned in No.146 above. White wax crayon, hurriedly applied in zigzag strokes, defines the blanketed reclining figures and the curved wall behind them. The circular and triangular forms against the chest of the seated foreground figure are enough to suggest a child in the arms of its mother. Another drawing of the same title, size and identical technique is also owned by the Henry Moore Foundation.

**148 Shelterers in the Tube 1941**
Pen & ink, wax crayon and watercolour,
15 × 22 (38 × 56)
Inscribed lower right 'Moore 41'
*Tate Gallery* (5712)

In the drawings showing figures receding into depth on the station platforms or in the train tunnels, the shelterers in the foreground are more detailed and carefully worked than those in the middle distance and background. Several of the figures here anticipate to a remarkable degree later sculptures. At the extreme right, the seated mother and child could almost be a preparatory study for the Northampton 'Madonna and Child' of 1943-4 (L.H.226). In the reclining figure directly in front of this group, the heavy limbs and the treatment of the drapery anticipate the 'Draped Seated Woman' and 'Draped Reclining Woman' of 1957-8 (L.H.428 and 431). The same blue-grey tonality appears in the following drawing, No.149. The study for 'Shelterers in the Tube' is to be found in the lower half of p.5 of the 'Second Shelter Sketchbook'.

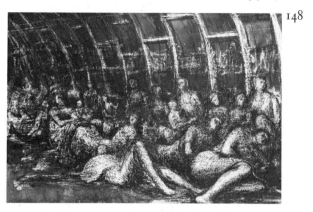

149 **A Tilbury Shelter Scene** 1941
Pencil, pen & brush & ink, wax crayon and
gouache, 16½ × 15 (42 × 38)
Inscribed lower left 'Moore 41'
*Tate Gallery* (5708)

The enormous shelter in a warehouse at Tilbury was
the subject of two large drawings, this version and
another in a private collection. At right just above
centre are the bales of paper which were stored in the
warehouse. The study for this drawing appears on
p.13 of the 'Second Shelter Sketchbook'.

150 **Woman Seated in the Underground** 1941
Pencil, pen & brush & ink, wax crayon and
gouache, 19 × 15 (48.2 × 38)
Inscribed lower right 'Moore 41'
*Tate Gallery* (5707)

Rare among the shelter drawings are studies of single
figures. In this fine example, typical of the densely
worked surfaces, using pen and ink, crayon and
gouache, the delicate network of pen and ink lines give
definition to the figure and drapery. Of particular
interest is the treatment of the head with the closely
knit two-way sectional lines covering it like a net.

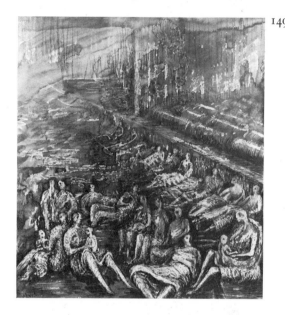

151 **Group of Shelterers During an Air Raid** 1941
Pen & ink, wax crayon, chalk and watercolour,
14½ × 21 (36.8 × 53.3)
*Art Gallery of Ontario*, Gift of the Contemporary
Art Society

As in 'Three Seated Figures' in the Art Institute of
Chicago No.142, it is only the treatment of the heads
which depart from the naturalism of the rest of the
figures. Mention has already been made of the thin
head of the figure at right, similar to the 'Warrior with
Shield' of 1953-4 (Fig.24). The head of the figure
seated on the floor, with the drapery forming an outer
protective shell, is reminiscent of the helmet head
sculptures, of which the first dates from 1939–40
(Fig.35).

In all the preliminary studies for larger drawings in
the first and second shelter sketchbooks, the composi-
tions have been squared for transfer, as is clearly visible
in the sketch for the Toronto drawing on p.17 of the
'Second Shelter Sketchbook' (Fig.48). In a number of
the large drawings based on these sketchbook studies,
the grid of lines is still visible, as in the present draw-
ing. In others, which in all probability were also
squared, these lines are hidden beneath the densely
worked surface.

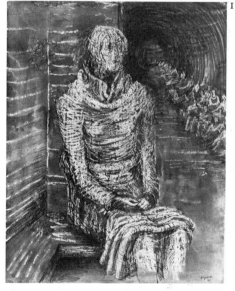

152 **Shelter Drawing: Sleeping Figure** 1940[?]
Chalk, crayon and ink wash, 8½ × 9⅜ (21.5 × 23.8)
Inscribed lower left 'Moore'
*Henry Moore Foundation*

In contrast to the subdued blue-grey tonality found in
many of the shelter drawings are the highly coloured
studies, such as the present drawing, with the red,
green and yellow highlights of the blankets. The chaotic
positions of the shelterers, somewhat similar to the

151

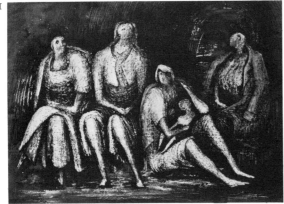

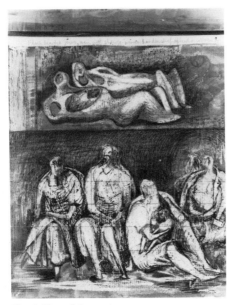

Fig.48 Henry Moore,
*Page 17 from Second Shelter Sketchbook*, 1941

152

composition 'Shadowy Shelter' of 1940, No.141, suggest that this drawing may also date from the autumn of 1940.

### 153 Seated Women in a Tube Shelter 1941
Pen & ink, chalk, crayon and watercolour,
$17 \times 10\frac{1}{2}$ (43.2×26.6)
Inscribed lower right 'Moore 41'
*Lord Clark*

Often the titles of the large drawings derive from the inscriptions describing their sketchbook studies. On p.56 of the 'First Shelter Sketchbook', the preparatory study for this drawing is inscribed 'Two Seated Women in a Shelter'.

### 154 Shelter Drawing 1941
Gouache, $17\frac{3}{4} \times 16\frac{1}{4}$ (45×41.3)
Inscribed lower right 'Moore 41'
*Mrs Neville Burston*

Few drawings provide a more convincing impression of the over-crowded conditions on the station platforms of the London Underground. With the high view point, distant perspectives are eliminated, so that we look down on reclining and seated figures, whose tightly packed bodies fill the entire composition, apart from the small area of the wall at upper right.

### 155 Shelter Scene: Bunks and Sleepers 1941
Pen & ink, wax crayon, watercolour and gouache,
$19 \times 17$ (48.2×43.2)
*Tate Gallery* (5711)

This and its pendant of the same title and size in the Cecil Higgins Art Gallery, Bedford, are the only two large drawings of this subject. There are, however, six sheets of studies of bunks and shelterers on pp.33, 71, 72, 73, 74 and 75 of the 'Second Shelter Sketchbook', of which the one on p.33 is the preparatory sketch for the Tate Gallery drawing. In addition there is a small study of this subject entitled 'Shelter Scene', in the collection of Mr Lockwood Thomson, Cleveland, Ohio.

### 156 Figure in a Shelter 1941
Pencil, pen & ink, wax crayon and wash,
$15 \times 22$ (38.1×56)
Inscribed lower right 'Moore 41'
*Wakefield Art Gallery and Museums*

This and a smaller version of the same subject, entitled 'Figure about to Lie Down in a Shelter' of 1941, are based on the figure at right on p.64 of the 'Second Shelter Sketchbook'. In both the shelter and coal-mine drawings Moore occasionally enlarged single figures chosen from a multi-figure composition.

### 157 Shelter Scene: Two Swathed Figures 1941
Chalk, pen & ink and watercolour,
$10\frac{7}{8} \times 15\frac{1}{16}$ (27.7×38.2)
*City of Manchester Art Galleries*

In this drawing one might almost say that the drapery *is* the subject. Only the three heads emerge, the internal forms protected by the rhythmic flow of the thick

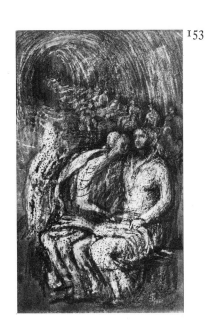

153

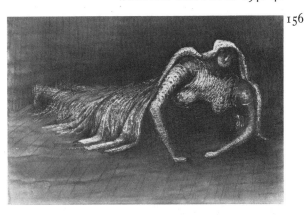

156

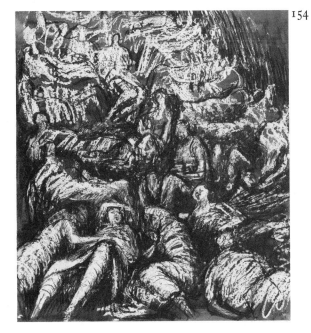

154

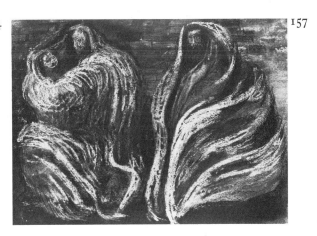

157

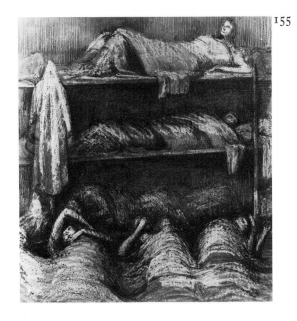

155

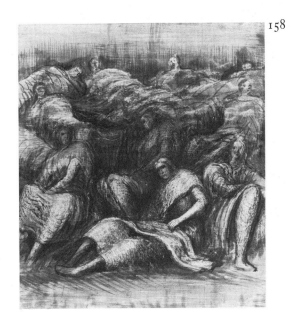

158

159

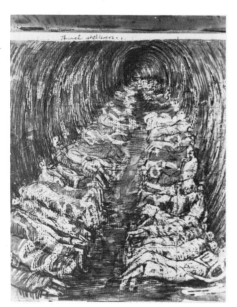

160

Fig.95 Henry Moore,
*Page 24 from Second Shelter Sketchbook, 1941*

blankets, the external forms around the figures. The two swathed figures were based on the studies at left and centre in the upper half of p.61 from the 'First Shelter Sketchbook'.

### 158  Women in a Shelter 1941
Watercolour and crayon, $18\frac{5}{8} \times 17\frac{3}{8}$ (47.2 × 44.2)
*Museum of London*

The study for the drawing appears on p.25 of the 'Second Shelter Sketchbook'.

### 159  Tube Shelter Perspective 1941
Pencil, chalk, wax crayon and watercolour,
$11\frac{1}{8} \times 9\frac{1}{4}$ (28.3 × 23.5)
*Private collection*

Of all the shelters which Moore visited, he found the Liverpool Street Extension the most visually exciting with two rows of figures sleeping on the tunnel floor. (See introduction p.32). On the evidence of the composition, at centre left on p.21 of the 'First Shelter Sketchbook' (Fig.46), it would appear that he was familiar with the extension by the late autumn or early winter of 1940, by which time he had probably filled about a third of the sixty-seven pages of this sketchbook. The study for the present drawing, however, appears on p.10 of the 'Second Shelter Sketchbook'. Both are closely related to the large drawing in the Tate Gallery 'Tube Shelter Perspective' (No.160) and the two studies for it. (See notes for No.160 below). The Liverpool Street Extension also appears in the sketch 'Tube Shelter Perspective' of 1941 in the collection of Dr and Mrs Henry Roland.

### 160  Tube Shelter Perspective 1941
Pencil, pen & ink, wax crayon and watercolour,
$18\frac{7}{8} \times 17\frac{1}{4}$ (48 × 43.8)
*Tate Gallery* (5709)

The definitive version of the subject of five drawings, 'Tube Shelter Perspective' is one of Moore's best known shelter drawings. The squared lines are still visible, a clear indication that this drawing was directly based on the study inscribed 'Tunnel shelterers', on p.24 of the 'Second Shelter Sketchbook' (Fig.95), and not on the intermediate and less detailed 'Study for Tube Shelter Perspective' of 1941 owned by the Henry Moore Foundation. The Tate drawing is discussed in the introduction, p.32.

### 161  Four Grey Sleepers 1941
Pen & ink, chalk, wax crayon and watercolour,
$16\frac{7}{8} \times 19\frac{5}{8}$ (42.9 × 50)
Inscribed bottom right 'Moore'
*Wakefield Art Gallery and Museums*

Tones of white, grey and black, without the distraction of brightly coloured blankets, lend a sombre note to this beautiful and sensitive drawing, based on the study on p.35 of the 'Second Shelter Sketchbook'. As a group, the shelter drawings depict an anatomy of sleep. It is obvious from the notes and the drawings themselves that Moore had carefully studied the varied

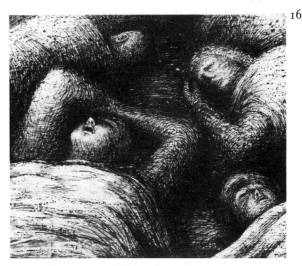
161

sleeping positions, and paid particular attention to the placement of arms and hands. An inscription on p.35 of the 'Second Shelter Sketchbook' reads: 'Figures in sleeping positions hands up to face, hands above heads etc., hands curled up near face'. The position of arms and hands are of considerable importance in the following series of drawings (Nos.162–8) of blanketed sleeping figures, with only their heads and arms visible.

162  **Sleeping Figures (Four Drawings)** 1941
  A (upper left) Pencil, 5 × 4¼ (12.7 × 10.8)
   Inscribed lower left 'Moore 41'; top 'Sleeping
   Figures'
  B (upper right) Pencil, 4¾ × 4¼ (12 × 10.8)
   Inscribed lower left 'Moore 41'; top 'Two
   Sleeping Figures'
  C (lower left) Pencil, 4¾ × 4⅛ (12 × 10.5)
   Inscribed lower left 'Moore 41'; top 'Sleeping
   Head and hand'
  D (lower right) Pencil, 4½ × 4⅛ (11.5 × 10.5)
   Inscribed lower left 'Moore 41'; upper right
   'Sleeping head'
  *Art Gallery of Ontario*, Purchase 1977

Unique among Moore's shelter drawings are these four hurried pencil sketches. The study inscribed 'Sleeping Figures' is related to the Wakefield drawing No.161. Amid the almost frenzied tangle of lines, a boldly drawn sectional line runs across and down the left arm of the figure just above centre, meeting the curved lines around the lower part of the arm. 'Sleeping head and hand' and 'Sleeping head' are closely related to the studies of four heads on p.68 of the 'Second Shelter Sketchbook' and to the Tate's 'Pink and Green Sleepers' No.165.

 These four drawings belonged to the late Mark Tobey.

162

163  **Sketch for Pink and Green Sleepers** 1941
  Pencil, chalk, wax crayon and wash,
  15½ × 20 (39.3 × 50.8)
  Inscribed lower right 'Moore 42'
  *Trustees of the British Museum*

The last six shelter drawings in this exhibition are of a theme found in many sheets towards the end of the 'Second Shelter Sketchbook', and in at least ten large drawings: blanketed sleeping figures seen from a low view point, with only the heads and arms exposed. This drawing, one of two large studies for 'Pink and Green Sleepers' in the Tate Gallery, No.165, is the less finished of the two versions. (See No.164). It was almost certainly based on the definitive sketch for the Tate Gallery drawing on p.67 of the 'Second Shelter Sketchbook' (Fig.96).

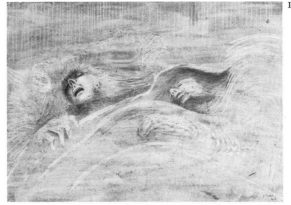
163

164  **The Two Sleepers** 1941
  Chalks, pen and watercolour, 15½ × 21½ (39.3 × 54.6)
  Inscribed lower right 'Moore 41'
  *Dr and Mrs Henry M. Roland*

A more elaborately worked up study for 'Pink and Green Sleepers', this drawing, like No.163, was no

164

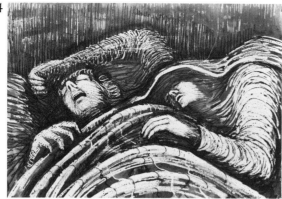

165

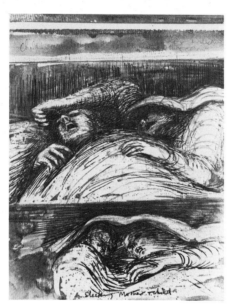

Fig.96 Henry Moore,
*Page 67 from Second Shelter Sketchbook*, 1941

doubt based on the sketch on p.67 of the 'Second Shelter Sketchbook' (Fig.96). The faces, hands, blankets, and the arm of the figure at right are highlighted in white; the faces are dramatically lit as if by spotlights.

**165 Pink and Green Sleepers 1941**
 Pen & ink, chalk, wax crayon, wash and gouache,
 15×22 (38×55.8)
 Inscribed lower right 'Moore 41'
 *Tate Gallery* (5713)

This, the definitive version, is perhaps Moore's best-known shelter drawing. He was obviously particularly attracted by this composition, for in addition to the study squared for transfer on p.67 of the 'Second Shelter Sketchbook' (Fig.96), on which this drawing was based, there are two sketchbook pages with related drawings, as well as the two large studies, Nos.163 and 164. On p.68 of the 'Second Shelter Sketchbook' the four heads are closely related to but not exact studies for either of the two heads in the Tate drawing. The full page drawing of a head on p.69 of the same sketchbook is, on the other hand, a study for the figure at left in 'Pink and Green Sleepers'. Of the seven other known large drawings of related compositions, No.167 is closest to the Tate version. (See also No.168.) Those not shown here belong to: Staatsgalerie Stuttgart; the Israel Museum, Jerusalem and three in private collections.

**166 Tube Shelter Scene III 1942**
 Brush, chalk and watercolour,
 $6\frac{9}{16}\times8\frac{9}{16}$ (16.6×21.7)
 Inscribed lower right 'Moore 42'
 *Lockwood Thompson*

The only drawing in the series in which the shelterers are not sleeping. The figure at right lifts the blanket over its head and peers at the figure lying close by. This, one of the last of the shelter drawings, was probably done early in 1942. The study for it appears in the bottom third of p.91 in the 'Second Shelter Sketchbook'.

**167 Two Sleepers 1941**
 Chalk, wax crayon and watercolour,
 12×18 (30.5×45.7)
 Inscribed lower right 'Moore 41'
 *Dr Walter Hussey*

No study has been found for this superb, yet terrifying drawing, which is described in the introduction, p.35. In the series of seven drawings which concludes this selection of shelter drawings, and in this work in particular, the gaping mouths and the extreme foreshortening are features which are remarkably similar to the sleeping apostles in Mantegna's 'The Agony in the Garden' in the National Gallery, London (Fig.97). One wonders if the resemblance is merely fortuitous?

168  Sleeping Shelterers: Two Women and a
      Child 1941
      Pen & ink, chalk, wax crayon and watercolour,
      $11 \times 18\frac{1}{8}$ (28.1 × 46)
      Inscribed lower right 'Moore 40'
      *University of East Anglia*, The Robert and Lisa
      Sainsbury Collection

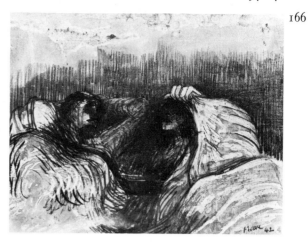

This and two other drawings in the series (owned by
a private collector and the Israel Museum, Jerusalem)
include more than two figures. The fact that the study
for the figure at left appears on p.84 towards the end
of the 'Second Shelter Sketchbook' suggests that this
drawing has been incorrectly dated 1940. A date of
late 1941 is more probable. In this touching drawing
a child sleeps between two women, with the expanse of
blanket in the foreground, like an ocean swell, rising
and falling over the bodies of the sleeping shelterers.

Fig.97 Andrea Mantegna,
*The Agony in the Garden*, 1459 (detail)
(National Gallery, London)

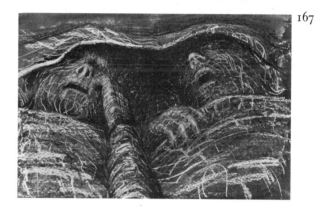

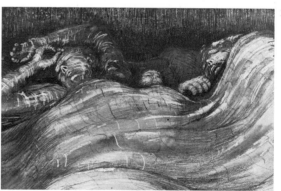

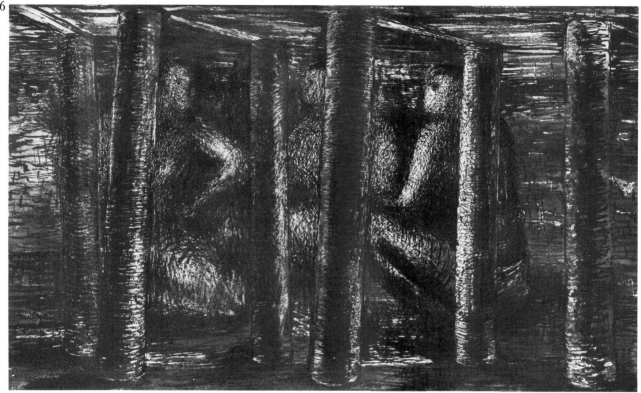

169

**169 Page 4 from Coalmining Notebook** 1941
Pencil and chalk, $7\frac{7}{8} \times 4\frac{1}{2}$ (20×11.5)
Inscribed upper left 'Shadow'; upper right '4';
bottom 'Pit pony – Large head in perspective'
*Henry Moore Foundation*

In this, the smallest of the three coal-mine sketchbooks, Moore drew *in situ* down the pit at the Wheldale Colliery at Castleford. This notebook originally contained sixty-three pages, numbered at upper right on the recto of each sheet. Pages 2, 11, 12, 14, 16 and 21 are missing. Many of the quick sketches and written notes were made down the mine, some in the near darkness of the tunnels near the coal face. The Deputy, who had been asked to show Moore the workings of the mine and the daily routine of the miner's working day, posed for a number of the studies in this notebook. Remembering a pose he had seen near the coal face, Moore occasionally asked the Deputy to pose for him in the less cramped, better lit spaces in the large tunnels and roads.

On p.4, the sketch of a pit pony is the study for the drawing in the upper half of 'Page from Coalmine Sketchbook: Boy and Pony' of 1942 (No.171). The inscription on the latter sheet refers to studies on pp.'4, 12, 13, 14 of pit notebook', which is perhaps a more suitable title for this little sketchbook which is now known as the 'Coalmining Notebook'. Several other drawings in the 'Coalmine Sketchbook' were based on studies in the pit sketchbook (see Nos.175, 177–180, 182 and 183).

170 **Page 31 from Coalmining Subject**
  **Sketchbook** 1942
  Pencil, pen & ink, wax crayon, coloured chalks and
  wash, 8 × 6⅜ (20.3 × 16.2)
  *Henry Moore Foundation*

The second of the three coal-mine sketchbooks is
slightly larger than No.169 above, and contains more
finished drawings. Both the 'Coalmining Subject
Sketchbook' and the 'Coalmine Sketchbook' have been
dismembered. In many of the coal-mine studies and
larger drawings the same technique and media found in
the shelter drawings were used: pencil, pen and ink, wax
crayon, wash and watercolour.

None of the drawings in this notebook has been
squared for transfer. It would appear that the large coal-
mine drawings were based on studies in the third and
largest of the notebooks, known as the 'Coalmine
Sketchbook'. (See No.171 below.) Another version of
the top composition in the present drawing appears on
'Page from Coalmine Sketchbook: Study for Coalminer
with Pick' of 1942 in the Collection of Irina Moore.

170

171 **Page from Coalmine Sketchbook: Boy and**
  **Pony** 1942
  Chalk, crayon and wash, 9⅞ × 7 (25.1 × 17.8)
  Inscribed top 'Boy and pony (4, 12, 13, 14 of pit
  notebook and see other notebook)'; lower right,
  'Moore 42'
  *Private collection*

This sheet is from the largest of the three coal-mine
sketchbooks, which was subsequently dismembered.
Of the thirty-five known drawings from this sketch-
book, fifteen are now owned by museums: Victoria and
Albert Museum, one; Yorkshire Consortium of
Museums and Resource Services, three; the British
Museum, five; Oeffentliche Kunstsammlung, Basel,
three; the Art Gallery of Ontario, three. One page is
in a private collection; the remaining drawings are
owned by the artist and his family. It was from the
studies in the 'Coalmine Sketchbook' that the larger
drawings were based. Only in the first notebook, No.
169, did Moore draw *in situ*. The drawings in this and
No.170 were done on his return to Hoglands after
about a fortnight's visit to Castleford.

The study at the top of this sheet was based on the
drawing of a pit pony on 'Page 4 from Coalmining
Notebook', No.169.

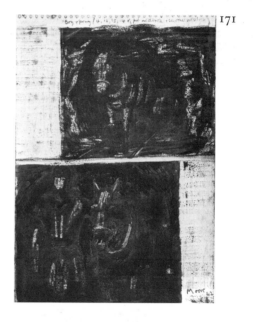
171

172 **Page from Coalmine Sketchbook: Types of**
  **Roads** 1942
  Pen & ink, crayon and wash, 9⅞ × 7 (25.1 × 17.8)
  Inscribed top 'Types of Roads (Tunnels) –
  Bar and legs – steel girdered etc.'; lower left
  'Moore 42'
  *Art Gallery of Ontario*, Gift of Henry Moore, 1974

Six studies of roads and tunnels leading to the coal
face. Related drawings appear on 'Page 15 from Coal-
mining Subject Sketchbook' inscribed 'types of tunnel
settings', and in 'Page from Coalmine Sketchbook:
Rock and Coal Formations'.

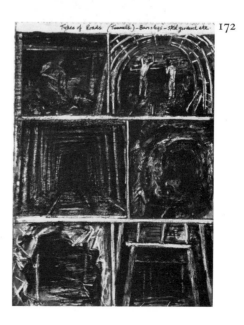
172

173
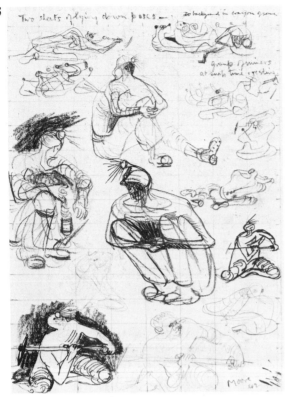

**173 Page from Coalmine Sketchbook: Study for Miners Poses and Positions** 1942
Pencil, pen & ink, crayon, $9\frac{7}{8} \times 7$ (25.1 × 17.8)
Inscribed across the top 'Two sheets of lying down poses – Do background in crayon of some'; below last sentence 'Group of miners at snap time and resting'; at lower right 'Moore 42'
*Art Gallery of Ontario*, Gift of Henry Moore, 1974
This and a similar sheet in the Victoria and Albert Museum show studies of miners at work and at rest. Four of the freely drawn sketches in the upper third of the page are stylistically related to the drawings for sculpture of the mid-1930s. In one of these, the almost abstract form at right just above centre, the circular shape of the helmet lamp, with the light radiating from it, is the only tenuous link with the subject – a miner at work. The two large studies of miners squatting on their haunches show one of the most typical poses of the men in the low, cramped spaces near the coal face. In fact, the artist said, the miners were so accustomed to working in such a pose that they often remained in this position during snap time (meal time) or during a break.

The entire sheet has been squared for transfer. At lower left is the study for 'Miner at Work' No.174. All the figure studies are included in the large drawing 'Miners Poses and Positions' in a private collection. See the related drawing 'Studies of Miners at Work' No.186, which was based on a sketch similar to the Toronto drawing in the Victoria and Albert Museum.

174
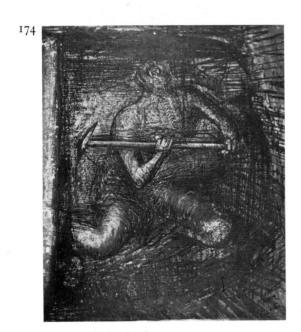

**174 Miner at Work** 1942
Pen & ink, chalk, crayon, wash and scraping, $12\frac{1}{4} \times 10\frac{1}{2}$ (31.1 × 26.7)
Inscribed lower right 'Moore 42'
*Henry Moore Foundation*
This drawing was based on the study at lower left in 'Page from Coalmine Sketchbook: Study for Miners Poses and Positions', in the Art Gallery of Ontario, No.173 above.

**175 Page from Coalmine Sketchbook: Study for Miners Resting During Stoppage of Conveyor Belt** 1942
Pen & ink, crayon and wash, $9\frac{7}{8} \times 7$ (25.1 × 17.8)
Inscribed across top: '22 × 13 Miners resting during stoppage of conveyor belt $4\frac{1}{8}$ [?]'; across centre of sheet 'Two Men working in Drift – ankle deep in water; Miner walking along low road; water coming from roof bits of coal on ground Moore 42'
*Art Gallery of Ontario*, Gift of Henry Moore, 1974
The composition in the upper half of the sheet, squared for transfer, is the study for 'Miners Resting During Stoppage of Conveyor Belt', in the Leeds City Art Galleries, No.176. The miner drilling at lower left was based on a sketch on p.22 of the 'Coalmining Notebook'. See notes for No.177 below.

176 Miners Resting During Stoppage of
Conveyor Belt 1942
Pen & ink, chalk, wax crayon and watercolour,
and squared in pencil, $13\frac{3}{8} \times 20$ (33.9 × 50.8)
Inscribed lower left 'Moore 42'
*Leeds City Art Galleries*

This beautiful drawing was based on the study in
No.175 above, in the Art Gallery of Ontario. Although,
as Moore has said, he was not at the time particularly
aware of Seurat's drawings, the masterful handling of
light and dark is, nevertheless, reminiscent of the conté
crayon drawings of Seurat's maturity which in later
years Moore has come to admire so greatly. One of the
two Seurat drawings in his own collection is reproduced
(Fig.54.)

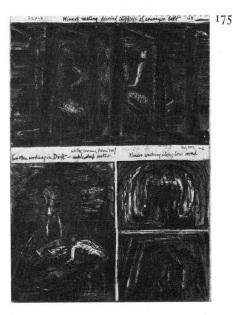

175

177 Page from Coalmine Sketchbook: Drilling
in Drift 1942
Pen & ink, chalk, wax crayon and watercolour,
squared in pencil, $9\frac{7}{8} \times 7$ (25.1 × 17.8)
Inscribed across top 'Drilling in Drift. (19, 20, 21,
22, 23 and [?] see [?] other notebook)'; across
centre '$3\frac{1}{2} \times 4\frac{3}{4}$ 15 × 20 22 × 15 $3\frac{1}{4} \times 4\frac{3}{4}$'; lower right
'Moore 42'
*Private collection*

Three of the four studies were based on sketches in
'Coalmining Notebook' (the 'pit notebook' of drawings
done *in situ*), which is referred to in the inscription
with page numbers at the top of the sheet. The sketch
at upper left was based on the study on p.20 of the
'Coalmining Notebook'; the one at upper right on
p.22; the one at lower right on p.23. The entire sheet
of four studies has been squared for transfer, although
only two large versions of miners drilling are known.
At upper right is the study for 'Miner Drilling in Drift'
of 1942, University of East Anglia at Norwich (The
Robert and Lisa Sainsbury Collection), and at lower
left is the study for another drawing of the same title,
in a private collection.

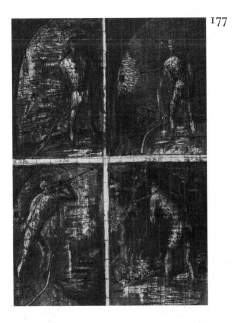

177

178 Page from Coalmine Sketchbook: Study for
Coalminer Carrying Lamp 1942
Pen & ink, chalk, wax crayon and watercolour,
squared in pencil, $9\frac{7}{8} \times 7$ (25.1 × 17.8)
Inscribed across top '15 × $18\frac{1}{2}$ Miner walking
along tunnel (3 of pit notebook) Moore 3 × 7/10'
*Private collection*

Both studies on this sheet were based on compositional
sketches on p.3 of the 'Coalmining Notebook'. (see
inscription at the top of the page). The drawing squared
for transfer is the study for 'Coalminer Carrying Lamp'
No.179 below.

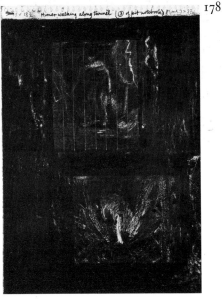

178

179 Coalminer Carrying Lamp 1942
Chalk, wax crayon, wash and scraping,
19 × $15\frac{1}{2}$ (48.2 × 39.4)
Inscribed lower left 'Moore 42'
*Private collection*

This drawing was based on the study squared for
transfer in No.178 above, which in turn was based on

179

Fig.53 William Holman Hunt,
*The Light of the World*, 1853
(Keble College, Oxford)

180

the sketch on p.3 of the 'Coalmining Notebook'. Stooping, carrying a lantern in his left hand, a miner emerges out of the fractured entrance of a tunnel. While working on this drawing, Moore was reminded of a reproduction of Holman Hunt's 'The Light of the World' (Fig.53), which hung in his parent's house in Castleford.

180  **Page from Coalmine Sketchbook: Miners' Faces 1942**
Pen & ink, chalk, wax crayon and wash,
$9\frac{7}{8} \times 7$ (25.1 × 17.8)
Inscribed top 'Miners faces – lips white because of licking – brilliant whites of eyes cheekbones whiter than rest – most black round nose and creases from nose etc'
*Private collection*

This, and its pendant in the collection of Irina Moore, are two of the finest sheets from the 'Coalmine Sketchbook'. On pp.1 (verso), 58, 61 and 62 of the little 'Coalmining Notebook', Moore made hurried sketches of miners' faces. The fact that the inscription at the top of the present drawing follows almost word for word the one on p.61 of the pit notebook just referred to, suggests that the studies made *in situ* were the basis for these more fully worked drawings. As mentioned in the introduction on p.39, the contrast between the whites of the miners' eyes and their blackened faces covered with coal dust reminded Moore of Masaccio's frescoes.

181  **Pit Boys at Pit Head 1942**
Pen & ink, chalk, wax crayon and watercolour,
$13\frac{1}{2} \times 21\frac{1}{2}$ (34.2 × 54.6)
Inscribed lower right 'Moore 42'
*Wakefield Art Gallery and Museums*

This composition, based on the study in 'Page from Coalmine Notebook: Study for Pit Boys at Pithead' in the collection Irina Moore, would appear to be the only large drawing of miners above ground. It shows the pit head winding gear in the background. The head of the miner at the extreme right, the most detailed and life-like of the four, was based on the squared study at upper right in the sketch mentioned above.

182  **At the Coal Face: Miner Pushing Tub 1942**
Pen & ink, chalks, wax crayon and wash,
$13\frac{1}{8} \times 21\frac{3}{4}$ (33.3 × 55.2)
Inscribed lower right 'Moore 42'
*Trustees of the Imperial War Museum*

This powerful drawing, with its dramatic contrast of light and dark, was based on the study in the upper half of 'Page from Coalmine Sketchbook: Studies for At the Coal Face: Miner Pushing Tub, and Coalminers' of 1942, in the Oeffentliche Kunstammulung, Basel. The inscription below the study reads: 'Man pushing tub lamp hanging from waist. Other miners in compartments in background'. Less finished studies of miners pushing tubs are found on pp.1 (verso), 29 and 30 of the 'Coalmining Notebook'.

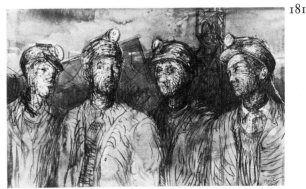
181

**183  Miners at Work on the Coal Face** 1942
  Pen & ink, chalk, wax crayon and wash,
  13 × 22 (33 × 55.9)
  Inscribed lower left 'Moore 42'
  *Birmingham City Museum and Art Gallery*
This composition is based on the study in the upper
half of 'Page from Coalmine Sketchbook: Study for
Miners at Work on the Coal Face' of 1942, in the
British Museum. A smaller study appears on p.33 of
the 'Coalmining Notebook'. At right, the miner is
wedged between the wooden pit props, with the light
reflecting off his back and the soles of his boots. In con-
trast, the body of the other miner (who does not appear
in the British Museum study) is dark, silhouetted
against the source of light in front of him.

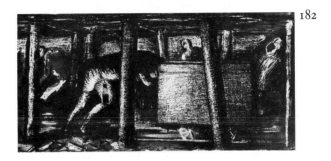
182

**184  Miners at Work** 1942
  Pen & ink and chalk, 22¼ × 17 (56.5 × 43.2)
  *Whitworth Art Gallery, University of Manchester*
Although no exact study for this drawing is known, the
figures in 'Page from Coalmine Sketchbook: Positions
of Individual Miners' in the British Museum are
closely related to these miners carrying lamps and
working at the coal face. A pendant to the Whitworth
drawing, of the same title and dimensions, is in the
City Museum and Art Gallery, Birmingham.

183

**185  Coalminers** 1942
  Chalk, crayon, wash and watercolour,
  13¾ × 25½ (35 × 64.7)
  Inscribed lower left 'Moore 42'
  *Private collection*
It is appropriate that one of the coal-mine drawings
used to belong to Moore's old grammar school in
Castleford, in the town where he was brought up and
where he made the first sketches for this series of coal-
mine drawings at the Wheldale Colliery. The study for
No.185 appears in the lower half of 'Page from Coal-
mine Sketchbook: Studies for At the Coal Face: Miner
Pushing Tub and Coalminers' in the Oeffentliche
Kunstsammlung, Basel.

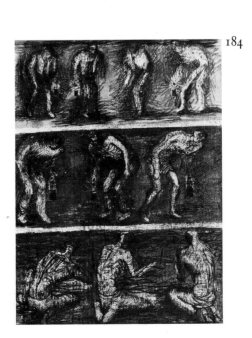
184

**186  Studies of Miners at Work** 1942
  Pen & ink, chalks, wax crayon and watercolour,
  24¾ × 17⅜ (62.8 × 44.1)
  Inscribed lower right 'Moore 42'
  *M. F. Feheley*
This, one of the largest of the coal-mine drawings, was
based on the studies of individual miners in 'Page from
Coalmine Sketchbook: Study for Miners at Work', in
the Victoria and Albert Museum. As in the Toronto
book page No.173, there are semi-abstract features, but
here, only in one of the thirteen studies of miners at
work. This appears at right, fourth from the bottom, in
which the miner's shoulder and the sharp form project-
ing from the leg, depict shapes reminiscent of the
pointed form drawings of 1939–40 (No.125). The pose
of the miner at lower left is identical to 'Miner at Work'
in the Imperial War Museum, although the latter was
based on another sketchbook page (see notes for No.

185

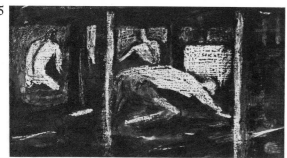

186

187). Related drawings of individual miners are in the Art Gallery of Ontario No.173, and the large 'Miners Poses and Positions', based on the latter drawing, in a private collection.

**187  Miner at Work** 1942
   Ink and chalk, 19½ × 19½ (49.5 × 49.5)
   Inscribed lower right 'Moore 42'
   *Trustees of the Imperial War Museum*

This drawing was based on the study, squared for transfer, at upper left in 'Page from Coalmine Sketchbook: Study for Miner at Work' in the collection of Irina Moore. A miner in a similar pose appears at lower left in No.173, and in the sketch in the Victoria and Albert Museum. The source of light, a lantern hanging from one of the pit props, throws a yellow-white light on the miner's back. The yellow light of the lantern itself also highlights the left edge and the hole of the coat hanging from the ceiling. The background is blue-grey, the large pit prop grey-brown and the smaller one at right a grey-blue. Great subtleties of tone and surface texture are achieved with pen and ink, chalk, crayon and watercolour in this, one of the most beautiful of the large coal-mine drawings.

187

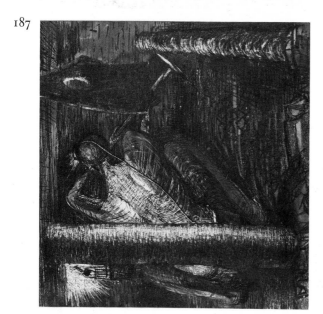

Page 120:   Illustration No.187 is reproduced on its side.
            See colour reproduction opposite p.37.

# Drawings 1942–77

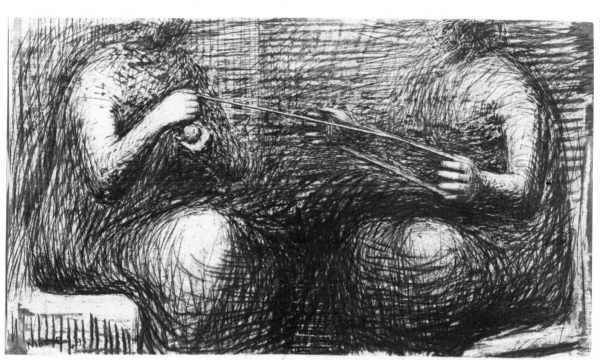

**188  Page from Sketchbook: Three Reclining Figures** 1942
Pencil, pen & ink, chalk, wax crayon and watercolour, $8\frac{15}{16} \times 6\frac{7}{8}$ (22.7 × 17.4)
Inscribed lower left 'Moore 42'
*Private collection*

By the summer of 1942, Moore had completed the series of coal-mine drawings and began filling a notebook with ideas for sculpture. He had worked for nearly two years on the war drawings, during which time no sculpture had been produced. In this drawing, one of many surviving sheets from a dismembered notebook, the rounded, hollowed-out figures are somewhat suggestive of the heavy, draped figures in the shelter drawings, but are rendered in a more abstract style. The central figure in No.188 anticipates the drawings of 1942 for the large elmwood 'Reclining Figure' of 1945–6 (L.H.263). See notes for No.189 below.

**189  Reclining Figure and Pink Rocks** 1942
Crayon, $22 \times 16\frac{1}{2}$ (56 × 42)
Inscribed lower left 'Moore 42'
*Albright-Knox Art Gallery, Buffalo, New York*
(Room of Contemporary Art Fund)

This is the largest of the four known drawings of 1942 for the elmwood 'Reclining Figure' of 1945–6 (L.H. 263). The present drawing may have been based on one of the two reclining figures in 'Studies' of 1942, Royal Museum of Fine Arts, Copenhagen. (The other two drawings are in private collections, see L.H. Volume I, p.250). None of the four drawings includes the breasts which appear in L.H.263. Three maquettes (L.H.247, 248 and 249) preceded the large carving. The forms at left in the background of the Buffalo drawing, recall the curved shape behind the shoulders of 'Reclining Figure' 1938 (No.118). Two closely related drawings of 1942 of sculptures in settings are No.190, 'Reclining Figure and Red Rocks' (British Museum), and 'Wood Sculpture in Setting of Red Rocks' (Museum of Modern Art, New York).

**190  Reclining Figure and Red Rocks** 1942
Pen & ink and chalk, $15\frac{3}{4} \times 22$ (40 × 56)
Inscribed lower right 'Moore 42'
*Trustees of the British Museum*

The outdoor setting and rock background are related to No.189 above, and to 'Wood Sculpture in Setting of Red Rocks' of 1942, in the Museum of Modern Art,

188

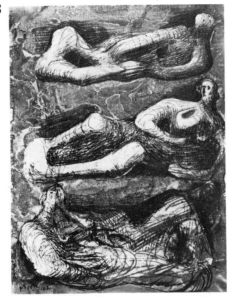

189

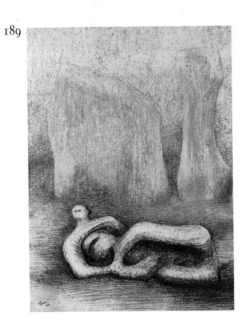

190

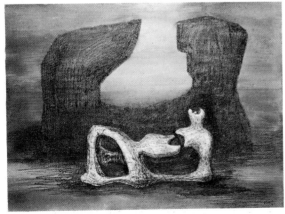

New York. A feature similar to the dramatic thrust of the left side of the rock appears in the first of the two-piece sculptures of the late fifties and early sixties – the leg end of 'Two Piece Reclining Figure No.1' of 1959 (L.H.457, Fig.55).

191 **Sculpture in Landscape** 1942
    Pen & ink and wax crayon, $14\frac{15}{16} \times 21\frac{3}{4}$ ($38 \times 55.3$)
    Inscribed lower left 'Moore 42'
    *Santa Barbara Museum of Art*, Gift of Wright
    Ludington 45.6.12

This peaceful rural setting which recalls 'Sculptural Object in Landscape' of 1939 (No.124), may also have been inspired by the view behind Moore's cottage in Kent (Fig.40), although the property had been sold at the beginning of the war. The two pointed forms behind the large reclining figure first appeared in earlier drawings; the sculpture at right with three points practically touching in 'Pointed Forms' of 1939 or 1940, in the Albertina (L.H. Volume 1, p.221); the upright sculpture with arrow head in 'Seated Figure and Pointed Forms' of 1939 (No.125).

192 **Study for Crowd Looking at a Tied-up Object** 1942
    Pen & ink and pencil, $5\frac{3}{4} \times 6\frac{3}{4}$ ($14.5 \times 17.1$)
    Inscribed top 'Crowd of people looking at a tied-up object, (veiled object/white draped object. (veiled sculpture [last two letters cut off]'; below this 'white drapery/Dark Sky?'; above the stones lower right 'stones'; bottom 'Do page of drawings of draped objects tied-up (white seated)'; (squared for transfer)
    *Private collection*

The preparatory study and the finished version (No. 193 below) of Moore's most famous pictorial composition are exhibited together for the first time. The probable source of this composition is discussed in the notes for No.193 below.

193 **Crowd Looking at a Tied-up Object** 1942
    Pencil, black and coloured chalk, wax crayon and wash, $15\frac{3}{4} \times 21\frac{5}{8}$ ($40 \times 55$)
    Inscribed lower left 'Moore 42'
    *Lord Clark*

The enigmatic subject matter of this unique pictorial composition has led to a certain amount of speculation as to a possible source. As the drawing is discussed in some detail in the introduction (p.41), it is sufficient to mention again that the source was almost certainly the photograph in Frobenius' *Kulturgeschichte Afrikas* (1933) showing a group of Nupe tribesmen standing around two veiled, Dako cult dance costumes (Fig.57). Moore owns a copy of this book, and has made other drawings derived from illustrations in it. See notes for Nos.112 and 126.

In 1957, Moore made seven drawings of tied-up objects and figures, but they have none of the sense of drama and expectancy of the present drawing.

'Crowd Looking at a Tied-up Object' appears in the

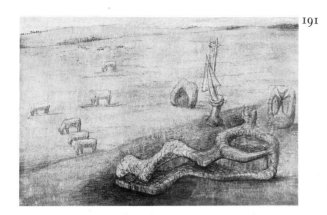

191

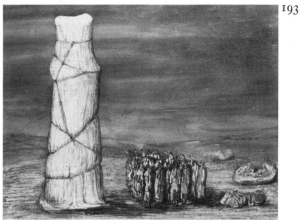

193

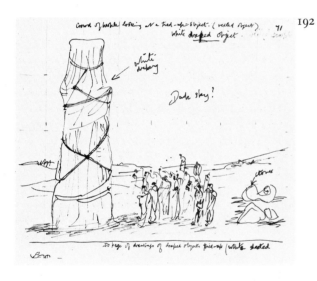

192

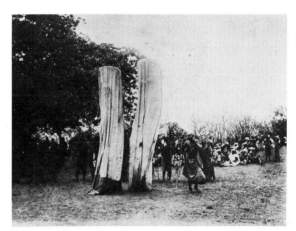

Fig.57 Nupe tribesmen standing around two
veiled Dako cult dance costumes

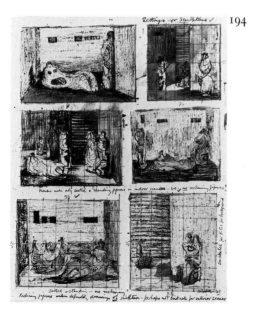

194

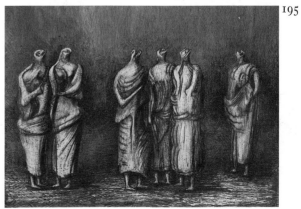

195

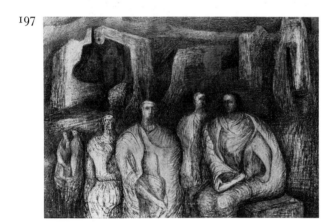

196

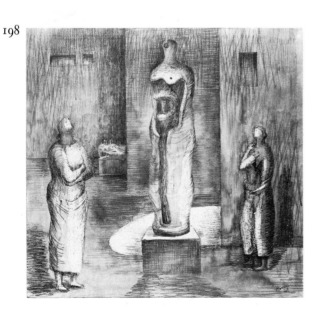

197

198

background of a drawing of 1946 'Girl Reading to a Woman and Child', No.207, and is the subject of an etching of 1966 'Crowd Looking at a Tied-up Object' (C.G.M.79).

### 194 Six Settings for Sculpture 1942

Pen & ink, chalk, wax crayon and watercolour, $8\frac{7}{8} \times 6\frac{7}{8}$ (22.5 × 17.5)
Inscribed lower right 'Moore 42'; top right 'Settings for Sculpture'; right of composition, upper right '$2\frac{1}{4}$'; below this '$2\frac{1}{4}$'; above composition, centre left '$3\frac{2}{10}$'; beside this page turned ninety degrees to right '$2\frac{3}{10}$'; below two compositions, centre 'Perhaps make only seated and standing figures in indoor scenes – i.e. no reclining figures'; above composition lower left '$3\frac{1}{4}$'; left of this '$2\frac{7}{10}$'; left of composition lower right, with sheet turned ninety degrees to right '3'; right of this with sheet turned ninety degrees to right 'see sketch for KCs for background'; below this '$2\frac{5}{8}$'; bottom 'seated and standing' – no reclining?/Reclining figures unless definitely drawings of sculpture – perhaps not suitable for interior scenes'.
*Private collection*

Four of the six compositions have been squared for transfer. The study at lower right is for 'Seated Women with Children' of 1942 (private collection). At centre left is the study for 'Figures in a Setting' of 1942 (L.H. Volume I, p.242), and at upper right is the sketch for 'Three Figures in a Setting' of 1942, now in the Santa Barbara Museum of Art (L.H. Volume I, p.242). The reclining figure in the composition at upper left appears in 'Figure in a Hollow' of 1942 (L.H. Volume I, p.249). No large drawing is known based on the squared composition at lower left. The inscription beside the study at lower right 'see sketch for KCs for background' may refer to the study for a drawing formerly in the collection of Lord Clark 'Mother and Child in Setting' of 1944.

For other drawings in this exhibition of figures in cell-like rooms see Nos.116 and 198.

### 195 Group of Draped Standing Figures 1942

Pencil, black crayon, India ink and grey wash, $15\frac{3}{8} \times 22\frac{1}{4}$ (39 × 56.5)
Inscribed lower right 'Moore 42'
*The Art Institute of Chicago*, Gift of Mrs Potter Palmer 1945.2

Both in the use of drapery and in the grouping of the figures, this composition reflects the influence of the shelter drawings. (See introduction, p.42). The three figures at centre anticipate the terracotta sketch-model of 1945 (L.H.258) for the Darley Dale stone 'Three Standing Figures' of 1947-8 (L.H.268) in Battersea Park, London. (See preparatory drawing for L.H.258 in L.H. Volume I, p.257)

Three standing figures grouped together have been the subject of other drawings and sculptures: 'Three Standing Figures' of 1951 (No.224) which was the

study for L.H.321 and 322, and the large three upright motives of 1955-6 (Nos.1, 2 and 7, L.H.377, 379 and 386) grouped together at the Kröller-Müller Museum, Otterlo, Holland.

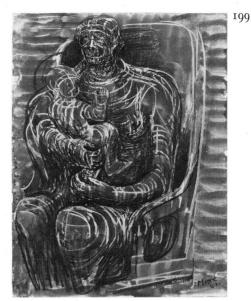

**196 Ideas for Sculpture: Draped Standing Figures** 1942
Pen, chalk and watercolour, $22\frac{5}{8} \times 17\frac{1}{2}$ ($57.5 \times 44.5$)
Inscribed lower right 'Moore 42'; top 'Draw each separately as a piece of sculpture–thinking in section line as modelling it as a clay sketch'
*M. F. Feheley*

The sectional line method of drawing was used in many works of the 1940s, culminating in the large studies of 1948 (see Nos.210, 212, 215 and 216).

**197 Figures with Architecture** 1943
Pen & ink, black and coloured chalks, wax crayon and wash, $17\frac{1}{2} \times 25$ ($44.5 \times 63.5$)
Inscribed lower right 'Moore 43'
*Mrs Neville Burston*

In this, one of Moore's finest studies of figures in an architectural setting, the solemn mood of the heavily draped women recalls something of the tragic nobility of the shelter drawings. (See No.143).

**198 Figures in an Art Gallery** 1943
Pen & ink, black and coloured chalks, wax crayon and wash, $18\frac{1}{4} \times 19\frac{1}{2}$ ($46.5 \times 49.5$)
Inscribed lower right 'Moore 42'
*Mrs Neville Burston*

This would appear to be Moore's only drawing of figures in an art gallery setting. The dramatically lit sculpture on a pedestal is closely related to several figure studies of 1940 (Nos.130 and 131), whereas the two standing women are stylistically related to the draped figures in the Feheley drawing of 1942 (No. 196).

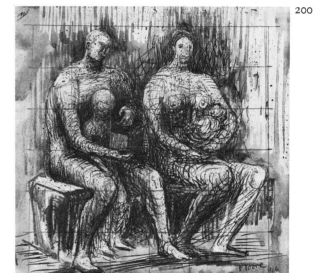

**199 Page from Madonna and Child Sketchbook** 1943
Pen & ink, crayon and watercolour, $8\frac{7}{8} \times 6\frac{7}{8}$ ($22.5 \times 17.5$)
Inscribed lower right 'Moore 43'
*Mr and Mrs Harry A. Brooks*

This is one of some twelve known sheets of studies for the Hornton stone 'Madonna and Child' of 1943-4 (L.H.226), commissioned by Dr Walter Hussey for the Church of St. Matthew, Northampton, of which he was then Vicar. The twelve terracotta maquettes of 1943 (L.H.215-225) which preceded the carving were the first sculptures made after the War Drawings. For the artist's account of the commission, see *Henry Moore on Sculpture*, pp.220-3.

**200 Family Group** 1944
Pen & ink, chalk, wax crayon and watercolour, (squared in pencil), $6\frac{3}{4} \times 7\frac{1}{4}$ ($17.2 \times 18.4$)
Inscribed lower right 'Moore 46'
*Private collection*

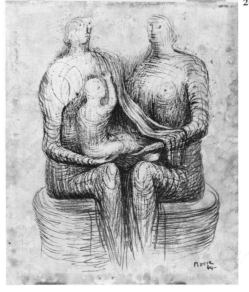

202

203

204

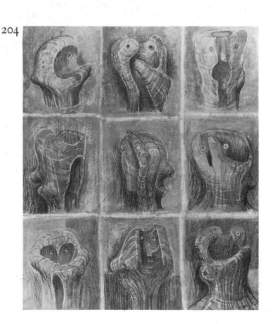

The Madonna and Child studies were followed by a series of family group drawings and terracottas. This is one of three family group drawings of 1944 included in this exhibition. (See Nos.201 and 202 below). For the artist's account of the family group sculptures see *Henry Moore on Sculpture*, pp.224–9.

**201 Family Group** 1944
Pen & ink and watercolour, $14\frac{1}{2} \times 12$ (36.8×30.5)
Inscribed lower right 'Moore 44'; top 'Page 9-R Fading from red to Blue-grey'; right just below centre, with sheet turned ninety degrees to the left '15×11' [and, crossed out] '1 ft $9\frac{1}{2} \times 12\frac{3}{4}$'
*M. F. Feheley*
See notes for No.200 above.

**202 Family Groups** 1944
Chalk, pen and watercolour, 22×15 (56×38)
Inscribed at lower left 'Moore 44'
*Mr and Mrs David Kelley*
In the top half of the sheet, the two studies of the same composition were the preparatory drawings for the terracotta 'Family Group' of 1944 (L.H.230). The studies below were not realized in sculpture. For other family group drawings see Nos.200 and 201 above.

**203 Ideas for Two-Figure Sculpture** 1944
Pencil, pen & ink, crayon and watercolour, $8\frac{7}{8} \times 6\frac{7}{8}$ (22.5×17.5)
Inscribed lower left 'Moore 44'; top, 'Two Reclining Figures[?]'; upper right '59'
*Museum of Modern Art, New York*, Purchase
Moore's habit of numbering sketchbook pages (here at upper right) has subsequently been most helpful in reconstructing and dating dismembered notebooks. This very beautiful sheet of studies was reproduced in colour on the jacket of the catalogue of Moore's first exhibition in America, held at the Museum of Modern Art, New York in 1946.

**204 Heads: Ideas for Metal Sculpture** 1944
Chalk, pen and watercolour, $19 \times 16\frac{1}{2}$ (48.2×42)
Inscribed lower right 'Moore 44'
*The Hon. Alan Clark* M.P.
On p.15 of the introduction, mention was made of the importance of the head in figurative sculpture. Moore has made many drawings and sculptures of heads and masks. Of the four drawings of heads in this exhibition, the earliest dates from *c*.1929 (No.82); the most recent from 1975 (No.258). See also No.128 of 1939.

**205 Three Seated Figures** 1944
Pen & ink, chalk, wax crayon and watercolour, $13\frac{3}{16} \times 22\frac{3}{4}$ (33.6×58)
Inscribed lower right 'Moore 44'
*Private collection*
There is a marked contrast between the wide, heavily draped bodies and the thin arms. Closely related are the studies of seated figures for terracotta sculptures, in the Philadelphia drawing, No.206 below.

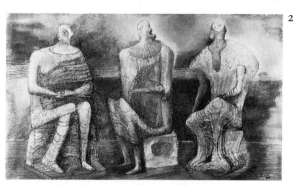

205

**206 Study Sheet for Seated Figures in Terracotta**
1945
Pen & ink, pencil and wash, 24⅞×19 (63.2×48.2)
Inscribed lower left 'Moore 45'; centre 'Seated
Figures (Terracotta)'
*Philadelphia Museum of Art*, The Louis E. Stern
Collection (63-181-49)
The draped seated figures in this drawing are related to
those in No.205 above.

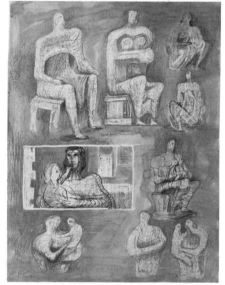

206

**207 Girl Reading to a Woman and Child** *c.*1946
Pen & ink, crayon and wash, 18×24 (45.7×61)
Inscribed lower left 'Moore'
*Lord and Lady Walston*
Scenes of family life – women bathing a child, women
reading and knitting (No.207), the rocking chair
studies (Nos.210 and 211) and family groups (No.212)
– were the subjects of a number of large drawings of the
1940s, most of which date from 1948. In the present
drawing, one of the earliest in the series, the curtains on
each side of the crowd looking at a tied-up object (see
No.193) suggest not the drawing but an actual scene
through the window which has caught the attention of
the woman on the right.

**208 Three Standing Figures in a Setting** 1948
Pen & ink, chalk and watercolour, 19½×24¾
(49.5×62.7)
Inscribed lower left 'Moore 48'
*Victoria and Albert Museum*
The last in the series of drawings in cell-like rooms with
slotted walls (which began in 1936, see notes for No.
116) were done between 1948–50. Here there is no
longer the claustrophobic atmosphere of a prison found
in earlier drawings. The walls have opened and the
three standing women are bathed in daylight, as they
wait expectantly at the edge of the room. Two later
drawings are known: 'Four Figures in a Setting' of 1949
in the National Gallery of Canada, and a drawing of
1950 in a private collection 'Eight Variations of
Figures in a Setting'.

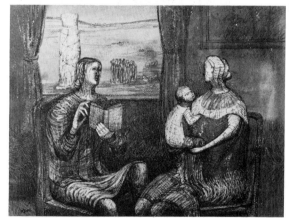

207

**209 Two Women Seated at a Table** 1948
Pen & ink, chalk and watercolour, 20½×22⅝
(52×57.5)
Inscribed lower right 'Moore 48'
*University of East Anglia*, The Robert and Lisa
Sainsbury Collection
One of the large drawings of 1948 of scenes of domestic
life. See notes for No.207.

**210 The Rocking Chair: Ideas for Metal
Sculpture** 1948
Pencil, pen & ink, chalk, crayon and watercolour,
21⅝×29⅞ (55×76)
Inscribed lower right 'Moore 48'
*Private collection*
Among Moore's most charming studies of family life
was the series of rocking chair drawings of 1948.
Doubtless inspired by his wife and two year old

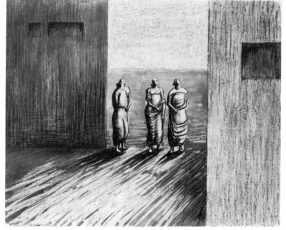

208

209

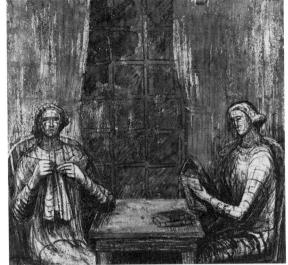

daughter Mary (who was born on 7 March, 1946), these drawings eventually led to the four rocking chair bronzes of 1950 (L.H.274–277). There are four large rocking chair drawings (see also No.211), as well as five sketchbook studies. Two sheets from a 1950–1 sketchbook are also known.

**211  The Rocking Chair** 1948
Pencil, wax crayon, watercolour and gouache, $20\frac{1}{4} \times 27\frac{7}{8}$ (51.4 × 70.8)
Inscribed lower left 'Moore 48'
*Birmingham City Museum and Art Gallery*
One of the four known large drawings of 1948 of this subject. (See No.210 above).

**212  Family Group** 1948
Pen & ink, chalk, gouache and wash, $21\frac{3}{4} \times 26\frac{7}{8}$ (55.2 × 68.2)
Inscribed lower right 'Moore 48'
*Art Gallery of Ontario*, Purchase 1974
The two-way sectional line method of drawing (see introduction p.16) reached its culmination in a number of the large studies of 1948. (See also Nos.210, 215 and 216.) A pendant to the Toronto drawing, of the same title and date, is in the Massey Collection of English Painting, in the National Gallery of Canada.

**213  Three Reclining Figures** 1948
Pen & ink, crayon and wash, $22\frac{1}{4} \times 15\frac{1}{2}$ (56.5 × 39.3)
Inscribed lower right 'Moore 48'
*Roloff Beny*
An almost identical version of this drawing is reproduced in colour opposite the title page in L.H. Volume I, fourth edition.

**214  Two Seated Figures** 1948
Pen & ink, chalk, wax crayon and watercolour, $21\frac{1}{4} \times 22\frac{3}{8}$ (54 × 57)
Inscribed lower left 'Moore 48'
*British Council, London*
These two women are more elongated and thinner than the bulky monumental figures which characterize other drawings of 1948. (See for example, Nos.215 and 216.) The head of the figure in the foreground is closely related to that of the reclining figure at the top of the Beny drawing (No.213 above).

210

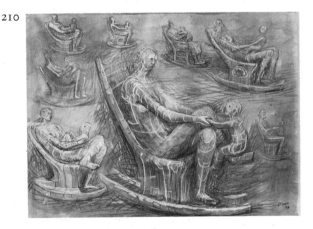

**215  Seated Figure** 1948
Chalk, pen and watercolour, $23\frac{3}{4} \times 22\frac{1}{2}$ (60.2 × 57.2)
Inscribed lower left 'Moore 48'
*Dr and Mrs Henry M. Roland*
In this drawing the sectional lines which define the contours of the large figure in the foreground are much heavier and spaced further apart than the more intricate, delicate handling in the Toronto drawing (No.212). The figure looks as if it has been composed of stones cut into sections, and fitted together like a three-dimensional jig-saw puzzle. One is reminded of the blocks of marble used for the 'Large Square Form with Cut' of 1969–71 (L.H.599), which was assembled at

211

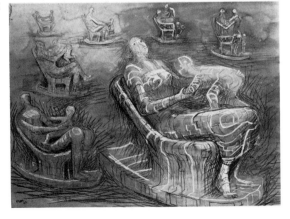

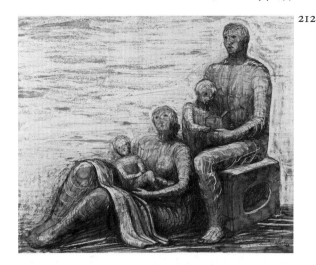

212

the Forte di Belvedere for the Florence exhibition in 1972 (Fig.98).

**216 Seated Figure** 1948
Gouache, 30¼×22¼ (76.8×56.5)
Inscribed lower left 'Moore 48'
*National Gallery of Canada, Ottawa*
Both in the sectional line technique, and in the monumental figure type portrayed, this drawing is closely related to the Toronto 'Family Group' of 1948 (No.212).

**217 Ideas for Sculpture: Internal and External
      Forms** 1948
Pen & ink, graphite, wax crayon and watercolour, 11½×9 (29.2×22.8)
Inscribed lower right 'Moore 48'
*Smith College Museum of Art, Northampton, Mass.*
This, one of three drawings of 1948 of internal and external forms, includes just left of centre the preparatory drawing for the four versions, in bronze and wood, of 'Internal and External Forms', 1951–4 (L.H. 294–297. See Fig.26). The form just left of centre appears again in 'Page from Sketchbook' 1950–1 (private collection). See introduction, p.43 for an explanation of the changes made in translating this sculptural idea into three dimensions.

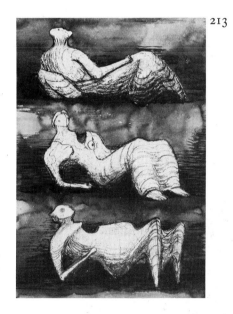

213

**218 Women Winding Wool** 1949
Crayon and watercolour, 13¾×25 (34.8×63.6)
Inscribed lower left 'Moore 49'
*Museum of Modern Art, New York*, Gift of
Mr and Mrs John A. Pope, in honour of Paul J.
Sachs
Women winding wool was the subject of four drawings of the previous year. (See L.H. Volume I, p.265). In No. 218 the rather rigid sectional line technique found in many studies of 1948 has given way to a much freer handling. The contrast of light and shade is reminiscent of the drawings of Seurat, which were to have a marked influence on some of Moore's drawings of the 1970s.

**219 Head of Prometheus** 1949
Pencil, pen & ink, chalks, wax crayon and watercolour, 13⅞×10¾ (35.2×27.2)
Inscribed lower right 'Moore 49' (recent)
*Private collection*
This was the definitive study for the lithograph 'Head of Prometheus' of 1950 (C.G.M.22), one of the lithographic illustrations Moore did for André Gide's translation of Goethe's *Prométhée* (see note on *Prométhée* before No.18 in Volume I of the Cramer catalogue).

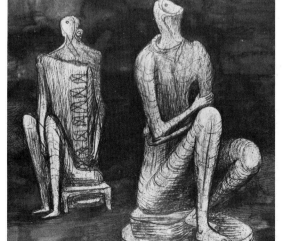

214

**220 Standing Forms** 1949
Pencil, ink, chalk and wash, 23¼×18⅞ (59×48)
Inscribed lower right 'Moore'
*Private collection*
Single and groups of standing figures were the subject of a number of drawings and sculpture of 1949–56, culminating in the series of upright motives of 1955–6.

215

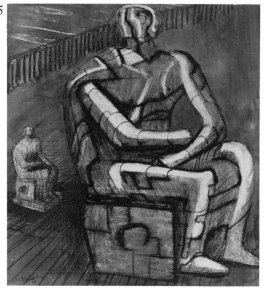

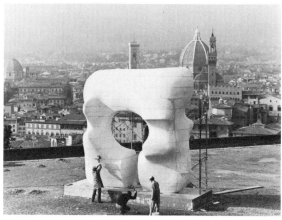

Fig.98 Henry Moore,
*Large Square Form with Cut*, 1969-71,
photographed at the Forte de Belvedere,
Florence

216

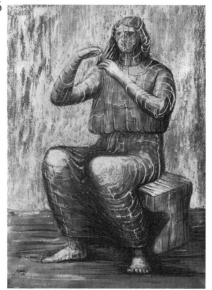

219

217

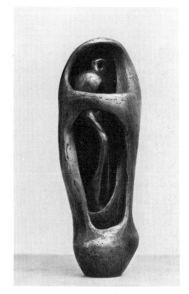

Fig.26 Henry Moore,
*Maquette for Internal and
External Forms*, 1951

220

221

222

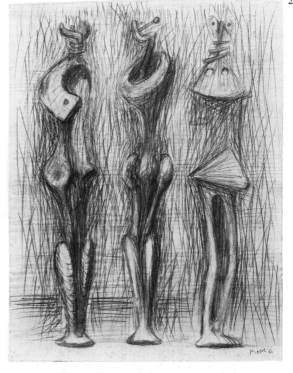

224

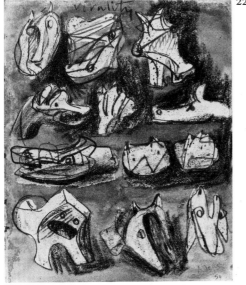

223

225

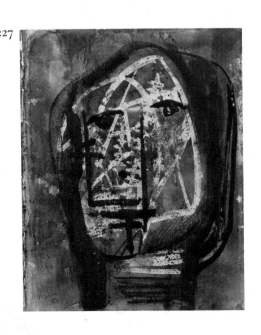

226

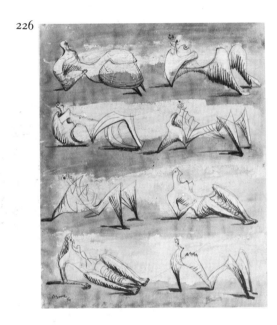

227

(See also No.224 and L.H.290, 297, 317-322.) The ten standing figures in the present drawing are prophetic of the thirteen maquettes and large versions of the upright motives of 1955-6.

**221 Sculpture Settings by the Sea** 1950
Pen & ink, and watercolour, $21\frac{1}{2} \times 15\frac{1}{2}$ ($54.5 \times 39.3$)
Inscribed lower right 'Moore 50'; top 'Sculpture settings by the sea'
*Mrs H. R. Jackman*

This is the only known drawing of sculptural ideas in settings by the sea.

**222 Seated Group of Figures** 1950
Chalk, crayon, gouache and wash, $14\frac{3}{4} \times 11$
($37.5 \times 28$)
Inscribed lower right 'Moore 50'
*Art Gallery of Ontario*, Gift of Sam and Ayala Zacks, 1970

Although none of these studies was to be realized in sculpture, the taut knees and legs of the figure just right of centre recall those of 'Seated Man' of 1949 (L.H.269a), and those of the father in the large bronze 'Family Group' of 1948-9 (L.H.269).

**223 Animal Heads** 1950
Pencil, chalks, wax crayon and watercolour,
$11\frac{7}{16} \times 9\frac{1}{2}$ ($29 \times 24.1$)
Inscribed lower right 'Moore 50', top 'vitality'
*Private collection*

This is one of three known animal head drawings of 1950. Its pendant is in the collection of Irina Moore; the other is in a private collection. The spiky horns in some of the studies in No.223 anticipate the bronze 'Goat's Head' of 1952 (L.H.302), although the sculpture would appear to have evolved from a bone form, and not from one of the animal head drawings. (See also 'Animal Head' of 1950, L.H.301.)

**224 Three Standing Figures** 1951
Chalk and wash, $19\frac{5}{8} \times 15\frac{1}{4}$ ($50 \times 38.5$)
Inscribed lower right 'Moore 51'
*Art Institute of Chicago*, Gift of the Estate of Curt Valentin

Thin, elongated standing figures were the subject of a number of drawings and sculptures of the late forties and early fifties, the most important being the bronze 'Standing Figure' of 1950 (L.H.290), which was based on a study in a drawing of *c*.1948 (L.H. Volume I, p.270).

The Chicago drawing would appear to be the definitive study for 'Maquette for Three Standing Figures' of 1952 (L.H.321), which was followed in 1953 by the larger version (L.H.322). A number of changes were made in translating the original ideas into three dimensions.

**225  Animal Drawing: Pig** 1953
Charcoal, 15 × 10 (38.1 × 25.4)
Inscribed lower left 'Moore 53'
*Private collection*

This decidedly comfortable and immovable pig is one of three studies drawn from life at a neighbouring farmyard at Perry Green. The long curve of the rump and back is accentuated by the arc of charcoal in the background, while the sheer weight of the animal is emphasized by the heavy contours, culminating in the vigorous and more detailed treatment of the head and ears.

**226  Reclining Figures: Drawing for Metal Sculpture** 1954
Pencil, chalks, wax crayon and watercolour,
16⅞ × 13⅝ (43 × 34.5)
Inscribed lower left 'Moore 54'
*Private collection*

Many of Moore's lithographs and etchings of the last thirty years have been based on preliminary drawings. (See introduction, p.45). The 1957 lithograph 'Six Reclining Figures' (C.G.M.38) was based on the upper three rows of studies in the present drawing. 'Page 154 from Sketchbook' 1950-1 (private collection) was the sketch for No.226.

**227  Page from Sketchbook: Head** 1958
Chalk, crayon, brush and India ink and watercolour, 11⅜ × 9⅜ (29 × 23.9)
Inscribed lower left 'Moore 58'
*Henry Moore Foundation*

This is one of a series of drawings of heads made in a 1958 sketchbook. The broad vertical and horizontal brush strokes give this head something of the caged-in appearance of 'Spanish Prisoner' of 1939 (No.129).

**228  Two Reclining Figures** 1961
Chalk, crayon, watercolour and felt pen,
11 15/16 × 9 7/16 (30.3 × 24)
Inscribed lower right 'Moore 61'
*Henry Moore Foundation*

Although Moore was no longer using drawings as a means of generating ideas for sculpture, some of the drawings were related to the sculpture of the period. This study, for example, may be compared with the massive bronze 'Three Piece Reclining Figure No.1' of 1961 (L.H.500, Fig.62).

**229  Two Piece Reclining Figures** 1961
Pencil, chalk, felt pen and watercolour, 11 15/16 × 9 7/16 (30.3 × 24)
Inscribed lower right 'Moore 61'
*Henry Moore Foundation*

The upper figure, with the dramatic thrust of the leg end, is closely related to the bronze 'Two Piece Reclining Figure No.1' of 1959 (L.H.457, Fig.55).

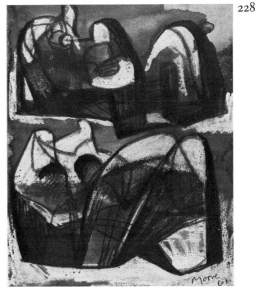

228

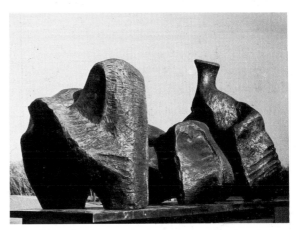

Fig.62 Henry Moore,
*Three Piece Reclining Figure No.1*, 1961-2

229

230

**230 Reclining Figure: Bunched** 1961
Coloured chalks with brush and water, $15\frac{1}{2}\times21\frac{1}{8}$
(39.4×53.5)
Inscribed lower right 'Moore 61'
*Private collection*

This drawing was based on a less finished study 'Figure in a Setting' of 1960 (in the collection of Mary Moore), in which the large reclining figure appears on the right of the sheet. In the present drawing, the large figure was drawn from 'Maquette for Reclining Figure: Bunched' of 1961 (L.H.489).

**231 Reclining Figures** 1963
Pencil and coloured inks, $18\frac{7}{8}\times22\frac{7}{8}$ (48×58)
Inscribed lower left 'Moore 63'
*Henry Moore Foundation*

This was the preparatory drawing for the lithograph 'Six Reclining Figures' of 1963 (C.G.M.48).

231

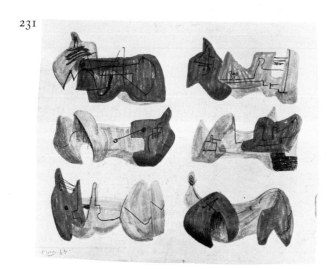

**232 Reclining Figure** 1964
Felt pen and collage, $17\frac{1}{8}\times13$ (43.5×33)
Inscribed lower right 'Moore 64'
*Henry Moore Foundation*

This is one of nine known collages of 1964. The reclining figure is a torn fragment from a lithograph of 1963 'Five Reclining Figures' (C.G.M.45) – the figure at upper left in the lithograph. This has been pasted on a fragment of the jacket for the book *Heads, Figures and Ideas* by Henry Moore, published in 1958.

**233 Gourd Women** 1964
Felt pens, wax crayon, chalk and wash,
$11\frac{7}{16}\times9$ (29.1×23)
Inscribed lower right 'Moore 64'; top centre
'Fruit Women'
*Private collection*

Although inscribed 'Fruit Women', the forms balancing at the top of each figure would appear to be gourds. Another somewhat whimsical drawing of 1964 is entitled 'Pot Women'.

232

**234 Two Reclining Figures** 1966
Pen & ink and felt pens, $11\frac{1}{2}\times9\frac{7}{16}$ (29.2×23.9)
Inscribed lower left 'Moore 67' (incorrectly)
*Henry Moore Foundation*

This is one of two preparatory drawings for the 1967 lithograph 'Two Reclining Figures in Yellow and Green' (C.G.M.74).

**235 Horsemen Crossing a Mountain Crevasse**
1970
Pen & ink and watercolour, $6\frac{15}{16}\times10$ (17.6×25.4)
Inscribed lower left 'Moore 70'
*Henry Moore Foundation*

Moore's renewed interest in drawing in recent years may be said to date from late 1969, when he made a few preparatory notebook studies of the elephant skull (which Sir Julian Huxley had given him several years earlier) before embarking on the 'Elephant Skull Album' of etchings (C.G.M.109–146). But it was not

233

until 1970, when Moore made some sixty-five pen exercises, as they are sometimes called, that his renewed interest in drawing began to gather momentum. Three of these are shown here – the present drawing, and Nos.236 and 237 below. Indeed, pen exercises is an appropriate title for many of these hurried, spontaneous studies in which Moore was getting his hand in again, warming up, as it were, after having neglected his drawing for some fifteen years. Several drawings were little more than doodles and scribbles; others were of pictorial fantasies (Nos.235 and 236), or of sculptural forms (No.237). Moore based a number of etchings on these pen exercises of 1970 (see C.G.M.154–162).

**236  Storm at Sea** 1970
   Pen & ink, $6\frac{7}{8} \times 10$ (17.5 × 25.4)
   Inscribed lower right 'Moore 70'
   *Henry Moore Foundation*
Anyone who has visited Moore's graphic studio in recent years will have seen pinned on the wall or lying on his desk postcards and reproductions of Old Master drawings. One recent copy (No.71) was based on such an item – a reproduction of Dürer's 'Portrait of Conrad Verkell', in the British Museum (Fig.80). At the time of writing, a postcard of Rembrandt's drawing 'Saskia Asleep in Bed' (Ashmolean Museum, Oxford) is on the artist's desk. Moore's enormous admiration for the drawings of Rembrandt is reflected in the calligraphic shorthand of some of the 1970 pen exercises. In fact the present drawing would appear to be an adaptation of Rembrandt's 'Christ in the Storm on the Sea of Galilee' of 1654–5, in the Kupferstichkabinett, Dresden, although the initial idea, the artist has said, was inspired by a storm he had witnessed at his summer house at Forte dei Marmi, north of Pisa.
   The etching and dry point 'Storm at Sea' of 1970 (C.G.M.156) was based on the present drawing.

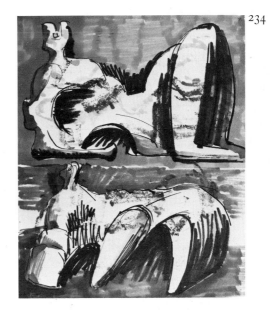
234

**237  Sculpture in Landscape** 1970
   Pen & ink and wash, $6\frac{7}{8} \times 10$ (17.5 × 25.4)
   Inscribed lower right 'Moore 70'
   *Art Gallery of Ontario*, Gift of Henry Moore, 1974
This is one of the studies of sculptural motives in the 1970 series. In contrast to the purely linear technique in No.236, Moore has also used brush and wash to define the dark, threatening sky, and to give the horizontal sculptural form a feeling of weight and mass.

**238  Three Seated Figures** 1971
   Chalk and wash, $11\frac{3}{4} \times 17$ (29.8 × 43)
   *Henry Moore Foundation*
Although in his recent drawings Moore has explored many new pictorial subjects, he has continued to produce variations on the two major themes which have dominated his work since the 1920s – the mother and child and the reclining figure. A related drawing, 'Three Seated Women and Children' of 1971, is in a private collection.

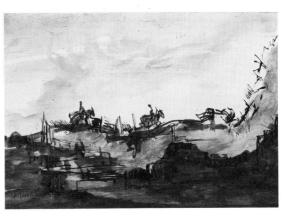
235

[135]

236

237

238

240

239

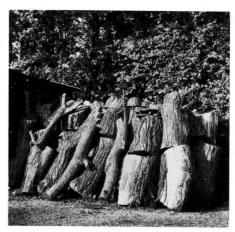

Fig.63 Log pile at Hoglands

**239  Log Pile** 1972
    Pen & ink and ball point pen, $7\frac{1}{8} \times 7$ ($18 \times 17.7$)
    *Henry Moore Foundation*

This is one of two drawings of the log pile beside the
coal shed at Hoglands (Fig.63). Here the vigorous
hatchings, cross-hatchings and zig-zag lines create a
range of tonal modulations from the deep blacks of the
shadows to the reflected light from the logs themselves.
The linear technique in this and in a number of recent
drawings may well owe something to Rembrandt's
etchings which Moore greatly admires – works such as
'A Negress on a Bed', a print which he chose to be
shown with his own drawings and prints in the Auden
Poems/Moore Lithographs exhibition at the British
Museum in 1974.

The present drawing was the preparatory study for
'Log Pile I' (etching and dry point) of 1972 (C.G.M.189).

**240  Stonehenge** 1972
    Pen & ink, chalk and wash, $6\frac{7}{8} \times 10$ ($17.5 \times 25.4$)
    Inscribed lower left 'Moore'
    *Henry Moore Foundation*

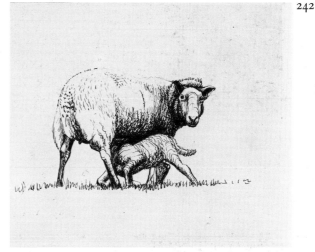
241

Before beginning the Stonehenge Album of etchings
and lithographs of 1972–3 (C.G.M.202–203, 207, 223),
Moore made some ten drawings, based on photographs.
He had begun the album with etching in mind, which
was the medium used in the first two prints, 'Stone-
henge A and B' (C.G.M.202–203). In the present draw-
ing, the linear technique could readily be adapted
and reworked with an etching needle. Moore soon
found, however, that lithography would be more suit-
able to portray what interested him most about
Stonehenge – the variety of textures of the weather-
worn stones. (See No.241 below.)

**241  Stonehenge** 1972
    Pen & ink, ball point pen, chalk and wash,
    $7\frac{13}{16} \times 11$ ($19.9 \times 28$)
    Inscribed lower left 'Moore'
    *Henry Moore Foundation*

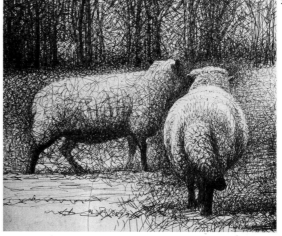
242

The style and media used in this drawing reflect the
change from the linear technique in No.240 above, to
a broader, less detailed treatment of the subject. Most
of the lithographs are closely related to the style of the
present drawing.

**242  Page 16 from Sheep Sketchbook: Sheep with
    Lamb V** 1972
    Ball point pen, $8\frac{1}{4} \times 9\frac{7}{8}$ ($21 \times 25$)
    *Private collection*

243

In 1972, Moore filled a sketchbook with studies of
sheep in the field behind the new maquette studio at
Hoglands. By no means an entirely new subject for
Moore, he had, fifty years earlier, made sketches of
sheep in Norfolk in the summer of 1922 (Fig.66).
Obviously the subject matter itself has had much to do
with the enormous popularity of these drawings and of
the album of sheep etchings of 1972 and 1974 (C.G.M.
196–201 and 225–235) which were based on a number
of studies in the Sheep Sketchbook. But judged purely

in terms of technique, the brilliance of the sheep draw-ings lies in the masterly handling of pen to define the hard solid boniness of legs and faces and the soft fullness of the thick wool. The variety of line is remarkable. In the present drawing, a fine saw-edged line marks the outline of the back. The wool itself and the shaded area above the lamb are defined by sharp flicks of the pen and by the more densely worked zig-zag lines. In p.38 below, the lines are even more varied, forming an end-less network of tightly knotted and larger swirling and zig-zag lines, giving a marvellous sense of depth.

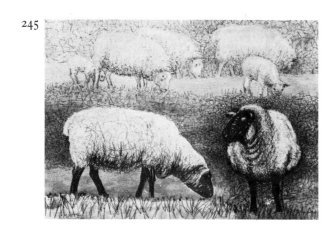

244

**243 Page 38 from Sheep Sketchbook: Sheep** 1972
Ball point pen, $8\frac{1}{4} \times 9\frac{7}{8}$ (21 × 25)
*Private collection*
The etching and dry point 'Sheep' of 1972 (C.G.M.201) was based on the present drawing.

**244 Page 45 from Sheep Sketchbook: Head** 1972
Ball point pen, $8\frac{1}{4} \times 9\frac{7}{8}$ (21 × 25)
*Private collection*
The etching and dry point 'Head' of 1974 (C.G.M.228) was based on the present drawing.

245

**245 Studies of Sheep No.II** 1972
Ball point pen, felt pen, chalk and watercolour,
$8\frac{1}{4} \times 11\frac{9}{16}$ (21 × 29.3)
Inscribed lower left 'Moore 72'
*Private collection*
This is one of four drawings which are of a slightly larger format than the pages of the Sheep Sketchbook.

**246 Reclining Figure on Water Background** 1972
Coloured inks and wash with collage of tissue paper, $20\frac{7}{8} \times 18\frac{7}{8}$ (53 × 48)
Inscribed lower right 'Moore'
*Private collection*
This is one of a 1972 series of preparatory studies for lithographs. The lithograph 'Reclining Figure with Sea Background' of 1973 (C.G.M.236) was based on the present drawing.

**247 Seated Mother and Child** 1972
Coloured ink and white gouache,
$9\frac{7}{8} \times 6\frac{1}{4}$ (25 × 15.8)
Inscribed lower left 'Moore 72'
*Jeffrey H. Loria Collection, New York*
Stylistically, this drawing recalls the series of notebook studies of 1943 for the Northampton 'Madonna and Child' (L.H.226). See No.199.

**248 Rock Landscape with Classical Temple** 1972
Charcoal and chalk with wash,
$8\frac{3}{8} \times 11\frac{7}{16}$ (21.3 × 29)
Inscribed bottom left 'Moore'
*Henry Moore Foundation*
The dark, foreboding atmosphere of the landscape, and the classical temple in the background are reminiscent of one of Moore's earliest pictorial drawings – 'Stones in a Landscape' of 1936 (No.113).

246

247

**249 Girl Doing Homework** 1973
Pen & ink, chalk, wash and gouache,
$10 \times 6\frac{15}{16}$ (25.4 × 17.6)
*Private collection*

The two earliest drawings of this subject were done in a sketchbook of 1954. Although these early drawings were made up, they were inspired by the artist's eight-year-old daughter Mary. The present drawing was based on the studies on p.76 from a sketchbook dated 1967–74, which includes ten sketches of girl doing homework. In addition, Moore did six drawings of this subject in 1973, and in the following year the series of six prints entitled 'Girl Doing Homework' I–VI (C.G.M. 326–331).

**250 Shipwreck** 1973
Pencil, charcoal, ball point pen and wash, $7\frac{1}{2} \times 6\frac{7}{8}$ (19 × 17.5)
*Henry Moore Foundation*

Among Moore's recent drawings are pictorial fantasies such as 'Storm at Sea' of 1970 (No.236), and the present study of a shipwreck. The subject may have been suggested by the work of Turner or Friedrich.

248

**251 Large Two Forms in Landscape** *c.*1973–4
Pencil, charcoal and watercolour (on blotting paper), $8\frac{1}{16} \times 11\frac{1}{8}$ (20.5 × 28.2)
Inscribed lower left 'Moore'
*Henry Moore Foundation*

In recent years, maquettes and large bronzes have been the subject of a number of prints and drawings. In the drawings Moore can create the ideal landscape settings for his sculpture, as he has done here for the bronze 'Large Two Forms' of 1966/9 (L.H.556). None of the recent drawings shows sculpture in urban, architectural settings where so many of Moore's large bronzes have been sited. In creating landscape settings in the drawings, he has remained true to the dictum quoted in the introduction: 'I would rather have a piece of my sculpture put in a landscape, almost any landscape, than in, or on, the most beautiful building I know'. The bronze 'Large Two Forms' was also the subject of a lithograph of 1967 (C.G.M.101).

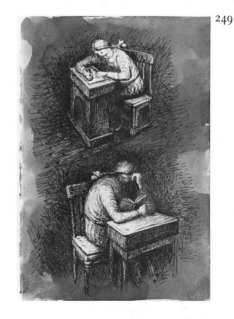

249

**252 Reclining Figure** *c.*1974
Charcoal, chalks and watercolour,
$8\frac{7}{8} \times 13\frac{7}{8}$ (22.7 × 35.2)
Inscribed lower right 'Moore'
*Henry Moore Foundation*

In a sketchbook dated 1974–6 is a series of drawings of reclining figures based on a group of three flint stones which Moore had arranged on a turn-table in his studio (Fig.68). On one of the stones he stuck a bit of clay to form a head. Some of the drawings show the three separate flint stones. In others, like the present drawing (based on a sketch on p.16 of the 1974–6 sketchbook), he has joined the three stones to form a single reclining figure.

250

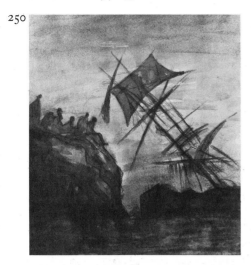

251

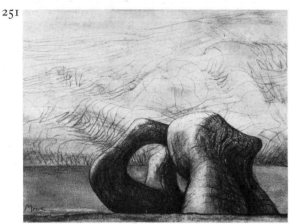

252

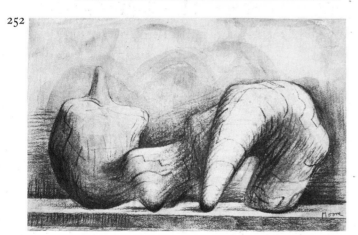

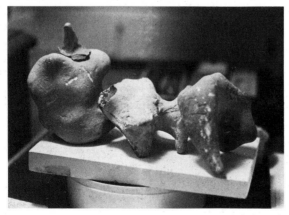

Fig.68 Flint stones in Henry Moore's maquette studio

**253 Reclining Woman in Setting** 1974
Black chalk, pastel, brush and water, $13 \times 18\frac{7}{8}$
$(33 \times 48)$
Inscribed lower right 'Moore 74'
*Henry Moore Foundation*

This drawing was based on a study on p.34 from a sketchbook dated 1969–74. A lithograph entitled 'Draped Reclining Figure' of 1974 (C.G.M.332) is closely related to the present drawing.

**254 Trees I** 1975
Charcoal and wash (on blotting paper),
$8\frac{1}{8} \times 10\frac{1}{4}$ (20.6 × 26)
Inscribed lower left 'Moore Italy 75'
*Henry Moore Foundation*

This study of trees was done in Italy at the artist's summer house at Forte dei Marmi. See No.255 below.

**255 Trees III** 1975
Black chalk, watercolour (on blotting paper),
$7\frac{5}{8} \times 10\frac{1}{4}$ (19.4 × 26)
Inscribed bottom, on right of tree at left 'Moore 75'
*Henry Moore Foundation*

Among Moore's most beautiful coloured drawings of recent years are seven studies of the hedge between the fields on his Hertfordshire estate (Fig.64). In contrast to the thin, more delicate branches in No.254 above, these drawings depict the gnarled, twisted roots and branches of this old hedge which over the years has been cut back many times.

**256 Seated Mother and Child** 1974
Chalk, watercolour and gouache, $10\frac{3}{8} \times 8\frac{3}{8}$
$(26.4 \times 21.2)$
Inscribed lower right 'Moore 75'
*Henry Moore Foundation*

The lithograph 'Seated Mother and Child' of 1975 (C.G.M.367) was based on the present drawing. This print was made for the de luxe edition of *Henry Moore The Graphic Work Vol.II* 1973–5 (Gérald Cramer, Geneva) 1976, and was used in reproduction as the frontispiece of this book.

**257 Circus Act: Trapeze Artists** 1975
Wash, gouache and ball point pen, $9\frac{1}{8} \times 9\frac{3}{8}$
$(23.2 \times 23.8)$
*Henry Moore Foundation*

This drawing was based on studies on pp.97–8 of No.6 Notebook of 1926. A lithograph of 1975 'Trapeze Artistes' (C.G.M.369) was based on the studies in the larger of the two sheets which make up the present drawing.

**258 Six Heads** 1975
Charcoal, gouache and watercolour,
$9\frac{9}{16} \times 12\frac{7}{8}$ (24.4 × 32.7)
Inscribed lower left 'Moore'
*Henry Moore Foundation*

Heads and masks have been the subject of many of

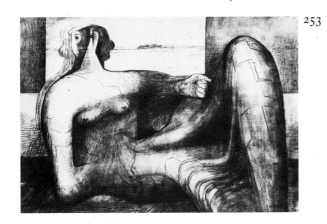

253

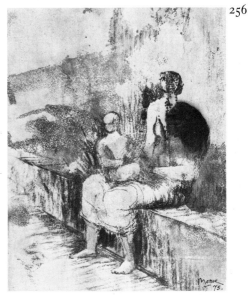

256

254

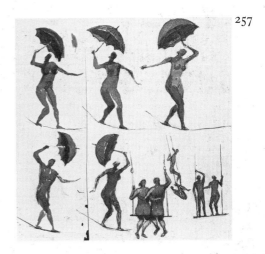

257

255

Fig.64 Hedge on Henry Moore's Estate

258

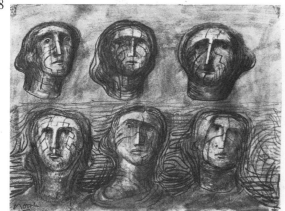

Moore's drawings and sculpture throughout his career. The present studies are reminiscent of the drawing 'Heads' of 1932 (L.H. Volume 1, p.183).

### 259  Landscape with Bonfire VIII 1975
Pencil, charcoal and watercolour, $9\frac{3}{4} \times 12\frac{15}{16}$ (24.7 × 32.8)
Inscribed lower right 'Moore'
*Henry Moore Foundation*

In 1975 Moore made a series of ten drawings of bonfires, of which nine include a landscape setting. The idea was suggested by the bonfire at Hoglands, where Irina Moore burns waste paper from the office, and garden rubbish.

### 260  The Artist's Hands: Study for Lithograph Hands I 1973
Charcoal, pen & ink, ball point pen and chalk, $6\frac{15}{16} \times 10$ (17.6 × 25.4)
*Private collection*

Moore's earliest known drawings of his own hands appear on p.25 of No.3 Notebook of 1922–4. In the mid-1950s he made a series of studies of hands (not his own) in the 'Heads, Figures and Ideas Sketchbook' of 1953–6. The present drawing and No.261 below formed part of a sketchbook dated 1969–77. In this sketchbook are two series of studies of the artist's hands. The first, executed in 1973, was followed by two lithographs 'Hands I and II' of 1973 (C.G.M.284–285). The present drawing was the study for Hands I.

259

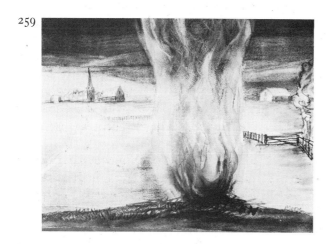

### 261  The Artist's Hands 1977
Chalk, charcoal and pencil, $10 \times 6\frac{15}{16}$ (25.4 × 17.6)
*Private collection*

The last work in this exhibition of Henry Moore drawings is appropriately, one of the recent studies of the artist's hands.

261

260

# Appendix: Copies of Works of Art

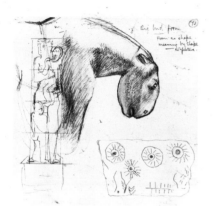

Fig.99 Henry Moore,
*Detail from page 72 of No.6 Notebook*, 1926

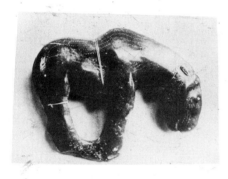

Fig.100 Horse, Neolithic period
(Museum Für Vor und Frühgeschichte,
Berlin)

Fig.101 Neolithic rock drawing at Douth

## Copies of European, Egyptian and Sumerian Art

In his very thorough study of the sculpture of the past, Moore indeed followed his own words of advice inscribed at the front of the No.6 Notebook of 1926: 'Keep ever prominent the world tradition/the big view of Sculpture.' His copies show that he was looking at some of the earliest creative work of man, sculptures and rock drawings from the Palaeolithic, Mesolithic and Neolithic periods. He has recorded his admiration for Prehistoric art in an article which appeared in *The Listener* in 1941. In describing the collection in the British Museum, he wrote:

> In the prehistoric and Stone Age room an iron staircase led to gallery wall-cases where there were originals and casts of Palaeolithic sculptures made 20,000 years ago – a lovely tender carving of a girl's head, no bigger than one's thumbnail, and beside it female figures of very human but not copyist realism with a full richness of form, in great contrast with the more symbolic two-dimensional and inventive designs of Neolithic art.[1]

The source for the following drawings of Prehistoric art, which appear in No.6 Notebook of 1926, was not the British Museum, but illustrations in Herbert Kühn's *Die Kunst der Primitiven* (1923).[2] On p.73 (No.69) of the Notebook the two drawings of a female figure are copies of the Palaeolithic steatite 'Venus of Grimaldi' (Fig.78), from the cave of Balzi Rossi or Grimaldi on the Mediterranean coast west of Genoa (Kühn, pl.1). Other drawings of this sculpture appear on pp.74 and 76 of this notebook. On p.72 (Fig.99) are two studies of works from the Neolithic period. The drawing of a horse was copied from a reproduction (Kühn, facing p.80) which shows a small amber horse, now in the Museum für For und Frühgeschichte, Berlin (Fig.100). In the drawing the areas of light and shade correspond to the lighting in the photograph, and have been broadly modelled, and yet considerable care was taken with the outline of the head, and details such as the eye, ear, nose and mouth. Even the row of dots which run from the mouth to the ear have been included.

The sketch directly below the horse's head on p.72 (Fig.99), is a copy of a Neolithic rock drawing from Douth, a prehistoric burial mound in the bend of the River Boyne, west of Drogheda in the Republic of Ireland (Kühn, p.87, see Fig.101). These Neolithic rock drawings, with their pattern of rayed suns or wheels, appear on one of the kerb stones, which forms part of the circle at Douth on the eastern side of the mound.

In 1935, in a review of Christian Zervos' *L'art de la Mésopotamie*, Moore wrote: 'For me, Sumerian sculpture ranks with Early Greek, Etruscan, Ancient Mexican, Fourth and Twelfth-Dynasty Egyptian, and Romanesque and early Gothic sculpture, as the great sculpture of the world.'[3] On p.216 of the No.3 Notebook of 1922–4 (Fig.102) is a drawing of part of a Sumerian work in the British Museum: the head of the stag on the left of the copper panel representing Im-dugud, symbol of

Ningirsu, the patron of the city of Lagash (Fig.103). This appears to be Moore's only copy of a Sumerian work.

Moore's copies of Greek art indicate, as do his writings on the subject, that he was for the most part attracted to very early works. At the top of 'Page from the Sketchbook' of *c*.1937 (Fig.94) the two helmet-like objects were copied from pls.4 and 5 in Christian Zervos' *L'art en Grèce des temps préhistorique au début du XVIIIe siècle* (Cahiers d'Art, 1934), which illustrate two prehistoric utensils or implements (Fig.93). Although the use or function of these Greek works is not known, their shape may well have led to Moore's drawings for helmet heads of 1939 (No.128) and to 'The Helmet' of 1939–40 (L.H.212, Fig.35). The drawings of the Greek works are, therefore, among the few copies which were to have a direct influence on Moore's sculpture. (See notes for No.128). Two sheets from No.3 Notebook include drawings of Cycladic sculpture dating from 2500 to 2000 B.C. On p.216 is a sketch of a typical Cycladic figure with arms crossed beneath the breasts (the original work has not been identified). On p.131 (Fig.104) the two drawings of a standing figure are almost certainly based on the well-known 'Lyre-Playing Idol' in the National Museum, Athens (Fig.105). At the top of this page is a sketch of a Cycladic head. Studies of a much later Greek work appear on p.72, of the same Notebook (Fig.106). These sketches of a female torso were in all probability drawn from 'Aphrodite Undoing her Sandal' (Fig.107), a second-century B.C. terracotta in the British Museum.

One of the two[4] known drawings of Etruscan sculpture is found towards the end of No.5 Notebook of *c*.1925–6. The seated figure on p.15[5] (No. 65) was based on an Alinari photograph (which Moore probably bought in Italy in 1925, and is still in his possession) of a third-century B.C. Etruscan figure of a young boy, in the Museo Etrusco Gregoriano in the Vatican (Fig.75). It is interesting to note that in the drawing, the sex of the figure has been changed by the addition of breasts. The pentimenti along the right hip, where the original outline is still visible, indicate that this part of the figure has been slightly widened and made more characteristically female.

A copy of a small Egyptian sculpture appears on p.85 of the No.2 Notebook of 1921–2 (Fig.108). This thumb-nail sketch is almost certainly a drawing of the Roman Period wooden standard in the shape of Ophoris, or Upuant, the wolf-god, in the British Museum (Fig.109).

The Gothic carvings at Methley Church near Castleford were, the artist has said, 'the first real sculptures that I remember',[6] and he recollected

Fig.102 Henry Moore, *Detail from page 216 of No.3 Notebook*, 1922–4

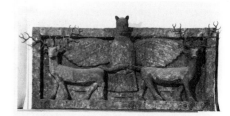

Fig.103 Copper panel representing Im-dugud, symbol of Nin-girsu, the patron of the city of Lagash, Sumerian (British Museum)

Fig.93 Two Prehistoric Greek implements (National Museum, Athens)

Fig.94 Henry Moore, *Page from Sketchbook*, 1937

Fig.35 Henry Moore, *The Helmet*, 1939–40

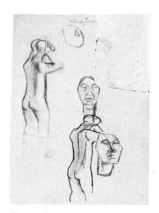

Fig.104 Henry Moore, *Page 131 from No.3 Notebook*

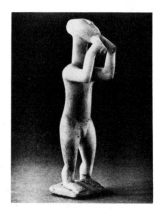

Fig.105 Lyre-playing Idol, Cycladic, 2500–2000 B.C. (National Museum, Athens)

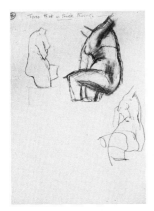

Fig.106 Henry Moore,
*Page 72 from No.3 Notebook, 1922–4*

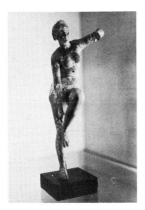

Fig.107 Aphrodite Undoing her Sandal,
2nd Century B.C.
(British Museum)

Fig.108 Henry Moore,
*Detail from page 85 of No.2 Notebook, 1921–2*

Fig.109 Wooden standard in the shape of
Ophoris, or Upuant, the wolf-god.
Egyptian, Roman period
(British Museum)

having drawn them as a boy of nine or ten. But the earliest surviving copy of Gothic sculpture, which appears on the left of p.128 of the No.4 Notebook of 1925 (No.64), is one of the Wise Virgins on the north portal of Magdeburg Cathedral (Fig.74). Moore has concentrated on accurately rendering one of the most striking features of the carving – the face – with its broad smile and plump cheeks somewhat puffed up under the eyes. The area above the folded arms in the drawing suggests the close-fitting drapery of the original, but oddly, from the waist down, where the handling is much freer, the figure is shown nude.

In 1924, Moore was awarded a travelling scholarship from the Royal College of Art and left for France and Italy in January, 1925.[7] The purpose of the scholarship was to enable students to study the Old Masters, and Moore was expected to send back to England, as evidence of study, copies of Italian art. Only three sheets of drawings have survived from his Italian trip. The earliest work copied was an anonymous early fifteenth-century Florentine drawing 'The Visitation', in the Uffizi (Fig.76).[8] The Moore drawing (No.66), now in the Art Gallery of Ontario, was almost certainly based on an Alinari photograph. In all the known copies Moore made of drawings and paintings he never drew the entire composition. He usually isolated and copied a single figure, as in all the drawings after Rubens. But in the Toronto drawing he has drawn six of the seven figures. (See notes for No.66). 'The Two Thieves, St. John and Roman Soldiers' (No.67), recently signed and dated Moore Italy 1925, was copied from an as yet unidentified drawing or painting, probably a northern Italy work from the second half of the fifteenth century. It shows the two thieves, St John, and the Roman soldiers playing dice. The faintly outlined figure at centre has not been identified.

One of Moore's most beautiful and sensitive copies (No.68) is of one of the huntsmen holding a falcon in his left hand, from a drawing in the Louvre attributed to Jacopo Bellini, 'Les Trois Morts et les Trois Vivants' (Fig.77). It is also the most painstakingly accurate of all his copies in which he has carefully followed the technique and details in the original; the parallel hatchings, the speckled effect above and below the rider's left foot, and the small circles between the horse's hind legs. Characteristically, he has singled out one passage, the horse and huntsman, from the composition as a whole. This drawing, like the other two just described, was probably done from a photograph of the original.

During the past several years, Moore had made a number of copies of works by Old Masters. In 1975 he did a series of four drawings after Giovanni Bellini's 'Pietà' in the Brera (Fig.81), one of which is included in this exhibition (No.72). One of the most interesting copies of recent years (No.71) is of Dürer's 'Portrait of Conrad Verkell' in the British Museum (Fig.80). Moore has in his possession a reproduction of the Dürer drawing, and it was from this that the copy was based. The loosely-handled drawing of the head was followed beneath by the landscape study which was suggested by the rugged face in the portrait.

In 1954 Moore made a series of nine drawings based on photographs in his possession of a Styrian Crucifixion of *c*.1515–20, now in the National Gallery of Ljubljana (Fig.79). The drawings, one of which is included in this catalogue (No. 70), were preliminary studies for a project suggested by Dr Walter Hussey, who had commissioned the Northampton 'Madonna and Child' of 1943–4 (L.H.226). (See catalogue notes for No.199.)

On the evidence of the Notebook drawings, it would appear that the artist whose work Moore most often copied was Rubens. In fact, the earliest surviving copy, on p.28 of No.2 Notebook of 1921–2 (Fig.110), is

a drawing of the partially draped goddess, Juno, at the right in 'The Judgement of Paris' of 1635–6 in the National Gallery, London (Fig.111). Moore has left out the drapery and drawn the goddess completely nude, as he sometimes did when copying semi-draped figures. On p.52 of the same Notebook (Fig.112) the figure at left is of the partially draped nude at the right of Rubens' 'Diana and Nymphs Surprised by Satyrs' of c.1635–6, formerly in the Kaiser-Friedrich-Museum. When asked recently what it was that he admired about Rubens' work, Moore said that 'the heavy weighty figures were an obvious subject for stone sculpture – and the compact poses'. Such a figure is the 'Venus Frigida' in the Musée Royal des Beaux-Arts, Antwerp (Fig.113). On p.10 of the No.3 Notebook of 1922–4 (Fig.114) the two studies at the top of the page were based on the 'Venus Frigida', whereas in the other studies the figure and pose have been imagined and drawn from another angle. In the latter pose, the figure at the bottom of the page forms part of the composition inscribed 'Adam and Eve'.[9] Three other studies after Rubens appear in this Notebook.[10]

To date, no copies have been found of works by European artists from the 199 years between the death of Rubens in 1640 and the birth of Cézanne in 1839. During his first year at the Royal College of Art, Moore and his friend, Raymond Coxon, visited Paris at Whitsun, anxious to see some original Cézannes. Sir William Rothenstein had arranged an introduction to the Pellerin family, with their incomparable collection of Cézanne's work. Moore was overwhelmed by one painting in particular, 'Les Grandes Baigneuses', 1898–1905, now in the Philadelphia Museum of Art (Fig.72). He has described his visit and this painting as follows: '. . . what had a tremendous impact on me was the big Cézanne, the triangular bathing composition with the nudes in perspective, lying on the ground as if they'd been sliced out of mountain rock'.[11] An undated drawing of c.1922 (No.62) shows, at left, a sketch of the female nude reclining in the right foreground of 'Les Grandes Baigneuses', and at centre right the two standing figures which appear directly behind the reclining figure in the painting.

Gauguin appears to have been the only other nineteenth-century French artist whose work Moore copied. On the right of p.52 of No.2 Notebook of 1921–2 (Fig.112), beside the figure copied from Rubens' 'Diana Bathing Surprised by Satyrs', is a pen and ink sketch of Gauguin's charcoal drawing 'Femme Nue' of 1892 (Fig.115). This drawing is reproduced in Charles Morice's *Paul Gauguin* (Paris, 1911, p.172), which may well have been the source of Moore's copy. It is interesting to note that the source of the Gauguin figure was a photograph which he owned of a frieze from the Javanese temple of Baraboudour.[12]

Fig.110 Henry Moore,
*Page 28 from No.2 Notebook*, 1921–2

Fig.111 Peter Paul Rubens,
*The Judgement of Paris*, 1635–6
(National Gallery, London)

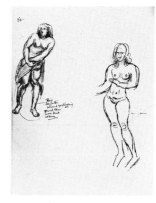

Fig.112 Henry Moore,
*Page 52 from No.2 Notebook*, 1921–2

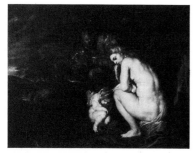

Fig.113 Peter Paul Rubens,
*Venus Frigida*, 1614
(Musée Royal des Beaux-Arts, Antwerp)

Fig.114 Henry Moore,
*Page 10 from No.3 Notebook*, 1922–4

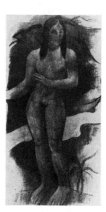

Fig.115 Paul Gauguin,
*Femme Nue*, 1892

## Copies of Primitive Art

> The term 'Primitive Art' is generally used to include the products of a great variety of races and periods in history, many different social and religious systems. In its widest sense it seems to cover most of those cultures which are outside European and the great Oriental Civilizations.[13]

Moore's definition of Primitive art serves as a useful introduction to this section on his copies of Negro, Oceanic, North and South American, and Mexican art. As one would expect, knowing Moore's interest during the 1920s in the arts of non-European cultures, his drawings of Primitive art far outnumber his copies of European paintings, drawings and sculpture discussed above. Almost all of these copies appear in the No.3 Notebook of 1922–4, and in the No.6 Notebook of 1926. They form a fascinating record of specific sculptures in the Ethnographic Collection of the British Museum which particularly interested Moore, and also of the four books on African and Peruvian art which he had studied and from which he made drawings.

Moore's first introduction to Primitive art was undoubtedly Roger Fry's *Vision and Design* (1920), which he had read at Leeds. 'Fry', Moore has written, 'in his essay on Negro sculpture stressed the "three-dimensional realization" that characterized African art and its "truth to material". More, Fry opened the way to other books and to the realization of the British Museum. That was really the beginning.'[14]

All Moore's copies of Primitive art are too numerous to include in this chapter. A selection has been made from five major areas: African, Oceanic, North American (Indian and Eskimo), Mexican and Peruvian.

Drawings of Negro sculpture, most of which are to be found in the No.3 Notebook of 1922–4, outnumber those made of any other forms of Primitive art. On p.103 of the No.3 Notebook (Fig.116) the sketch at lower right is of the 'Standing Figure of a Man', Jukun [?] from Southern Nigeria, in the British Museum (Fig.117). The two drawings of a female figure on p.105 of the same Notebook (No.63) are of particular interest. They are copies of a Mumuye carving from Northern Nigeria, 'Standing Figure of a Woman' (Fig.73), also in the British Museum. In 1951, Mr William Fagg asked Moore, whilst they were visiting the important exhibition of tribal art held during the Festival of Britain: 'Which Sculpture would you select as showing the best use of the special qualities of wood?'[15] His choice was the Mumuye carving (then thought to be from the Chamba tribe) which he had drawn in the British Museum nearly thirty years earlier. In his reply Moore explained what he admired about the sculpture: 'The Chamba figure seems to me one of the best from this point of view. The carver has managed to make it "spatial" by the way in which he has made the arms free and yet enveloping the central form of the body.'[16] On the lower left of p.105 (No.63) is a sketch of a wood carving of a human head from the Baga of French Guinea, in the British Museum.[17] All the works copied on this page were almost certainly drawn in the British Museum. The Ethnographic room, Moore has written, 'contained an inexhaustible wealth and variety of sculptural achievement (Negro, Oceanic Islands, and North and South America), but overcrowded and jumbled together like junk in a marine stores, so that after hundreds of visits I would still find carvings not discovered there before'.[18]

Illustrations in two German books on African art, Carl Einstein's *Negerplastik* (1920), and Ernst Fuhrmann's *Afrika* (1922), were the other principal source for Moore copies. The sketch of a head on p.120 of the

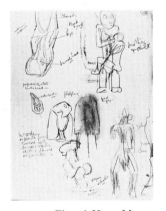

Fig.116 Henry Moore, *Page 103 from No.3 Notebook*, 1922–4

Fig.117 Standing figure of a man, Jukun[?], Southern Nigeria (British Museum)

No.3 Notebook of 1922–4 (Fig.118), just above centre right, is a copy of the Negro head (Fig.119) which is reproduced from Einstein's book (pl.15).[19] P.138 from the same Notebook includes three drawings of other examples of Negro sculpture which are illustrated in Einstein.[20]

Three notebook pages contain copies of works illustrated in Fuhrmann's *Afrika*. All the figures on p.143 of the No.3 Notebook (Fig.120) are from Fuhrmann. The three sketches in the upper half of the page are, from left to right, of pls.31, 69 and 71 respectively, and the two drawings below, showing in each case only the lower half of the figures, are copies from pls.75 and 73 in Fuhrmann. On p.121 of No.3 Notebook and p.17 of No. 5 Notebook are drawings of two other carvings illustrated in Fuhrmann.[21]

In spite of Moore's obvious interest in Negro sculpture in the 1920s, his carvings of the period, with the exception of 'Head of a Girl' 1922 (L.H.4) and 'Standing Woman' 1923 (L.H.5), reflect little direct influence. The forms and decorative designs of Oceanic art, on the other hand, he not only copied, but saw in them shapes which he transformed and incorporated in his own work. In his article on 'Primitive Art' Moore wrote:

Comparing Oceanic art generally with Negro art, it has a livelier, thin flicker, but much of it is more two-dimensional and concerned with pattern making. Yet the carvings of New Ireland have, beside their vicious kind of vitality, a unique spacial sense, a bird-in-a-cage form.[22]

Two copies of Oceanic works appear on p.105 of No.3 Notebook (No.63). To the right of the larger of the two drawings of the Mumuye carving are two sketches, frontal and profile views of a club of the bird-headed type from New Caledonia. The two studies were almost certainly made in the British Museum, where there are a number of examples of this type of club.[23] The inscription, 'Small abstract carving', indicates that the artist was considering basing a small sculpture on the shape of the club head. Mr William Fagg has suggested that the drawing at bottom right on p.105 may be of a carving from the Solomon Islands, but the precise source has not as yet been found.

The central and lower studies on p.90 of No.3 Notebook (Fig.121) were based on the powerful and dynamic Polynesian carving from the Hawaiian Islands, 'Figure in the Form of a Woman [?] Dancing', in the British Museum (Fig.122). The drawings show the sculpture in the position in which it was exhibited at the time, resting on its fingers and toes. In more recent years the figure has been exhibited in the standing position.[24] The crawling figure at the top of p.90 may be a free copy of 'Seat in the Form of a Male Figure', Arawak, Dominican Republic, in the British Museum.[25]

Fig.118 Henry Moore, *Page 120 from No.3 Notebook*, 1922–4

Fig.119 Negro head, pl.15 in *Negerplastik* by Carl Einstein

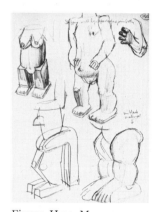

Fig.120 Henry Moore, *Page 143 from No.3 Notebook*, 1922–4

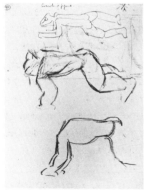

Fig.121 Henry Moore, *Page 90 from No.3 Notebook*, 1922–4

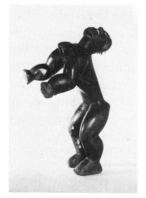

Fig.122 Figure in the Form of a Woman Dancing[?], Hawaiian Islands (British Museum)

Fig.123 Male figure, German New Guinea

Fig.124 Henry Moore, *Page 1 from No.6 Notebook*, 1926

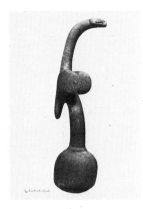

Fig.125 Stone Pestle, North-East Papua,
New Guinea (British Museum)

Fig.126 Henry Moore,
*Page 107 from No.3 Notebook*, 1922–4

Fig.127 Henry Moore,
*Page 106 from No.3 Notebook*, 1922–4

Fig.128 Henry Moore,
Inside back cover of *Sketchbook B*, 1935

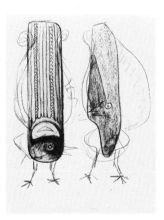

Fig.129 Henry Moore,
*Page from Sketchbook*, 1935 and 1942

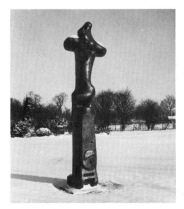

Fig.130 Henry Moore,
*Upright Motive No.1 : Glenkiln Cross*,
1955–6

Moore made three drawings in all of one of the most extraordinary examples of Primitive art he chose to copy. The carving is of a male figure standing on a sort of column, a work from German New Guinea (Fig.123). One of the three drawings appears on p.1 of the No.6 Notebook of 1926 (Fig.124); the other two on pp.102 and 103 (Fig.116) of No.3 Notebook. All three, which show the figure in profile to the left, were copied from an illustration on a loose page from an unidentified German book or periodical. As the drawings show the profile of the standing figure, the frontal view is illustrated here (Fig.123), from another page from the same source. From this view the arms appear to be logically connected with the shoulders, whereas in fact the head is supported by the hands, and the top of the arm is truncated at the shoulder.

Among Moore's most interesting copies are the series of drawings of the 'Stone Pestle' in the form of a bird, north-east Papua, New Guinea (Fig. 125). On p.107 of No.3 Notebook (Fig.126) the two large studies are straightforward copies of the original. The pen and ink sketch set between the two larger drawings shows a much more compact, less elongated bird, although obviously based on the original in the British Museum. In the drawings on p.106 (Fig.127), Moore has used the New Guinea carving as a point of departure for an 'abstraction', as the accompanying inscription states, and, like the transformation drawings of natural forms of the early 1930s (Nos.89 and 93), the object copied had been considerably altered. The studies on p.106 can no longer be classified as faithful copies of the 'Stone Pestle', but as studies for sculpture.

This selection of copies of Oceanic art ends with the small but important drawing on the inside back cover of Sketchbook B of 1935 (Fig.128). The two sketches of what is probably the same rectangular object are of an implement or a detail of a carving from New Ireland (see inscription at upper left). The original has not as yet been identified. This object appears again on the left in a page from a sketchbook of 1935 and 1942[26] (Fig.129) as a preliminary study for a cover for the Magazine *Poetry London*.[27] To each of the two forms, which were based on the studies in Fig.128, have been added wings, beaks and legs. Lyre birds were the subject of several of Moore's cover designs for *Poetry London*. In 1955–6 he again drew on the relief-like panel from New Ireland, incorporating the design of the drawing at left in Fig.129 in the 'Glenkiln Cross' (L.H.377, Fig.130). The top section of the sculpture, in the form of a cross, resembles an eroded torso with truncated arms. Moore has described the rectangular front of the lower half of the sculpture as 'the column and on it are little bits of

[149]

drawing which don't matter sculpturally, which represents a ladder and a few other things connecting it with the Crucifixion'.[28] This ladder was obviously suggested by the herring-bone design in the two drawings.

A number of drawings of works of the Eskimo and North American Indian cultures show artifacts, tools and weapons. On p.100 of No.3 Notebook (Fig.131) the sketch at upper right is of a north-west coast Indian pipe, in the Christy Collection of the British Museum. The two sketches on this page inscribed 'fish tail' and 'bore hole' are probably of Eskimo ivory harpoon heads, and between them is a drawing of an Eskimo needle case. In the bottom row of studies, the three drawings at left may be of a small Eskimo carving of a seal.[29] Two copies of works in the British Museum from the north-west coast of America appear on p.103 of No.3 Notebook (Fig.116). The drawing at upper right is of the small carving 'Woman and Child', Nootka Indians [?], Vancouver Island. The two sketches below the inscription 'fledgling' are almost certainly of a spear thrower of the Tlingit in Alaska.[30]

In view of Moore's deep admiration for Mexican sculpture, it is somewhat surprising to find so few copies of individual works. He did not, for example, make drawings of the 'Chacmool' reclining figure (Fig.28). The two drawings of a whale [?] on p.55 of No.4 Notebook (Fig.133) were almost certainly based on pl.99 in Ernst Furhmann's *Mexiko III* (1922),[31] which illustrates the bone (jaw) of an animal. The drawing inscribed 'Head of Christ in alabaster/Mexican' on p.97 of No.6 Notebook may well have been freely drawn from a Mexican mask.

This discussion of copies of Primitive art ends with two drawings of Peruvian objects. The large study of two heads on p.120 of No.3 Notebook (Fig.118) was based on the heads which appear on the neck of a pot from Trujillo, which is reproduced, pl.15 in Ernst Fuhrmann's *Reich der Inka* (1922),[32] (Fig.135). Moore has isolated the figurative elements, leaving out the pot to which they are attached. On p.30 of No.6 Notebook (Fig.136) the llama was copied from pl.109 in Walter Lehmann's *The Art of Old Peru* (1924). Another Peruvian pot (Fig.60) was the source of the bronze 'Mother and Child' of 1953 (L.H.315, Fig.59), both of which are discussed in the Introduction on p.44.

This survey of Moore's copies comprises an extensive record of his extraordinarily catholic taste and interest in sculpture, paintings, drawings and artifacts from 20,000 B.C. to the early twentieth century. The drawings themselves complement, and in certain instances, illustrate his comments and published articles on various artists, periods and cultures. Copying for him was a private form of education, a way of studying and observing some of the works of art which he found of particular interest.

Moore's knowledge of the history of world sculpture is profound. It seems somewhat surprising that in 1923 an instructor in the modelling school at the Royal College of Art could write of him: 'He appears to be somewhat limited in his interest of tradition in sculpture.' This judgement is nowhere more clearly refuted than in Moore's copies of the art of the past.

Fig.131 Henry Moore,
*Page 100 from No.3 Notebook*, 1922–4

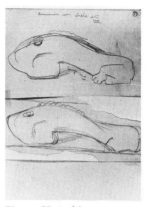
Fig.133 Henry Moore,
*Page 55 from No.4 Notebook*, 1925

Fig.135 Peruvian pot from Trujillo

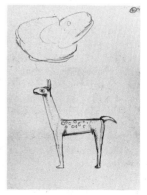
Fig.136 Henry Moore,
*Page 30 from No.6 Notebook*, 1926

# Notes

Many of the quotations have come from the following works. The abbreviated form, given in quotation marks after each item, is used throughout the notes.

When no reference has been given in the text for a quotation by Henry Moore, the statement was made in conversation with the author.

*Henry Moore*, photographed and edited by John Hedgecoe, words by Henry Moore, London, 1968. 'Hedgecoe'

*Henry Moore on Sculpture*, a collection of the artist's writings and spoken words edited with an introduction by Philip James, London, 1966. 'Henry Moore on Sculpture'

Herbert Read, *Henry Moore*, London, 1965. 'Read'

John Russell, *Henry Moore*, London, 1968. 'Russell'

David Sylvester, *Henry Moore*, catalogue of an exhibition at the Tate Gallery, Arts Council of Great Britain, 1968. 'Sylvester'

Gérald Cramer, Alistair Grant, David Mitchinson, *Henry Moore, Catalogue of Graphic Work*, vol.I (1931–72), vol.II (1973–5). Gérald Cramer, Geneva, 1973 and 1976. 'C.G.M.'

Catalogue raisonné, Lund Humphries London, 4 vols. as given below. 'L.H.'

*Henry Moore: Volume One, Sculpture and Drawings 1921–48*, Ed. David Sylvester with an introduction by Herbert Read, fourth edition (completely revised) 1957.

*Henry Moore: Volume Two, Sculpture and Drawings, 1949–54*, with an introduction by Herbert Read, second edition (revised) 1965.

*Henry Moore: Volume Three, Complete Sculpture 1955–64*, Ed. Alan Bowness with an introduction by Herbert Read, 1965.

*Henry Moore: Volume Four, Complete Sculpture 1964–73*, Ed. Alan Bowness, 1977.

### Life Drawing (pp.9–18)

[1] Henry Moore on Sculpture, p.115.
[2] Albert Elsen, *Auguste Rodin: Readings on his Life and Work*, 1965, p.7.
[3] Henry Moore on Sculpture, p.31.
[4] Ibid, p.32.
[5] Hedgecoe, p.236.
[6] Henry Moore on Sculpture, p.32.
[7] Ibid, p.115 (on reading this statement, Moore recently altered the original quotation to this form).
[8] Ibid, pp.33–4.
[9] Ibid, p.34.
[10] Moore said recently that Rothenstein did three portraits of him. He gave one of these to Moore, but its whereabouts is unknown.
[11] William Rothenstein, *Since Fifty: Men and Memories, 1922–1938*, London, 1939, p.38.
[12] John Rothenstein, *Modern English Painters: Lewis to Moore*, London, 1956, p.313.
[13] From an article by Henry Moore in *The Times*, Thursday 2 November 1967.
[14] In Moore's 'Two Standing Nudes' of 1923 (Fig.2), the figure at the right is stylistically so closely related to Underwood's life drawings as to suggest that it may, in fact, have been drawn by him.
[15] Barbara Hepworth mentioned her admiration for Underwood's teaching, in conversation with the author in 1971.
[16] Hedgecoe, p.38 (on reading this statement, Moore recently altered the original quotation to this form).
[17] In dating early life drawings in recent years, Moore often printed his signature in upper case on the student drawings of 1921–5.
[18] Moore recently compared his drawing 'Seated Figure' (Fig.1) to Degas's 'Etude de Deux Danseuses' (Fig.5) in his own collection.
[19] The broken line and wash technique in 'Reclining Female Nude' (Fig.6) also reminded Moore of Tiepolo's drawings. He asked the author if the style of this life drawing reminded him of the work of an Old Master.
[20] See Braque's classically inspired Kanephoroi – young women carrying baskets of fruit and flowers on their heads, as well as his chalk and charcoal nude studies from these years, in Douglas Cooper's *Braque: The Great Years*, The Art Institute of Chicago, 1972, Figs.30–34.
[21] Henry Moore on Sculpture, p.117.
[22] Hedgecoe, p.233.
[23] Ibid, p.233.
[24] Moore said recently that he drew more often at the Colarossi Academy.
[25] See C.G.M.12, 46, 109.
[26] Henry Moore on Sculpture, p.44.
[27] Sylvester, p.63.
[28] The series of masks of 1928–9 is discussed in the entry for No.82.
[29] Hedgecoe, p.236.

### Copies of Works of Art (pp.19–20)

[1] Henry Moore on Sculpture, p.57.
[2] Ibid, p.33.
[3] Ibid, p.49.
[4] Ibid, p.157.
[5] Ibid, p.33.

### Drawings 1921–40 (pp.21–7)

[1] Henry Moore on Sculpture, p.67.
[2] 'Sketchbook for the Relief on the Underground Building' of 1928 (Henry Moore Foundation) is not included in this exhibition. This sketchbook is discussed in the entry for No.79.
[3] Theodore Reff, *The Notebooks of Edgar Degas*, 2 vols., Oxford University Press, 1976.
[4] Notebooks 2–6 (No.1 Notebook has been lost) and 'Sketchbook for the Relief on the Underground Building' of 1928 have been catalogued in 'The Drawings of Henry Moore', a thesis submitted by Alan G. Wilkinson for the Ph.D. degree at the Courtauld Institute of Art, University of London, 1974. No.6 Notebook of 1926 has been reproduced in facsimile: *Sketchbook 1926*, published by Ganymed Original Editions Ltd in association with Fischer Fine Art Ltd, London, 1976. The catalogue includes an introduction by Henry Moore, and catalogue notes by Alan G. Wilkinson.

NOTES

## Wartime Drawings:
### Coal-mine Drawings (pp.36–40)

1 A copy of Dickey's letter is in the archives of the Imperial War Museum, London.
2 Moore's letter is in the archives of the Imperial War Museum, London.
3 Moore had a poisoned hand at the time.
4 Moore's letter is in the archives of the Imperial War Museum, London.
5 A copy of Dickey's letter is in the archives of the Imperial War Museum, London.
6 In January 1972 Moore wrote for the author this description of his first day down the pit. The quotation appears in the author's Ph.D. thesis on 'The Drawings of Henry Moore', Courtauld Institute of Art, University of London, 1974, pp.312–3.
7 *Pit Notebook* is certainly a more suitable title for the smallest of the three coal-mine sketchbooks. Moore himself refers to 'pit notebook' in a number of later drawings. (See No.171.)
8 On 21 November, 1941 the photo news editor of the periodical *Illustrated* wrote to Moore asking if they might send a photographer to Yorkshire to record him drawing the coalminers. The two photographs shown here (Figs.50 a and b) are reproduced from the originals taken by *Illustrated*.
9 Henry Moore on Sculpture, p.216.
10 From an unpublished taped conversation between Henry Moore and Joseph Darracott, on the occasion of an exhibition of Henry Moore's War Drawings at the Imperial War Museum, June–October 1976.
11 Henry Moore on Sculpture, p.216.
12 *Auden Poems / Moore Lithographs*. An exhibition of a book dedicated by Henry Moore to W. H. Auden, with related drawings, British Museum, 1974. Section three: The coal-mine drawings. (No page number.)
13 Notes written by Moore for the author in January 1972 and first quoted in 'The Drawings of Henry Moore', 1974, pp.314–5 (see Note 6 above).
14 Ibid, p.315.
15 A copy of Dickey's letter is in the archives of the Imperial War Museum, London.
16 For distribution of the coal-mine drawings, see back page of the leaflet written by Joseph Darracott, published on the occasion of the exhibition of Henry Moore's War Drawings at the Imperial War Museum, London, 1976.
17 *Auden Poems / Moore Lithographs*, Section three: The coal-mine drawings (see Note 12 above).

## Drawings 1942–77 (pp.41–7)

1 The artist told the author recently that he worked on the coal-mine drawings for about eight or nine months.
2 See William S. Rubin, *Dada, Surrealism, and their Heritage*, The Museum of Modern Art, New York, 1968, pp.32 and 33.
3 See *Goya His Life and Work*, Pierre Gassier and Juliet Wilson, 1971, English edition, p.325, No.1573 'Disparate de miedo' (Fearful Folly).
4 Mention has been made of the fact that Moore owns a copy of this book. For other drawings based on photographs in Frobenius, see notes for No.112.
5 Read, p.176.
6 Hedgecoe, p.61.
7 Henry Moore on Sculpture, p.250.
8 During the summer of 1930 the Moores spent a fortnight with some friends (including Ben Nicholson, Barbara Hepworth, and Ivon Hitchens) at Happisburgh on the Norfolk coast. Moore has described the holiday as follows: 'It was very good weather, and it was there we found ironstone pebbles which were hard enough and also soft enough to carve. Some were already beautifully simplified shapes' (Quoted in *Ben Nicholson*, a *Studio International* Special, edited by Maurice de Sausmarez, 1969, p.24.) Moore made four ironstone sculptures in 1930 (L.H.85–88).
9 Hedgecoe, p.269.
10 Henry Moore on Sculpture, p.62.
11 See preface by Henry J. Seldis to Moore's *Elephant Skull Album*, Gérald Cramer, Geneva, 1970.

## Life Drawing (Nos.1–61)

1 Daniel Halévy, *My Friend Degas*, London, 1966, p.50.
2 Henry Moore on Sculpture, p.193.
3 Ibid, p.131.
4 Henry Moore on Sculpture, p.58.
5 Hedgecoe, p.56.
6 Henry Moore on Sculpture, p.157.
7 Hedgecoe, p.61.
8 Ibid, p.175.

## Drawings 1921–40 (Nos.73–136)

1 See Alan G. Wilkinson, 'The Drawings of Henry Moore', unpublished Ph.D. thesis, Courtauld Institute of Art, University of London, 1974, pp.41–247
2 *Sketchbook 1926*, published by Ganymed Original Editions Ltd, in association with Fischer Fine Art Ltd, London, 1976. The catalogue includes an introduction by Henry Moore and catalogue notes by Alan G. Wilkinson.
3 See the author's thesis (Note 1 above) pp.256–8.
4 About four years ago the artist trimmed this sheet, cutting off the entire left side showing the man carrying child. The photograph shown here is the only surviving record of the original sketch.
5 Hedgecoe, p.45.
6 See Henry Moore on Sculpture, p.70.
7 This sketchbook is in the collection of the Henry Moore Foundation.
8 Russell, p.28.
9 This date was probably suggested by the artist, in conversation with Read.
10 Read, p.72.
11 Sylvester, p.156, Note 12.

5 Henry Moore on Sculpture, p.67.
6 Ibid, p.146.
7 Hedgecoe, p.100.
8 Albert E. Elsen, *Rodin*, The Museum of Modern Art, New York, 1963, p.156.
9 In recent years maquettes and large bronzes have been the subject of a number of drawings (Nos.251 and 252), and graphics (C.G.M.101, 105, 106, 108.)
10 Henry Moore on Sculpture, p.67.
11 Ibid, p.150.
12 Hedgecoe, p.100.
13 Henry Moore on Sculpture, p.149.
14 Hedgecoe, p.269.
15 Henry Moore on Sculpture, p.67.
16 Both carvings are discussed in detail in the author's forthcoming article on the 1930 'Reclining Woman' (L.H.84), in the National Gallery of Canada Bulletin.
17 See Zervos, vol.7, 1926–32, Nos.84–109.
18 'Art in Britain 1930–1940 Centred around Axis, Circle, Unit One', Marlborough Fine Art Ltd, London, March–April 1965. Two essays by Herbert Read, Notes and Documentation by Jasia Reichardt.
19 Ibid, p.5.
20 Ibid, p.5.
21 Henry Moore on Sculpture, p.70.
22 Ibid, p.149.
23 Moore owns a copy of this book.
24 Henry Moore on Sculpture, p.97.
25 Hedgecoe, p.93.
26 Donald Hall, *Henry Moore: The Life and Work of a Great Sculptor*, London, 1966, p.83.

## Wartime Drawings:
### Shelter Drawings (pp.28–35)

1 Constantine Fitz Gibbon, *The Blitz*, London, 1957, p.101.
2 Henry Moore on Sculpture, pp.212 and 216.
3 Hedgecoe, p.134.
4 Henry Moore on Sculpture, p.212.
5 The late Lady Clark bequeathed the 'First Shelter Sketchbook' to the British Museum.
6 Henry Moore on Sculpture, p.216.
7 For distribution of the shelter drawings, see back page of the leaflet written by Joseph Darracott, published on the occasion of the exhibition of Henry Moore's War Drawings at the Imperial War Museum, London, June–October 1976.
8 James Johnson Sweeney, *Henry Moore*, The Museum of Modern Art, New York, 1946, p.72.
9 T. S. Eliot, *Four Quartets*, The Folio Society, 1968, p.34.
10 Ibid, p.48.
11 Wax crayon was used in a number of pre-shelter drawings of 1940. See for example Nos.130, 132 and 136.
12 Henry Moore on Sculpture, p.218.
13 This sheet of notes is in the artist's possession.
14 Henry Moore on Sculpture, pp.216 and 218.
15 Ibid, p.218.
16 Ibid, p.218.
17 Ibid, p.103.
18 Ibid, p.218.

[152]

[12] The artist told the author that he thinks he did a relief of a reclining figure, on the back of a garden bench. The carving, however, has been lost or destroyed.

[13] See pp.39 and 55 of No.3 Notebook, and pp.21, 27, 41 and 77 of No.5 Notebook.

[14] Moore's copy of this book is inscribed on the fly-leaf 'Henry Moore 1928'.

[15] See Read, p.84; Russell, p.34; Sylvester, p.35.

[16] Henry Moore on Sculpture, p.68.

[17] Alan Bowness, *Modern Sculpture*, London, 1965, p.70.

[18] Henry Moore on Sculpture, p.68.

[19] Hedgecoe, p.76.

[20] Russell, p.67; Sylvester, p.63.

[21] Alfred H. Barr, Jr, *Picasso Fifty Years of his Art*, The Museum of Modern Art, New York, 1966, p.63.

[22] Herbert Read, *Ben Nicholson, Paintings, Reliefs, Drawings*, Lund Humphries, London, 1948, No.69.

[23] Henry Moore on Sculpture, p.101.

[24] Hedgecoe, p.105.

[25] Henry Moore on Sculpture, p.209.

[26] Hedgecoe, p.107.

[27] Erich Neumann, *The Archetypal World of Henry Moore* (translated from the German by R. F. C. Hull), New York, 1959, p.52.

[28] *The Penguin Book of English Verse*, edited by John Hayward, 1956, p.82.

[29] The work of Naum Gabo, who came to England in 1935 and settled in Hampstead, no doubt influenced the stringed figure drawings and sculpture of Moore and Hepworth.

[30] Henry Moore on Sculpture, p.209.

[31] Geoffrey Grigson, *Henry Moore*, The Penguin Modern Painters, London, 1944, pp.15 and 16.

**Appendix: Copies of Works of Art**
(pp.143–50)

[1] Henry Moore on Sculpture, p.157.

[2] Other copies of works illustrated in Kühn's *Die Kunst der Primitiven* also appear in No.6 Notebook of 1926: on p.75 a drawing of a bas-relief of a female figure grasping a curved object, from the shelter of Laussel in the Dordogne (pl.2 in Kühn); on p.69 copies of Norwegian rock drawings of reindeer, illustrated on p.55 in Kühn; on p.71 two copies of rock drawings of reindeer from northern Norway, illustrated on p.56 in Kühn.

[3] Henry Moore on Sculpture, p.165.

[4] On p.215 of No.3 Notebook of 1922–4 the small reclining figure at the top of the page is remarkably similar to an Etruscan bronze in the British Museum, 'Reclining Satyr' of *c.*490 B.C. from Pistoia.

[5] It would appear that Moore began the drawing in the front of this notebook, filling pp.1–26, of which the present drawing is p.15. He then turned the notebook round 180 degrees and began at the back, numbering the pages 1–100.

[6] Hedgecoe, p.23. Photographs of two of the carvings on Methley Church also reproduced on that page.

[7] Moore's account of this trip is given in Henry Moore on Sculpture, pp.37–43.

[8] The author, in his Ph.D. thesis on 'The Drawings of Henry Moore', Courtauld Institute of Art, University of London, 1974, pp.32–3, stated incorrectly that the studies in the present drawings were of figures from the School of Giotto 'The Visitation' in the Lower Basilica of San Francesco at Assisi.

[9] A more fully realized drawing of Adam and Eve appears on p.85 of No.3 Notebook.

[10] On pp.30 and 45 are studies which were almost certainly derived from the woman in the left foreground of Rubens' 'The March of Silenus'. The female nude on p.41 would appear to be a copy of the Syrinx in Rubens' 'Pan and Syrinx', in the Collection of H.M. The Queen.

[11] Henry Moore on Sculpture, p.190.

[12] This frieze is reproduced Fig.7, p.196 in Henri Dorra's 'The First Eves in Gauguin's Eden', *Gazette des Beaux Arts*, Volume 41, 1943, pp.189–202.

[13] Henry Moore on Sculpture, p.155.

[14] Ibid, p.49.

[15] Ibid, p.173.

[16] Ibid, p.173.

[17] This carving was published in William Fagg's article 'Two Woodcarvings from the Baga of French Guinea', in *Man a Monthly Record of Anthropological Science*, published under the direction of the Royal Anthropological Institute of Great Britain and Ireland, XLVII, 1947, article 113, pp.105–6, pl.H. I am indebted to Mr Fagg for having identified the Moore drawing as a copy of the Baga carving.

[18] Henry Moore on Sculpture, p.157.

[19] Dr John Golding has pointed out (*Cubism*, London, 1968, p.140, footnote 2) that 'Some of the heads in Derain's 'Baigneuses' and several in the 'Last Supper' are close to a Negro head reproduced by Carl Einstein in his 'Neger plastik', Munich 1920, pls.14 and 15. This head was in the collection of Frank Haviland, a friend of Derain's'. I am indebted to Dr Golding for identifying the Moore drawing as a copy of this Negro head.

[20] The copies on p.138 of No.3 Notebook from illustrations in Einstein's 'Neger plastik' are: the leg and torso in profile to the right in the upper half of the page just right of centre – from the figure at right (of the double figure), pl.87 in Einstein; the sketch at upper left – from the head-dress of the figure at right pl.67 in Einstein; directly below the sketch of the leg and torso in profile, the drawing of an elaborate head-dress – from a work illustrated (pl.105) in Einstein.

[21] On p.121 of No.3 Notebook, the head in profile is almost certainly a copy of the well-known 'Kneeling Figure Holding a Bowl', Musée Royal de l'Afrique Centrale, Tervuren, pl.18 in Fuhrmann. On p.17 towards the end of No.5 Notebook is a copy of a sculpture from Cameroon – a seated male figure holding a gourd, pl.63 in Fuhrmann.

[22] Henry Moore on Sculpture, p.159.

[23] See *Melanesia A Short Ethnograph*, by B. A. L. Cranstone, published by the Trustees of the British Museum, London, 1961, p.68, Figs.23, c, d, and e.

[24] Mr William Fagg has written in the notes on the Polynesian carving, pl.80 in *The Tribal Image*, published by the Trustees of the British Museum, London, 1970; 'Yet it has been noticed (first, possibly, by Mr. John Read when making a film in the British Museum on Henry Moore's work some years ago) that the figure displays its extraordinary merits to far greater effect when standing (which it does in perfect balance) than when in the prone position: the front of the body has far more dynamic sculptural interest than the back, but this is seen only in the standing posture'.

[25] See William Fagg, *The Tribal Image*, published by the Trustees of the British Museum, London, 1970, pl.4.

[26] The 1935 sheet would appear to have been reworked in 1942.

[27] Moore designed a number of covers for *Poetry London*. The cover of issue No.7, October–November 1942, shows three studies of lyre birds. In the November–December issue, No.8, the cover shows two different versions of lyre birds.

[28] 'Henry Moore looking at his work with Philip James', sound and film strip unit. Sound editor John Yorke. Two 12″ double sided 33⅓ r.p.m. records. Visual Publications, London.

[29] I am indebted to Miss Elizabeth Carmichael of the British Museum for suggesting these identifications.

[30] Reproduced in *Handbook to the Ethnographical Collections*, British Museum, London, second edition, 1925, p.277, Fig.265.

[31] The artist's copy of this book is inscribed on the fly-leaf: 'Henry Spencer Moore 1923'.

[32] The artist's copy of this book is inscribed 'Henry Spencer Moore 1923'. In addition, the two bird studies on p.101 of No.3 Notebook derive from a bird motif on an Inca pot from Chimbote, reproduced (pl.51) in Fuhrmann's *Reich der Inka*.

# Bibliography

## Books on Henry Moore's drawings

Kenneth Clark, *Henry Moore: A Note on His Drawings*, exhibition catalogue, Buchholz Gallery, New York 1943.

Kenneth Clark, *The Drawings of Henry Moore*, Thames and Hudson, London 1974.

Hanns Theodor Flemming, *Henry Moore Katakomben*, Piper Verlag, Munich 1956.

Geoffrey Grigson, *Henry Moore*, Penguin Books, Harmondsworth 1943.

David Mitchinson, *Henry Moore Unpublished Drawings*, Fratelli Pozzo, Turin 1971.

Henry Moore, *The Drawings of Henry Moore*, Curt Valentin, New York 1946.

Henry Moore, *Heads, Figures and Ideas: A Sculptor's Notebook*, George Rainbird Ltd, London; The New York Graphic Society, Connecticut 1958.

Henry Moore, *Shelter Sketch Book*, (Facsimile), Editions Poetry, London 1945.

Henry Moore, *Shelter Sketch Book*, (Facsimile), Marlborough Fine Art, London; Rembrandt Verlag, Berlin 1967.

Henry Moore, *Sketchbook 1926*, Ganymed Original Editions Ltd in association with Fischer Fine Art Ltd, London 1976. Introduction by Henry Moore, catalogue notes by Alan G. Wilkinson.

Herbert Read, 'The Drawings of Henry Moore', *Art in America*, No.3, pp.10–17, 1941.

Alan G. Wilkinson, *The Drawings of Henry Moore*, Borden Pub. Co, Alhambra 1970.

Alan G. Wilkinson, Introduction to *Henry Moore Drawings, Gouaches, Watercolours*, exhibition catalogue, Galerie Beyeler, Basel 1970.

Alan G. Wilkinson 'The Drawings of Henry Moore', Ph.D. thesis for the Courtauld Institute of Art, University of London, 1974.

## Books, articles and catalogues with important references and illustrations of Henry Moore's drawings

Giulio Carlo Argan, *Henry Moore*, De Silva, Turin 1948.

Giulio Carlo Argan, *Henry Moore*, Fratelli Fabbri, Milan 1971.

Cecil Beaton, Introduction to *War Pictures by British Artists* (Second Series No.2), London 1943.

Giovanni Carandente, *Henry Moore Florence Forte de Belvedere*, exhibition catalogue, Il Bisonte, Florence 1973.

Gérald Cramer, Alistair Grant, David Mitchinson, *Henry Moore, Catalogue of Graphic Work*, vol.I (1931–72), vol.II (1973–5), Gérald Cramer, Geneva 1973.

Elda Fezzi, *Henry Moore*, Sansoni, Florence 1971.

Will Grohmann, *The Art of Henry Moore*, Rembrandt Verlag, Berlin 1959.

Donald Hall, *Henry Moore The Life and Work of a Great Sculptor*, Victor Gollancz, London 1966.

A. M. Hammacher, *70 Years of Henry Moore*, exhibition catalogue, Ed. David Mitchinson, Rijksmuseum Kröller-Müller, Otterlo 1968.

*Henry Moore*, photographed and edited by John Hedgecoe, words by Henry Moore, Thomas Nelson, London 1968.

J. P. Hodin, *Henry Moore*, de Lange, Amsterdam 1956.

Werner Hofman, *Henry Moore Schriften und Skulpturen*, Fischer Verlag, Frankfurt 1959.

*Henry Moore on Sculpture*, a collection of the artist's writings and spoken words edited with an introduction by Philip James, Macdonald, London 1966.

Ionel Jianou, *Henry Moore*, Arted, Paris 1968.

Robert Melville and E. Peterman, Introduction to *Die Shelterzeichnungen des Henry Moore*, exhibition catalogue, Staatsgalerie, Stuttgart 1967.

Robert Melville, 'Henry Moore: The Recent Sketch-book', *Graphics*, Zurich, September-October 1959.

Robert Melville, *Henry Moore: Sculpture and Drawings 1921-1969*, Thames and Hudson, London 1970.

Henry Moore and John Russell, Introduction to *Auden Poems/Moore Lithographs*, exhibition catalogue, British Museum, London 1974.

J. B. Morton, Introduction to *War Pictures by British Artists*, London 1942.

Erich Neumann, *The Archetypal World of Henry Moore*, Pantheon Books, New York 1969.

Rudolf Pfefferkorn, *Englische Malerei Der Gegenwart*, Baden-Baden 1953.

Herbert Read, *Henry Moore Sculptor*, Zwemmer, London 1934.

**Catalogue raisonné**, Lund Humphries, London, 4 vols. as given below:

*Henry Moore: Volume One, Sculpture and Drawings 1921-48*, Ed. David Sylvester with an introduction by Herbert Read, fourth edition, 1957. (See also first edition 1944, second edition 1946, third edition 1949.)

*Henry Moore, Volume Two, Sculpture and Drawings 1949-54*, with an introduction by Herbert Read, second edition, 1965. (See also first edition 1955.)

*Henry Moore: Volume Three, Complete Sculpture 1955-64*, Ed. Alan Bowness with an introduction by Herbert Read, 1965.

*Henry Moore, Volume Four, Complete Sculpture 1964-73*, Ed. Alan Bowness, 1977.

Herbert Read, *Henry Moore*, Thames and Hudson, London 1965.

John Rothenstein, *Modern English Painters: Lewis to Moore*, Eyre & Spottiswood, London 1956.

John Russell and Vera Lindsay, 'Conversations with Henry Moore', *The Sunday Times*, London 1961.

John Russell and Vera Lindsay, 'Moore explains his Universal Shapes', *New York Times Magazine*, New York, 11 November 1962.

John Russell, *Henry Moore*, Penguin Books, Harmondsworth 1968.

*Homage to Henry Moore*, Ed. G. di San Lazzaro, XXe Siècle, Paris 1972.

Henry J. Seldis, *Henry Moore in America*, Praeger, New York 1973.

James Johnson Sweeney, *Henry Moore*, The Museum of Modern Art, New York 1946.

David Sylvester, *Sculpture and Drawings by Henry Moore*, catalogue of an exhibition at the Tate Gallery, Arts Council of Great Britain, 1951.

David Sylvester, *Henry Moore*, catalogue of an exhibition at the Tate Gallery, Arts Council of Great Britain, 1968.

## Books illustrated by Henry Moore

Constantine FitzGibbon, *The Blitz*, Alan Wingate, London 1957.

J. W. Goethe, *Promethée*, translated by André Gide, (eight lithographs), Paris 1950.

Jacquetta Hawkes, *A Land*, Cresset, London 1951.

Murray Hickey Ley, *A is All*, (frontispiece and inside jacket cover) Grabhorn Press, San Francisco 1953.

Edward Sackville-West, *The Rescue*, (six illustrations) Martin Secker & Warburg, London 1944.

*A Map of Hearts*, Ed. Stephan Schimanski and Henry Treece, (cover design) London.

*Festschrift* for KFR, Ed. Tambimuttu, (cover design) The Lyrebird Press, London 1972.

*Poetry London*, Ed. Tambimuttu, vol.II, No.7 & No.8, and vol.III, No.11, (cover designs), London 1942 & 1947.

# Lenders

Page 156   List of Lenders.
          M. F. Fehely should read M. F. Feheley.

# Acknowledgements

I would like to thank most warmly Alan Bowness, Dr John Golding and Dr Christopher Green, of the Courtauld Institute of Art, for their encouragement and advice during my five years of research at the University of London on the drawings of Henry Moore. I should also like to thank the following for their help during the preparation of the exhibition and catalogue: Sir Geoffrey Agnew, Adrian Brink, Harry A. Brooks, Julia Brown, Frances Carey, Barbara Dodge, Dr R. H. Hubbard, Robin Johnson, James Kirkman, Margaret McLeod, M. D. McLeod, Jeffrey H. Loria and John Synge. I am indebted to my colleagues at the Art Gallery of Ontario for their advice and support: William J. Withrow, Director; Michael George, Secretary-Treasurer; Dr Richard Wattenmaker, Chief Curator; Bill Auchterlonie, Curatorial Co-ordinator; Carlo Catenazzi, Photographic Technician; James Chambers, Head Photographer; Faye Craig, Assistant, Photographic Services; Anne Hurley, Administrator of the Gallery Shop; Ralph Ingleton, Practitioner, Conservation Department; Judi John, Communications Officer; Katherine A. Jordan, Curator of Prints and Drawings; Olive Koyama, Head of Publications; Alex MacDonald, Head of Public Affairs; Ian McMillan, Traffic Manager; Larry Ostrom, Photographer; Sybille Pantazzi, Librarian; Larry Pfaff, Assistant to the Librarian; Eva Robinson, Registrar; John Ruseckas, Chief Preparator and his staff; Barry Simpson, Assistant Registrar; Maia-Mari Sutnik, Co-ordinator Photographic Services; Eduard Zukowski, Chief Conservator. I am particularly grateful to my secretary Merike Kink for her help with the organization of the exhibition. To the following members of the staff of the Tate Gallery I am deeply indebted for their help with both the organization of the exhibition and the production of the catalogue: Michael Compton, Vicki Elliott, Caroline Odgers and Ruth Rattenbury of the Exhibitions Department, and Iain Bain and Pauline Key of Tate Publications. I would also like to thank Ruby Stoltenhoff and Judy Moon of the Exhibitions Department, and the following members of the Photographic Department: Michael Duffett, David Lambert and David Nye. I owe a special debt of gratitude to Margaret Willes for editing the manuscript.

To Mrs Betty Tinsley, Henry Moore's secretary, and David Mitchinson, I owe a great deal for their tireless assistance with numerous details related to this exhibition. Juliet Wilson has been most helpful in organizing the loans and documentation of drawings lent by the Henry Moore Foundation and the artist's family. We are most grateful to Mrs Irina Moore and Mary Moore for the many drawings they have lent to the exhibition. Finally, I am at a loss to express adequately my deep gratitude to Henry Moore. Since March 1969 I have made many visits to Hoglands and had the invaluable experience of spending many hours discussing the drawings with the artist himself. He has been unfailingly generous with his time, and has always been willing to answer countless questions about his sculpture and drawings. Working so closely with Henry Moore has afforded me the privilege of a direct encounter with a great artist's knowledge and experience of the art of drawing.

Alan G Wilkinson